THE TYPOGRAPHIC EXPERIMENT

RADICAL INNOVATION IN CONTEMPORARY TYPE DESIGN

Thames & Hudson

Teal Triggs

BOOK DESIGN: Joe Ewart for Society and Niall Sweeney at Pony.

TYPOGRAPHY: Trade Gothic (1948–60) was designed by Jackson Burke (1908–75) while director of type development for Mergenthaler-Linotype (US). Burke, who also designed Majestic (1953–56) and Aurora (1960), developed the TeleTypesetting System (TTS) for magazines and for the development of fonts for Native American languages.

DEDICATION: This book is dedicated to my father, Edward E. Triggs (1930–99), whose passion and commitment to typography and design education was truly inspirational.

ACKNOWLEDGMENTS: A book such as this would not have been possible without the combined efforts of all its contributors. I would like to give special thanks to the featured designers and typographers and acknowledge their patience in responding to my endless questions and requests.

Special mentions need to be made to Jen Donaghy, Azusa Ozawa, Gina Ha-Gorlin, Haoko Hasegawa, Yuki Maetani and Alan Záruba, whose significant contributions as researchers for this project are fully recognized and greatly appreciated.

I would also like to acknowledge the following for consultation and generous assistance in the making of this book: Lucas Dietrich and Catherine Hall at Thames & Hudson, Krisztina Somogyi, Louise Sandhaus, Norman Hathaway, Rudy VanderLans, Cornel Windlin, Katherine McCoy, Jan van Toorn, Theo van Leeuwen, Paul Elliman, Alex Williamson, the librarians at Kingston University, London College of Printing and St. Bride Printing Library.

And, finally, to my friends and family who provided enormous support, especially Siân Cook, Joe Ewart, Niall Sweeney and my partner Roger Sabin.

006 INTRODUCTION:
THE TYPOGRAPHIC EXPERIMENT:
FROM FUTURISM TO FUSE

020 CHAPTER 1:
THE MEDIUM IS THE MESSAGE
026 Martin Venezky
032 Hamish Muir
036 David Carson
040 Gyöngy Laky
044 Katsuya Ise & students
050 Diane Gromala

054 CHAPTER 2:
MAPPING MEANING AND DEFINING SPACES
060 Paul Elliman
066 Peter Anderson
070 David Crow
074 Elevator
078 Pablo A. Medina
084 Lucille Tenazas
088 Jonathan Barnbrook
092 Jenny Wilson & students
096 Sibylle Hagmann
100 Pierre di Sciullo
104 Saki Mafundikwa & students

First published in the United Kingdom in 2003 by Thames & Hudson Ltd, 181A High Holborn, London WC1V 7QX

www.thamesandhudson.com

British Library Cataloguing-in-Publication Data
A catalogue record for this book is available from the British Library

ISBN 0-500-51143-8

Printed and bound in China by C&C Offset

108 CHAPTER 3:
 TYPO-ANARCHY AND THE DIY OF DESIGN
114 Michael Worthington
120 Rian Hughes
124 Noriyuki Tanaka
130 Klára Kvízová
134 Fumio Tachibana
140 Aleš Najbrt

144 CHAPTER 4:
 VISUAL POETRY
150 Lucinda Hitchcock & students
154 Susan LaPorte
158 Melle Hammer
162 Stuart Bailey
168 Peter Bil'ak
172 Ahn Sang-Soo
176 Studio Blue

180 CHAPTER 5:
 SMALL SCREEN (BIGGER PICTURE)
186 Mikon van Gastel
192 Fred Flade
196 Katherine McCoy & students
202 Nick Bell
206 Nancy Nowacek
210 Zsolt Czakó
214 Elliott Peter Earls

220 BIBLIOGRAPHY
223 CREDITS

THE TYPOGRAPHIC EXPERIMENT: FROM FUTURISM TO FUSE

Lo-Res-28

Lo-Res-22

Lo-Res-15

Lo-Res-12

Lo-Res-9

Zuzana Licko's experiments in type design in the digital realm culminated in the design of Lo-Res (2002), a font family that emerged out of earlier bitmap experiments with Oakland, Emperor, Universal and Emigre (all 1985). She deals with the restrictions of screen resolution almost fifteen years before the current obsession with low-resolution typefaces.

This book is about the typographic experiment. It is a reflection on the point in the design process when the constraints of convention are released and the fundamental notions of function and aesthetics are challenged. The typographic experiment is a way of trying something out, of playing. It is about innovation but it is not always formulaic nor is there an established set of rules. Positioned within a more scientific context, experimentation is a process by which a hypothesis is tested under controlled conditions to discover an unknown effect. In both cases experimentation is a legitimate research method. It may occur in the development of print-based or screen-based solutions and may be advanced in the laboratory of the urban environment or in the realm of the virtual. The results will often inform the strategies and methods by which designers and typographers approach their commercial activity.

The book takes a fresh look at the work produced over the last decade by thirty-seven type designers and typographers internationally who engage with the notion of experimentation. It has as its starting point a definition of experimental as a valid means of rational investigation, of taking risks and viewing those risks as crucial to the development of the overall design process. 'Process', as designer Daniel Friedman wrote, 'is a system of operations or a series of changes or actions in the production of a result'[1]. Process is also about continuous learning – and engaging with the experiment. By no means a comprehensive study of experimental typography, this is more an attempt to reveal some of the ways in which the experimental has influenced the development of a new visual and theoretical vocabulary for the discipline whether explicitly or implicitly. To experiment extends the work beyond the limits of 'newness' and 'plays it out into the territory of the unknown'[2].

Traditionally, the role of the experimental has been located within the territory of the avant-garde, operating outside dominant traditions. Consider British architectural group Archigram's innovative 'Plug-In City' (1964); and composer John Cage's composition 4'33" (1952). In literature, the existential writings of James Joyce and 'cut-ups' of Brion Gysin and William S. Burroughs (1959) were experimental in the way words and language were deconstructed to create a fragmentary non-linear approach to the contemporary narrative form. In cinema, remember the exploratory Dada films of Man Ray (Return to Reason, 1923) or Lars von Trier and the

'Dogme95' movement (1995), whose manifesto called for a democratization of cinema; for example, films were to be made on location with hand-held cameras. The avant-garde offers critiques of the mainstream, challenging accepted conventions and developing new 'ways of seeing' or, in the case of typography, new 'ways of reading'[3]. The avant-garde may reject existing traditions or canons of style but it may also take forward ideas and develop original positions. Some may argue that a handful of examples will transcend time, but what is experimental at one historical point or in one cultural context may not be considered experimental in another. The avant-garde is an inherently 'insecure position' and its boundaries constantly changing as it searches for the next 'new' thing[4].

So, how do we define the contemporary typographic experiment in graphic design? In 1996, design critic Rick Poynor wrote that we have seen 'the mainstreaming of experimental approaches to typography'[5]. Oddly shaped columns of type, the multiple layering of information and the questionable legibility of typefaces had fostered a backlash against cool Swiss Modernism and were seemingly commonplace. Advances in computer technology offered new aesthetic possibilities but also a greater democratization of design and print production, which naturally led to a plethora of personalized typefaces and designers parading their new roles as graphic authors. At the same time as self-expression and experimentation took hold, such typographic conventions as legibility and readability came under siege. Deconstruction and Postmodernism were adopted as typographic buzz words and, in their wake, theory often overshadowed the pragmatism of function. It would appear that as our perceptions of language and its theoretical underpinnings shifted, so too did the way in which language was documented through the visible word. This may have shaken up the visual world momentarily, but experimental typography soon transposed itself from the realm of the 'radical' into the arena of an ostensibly accepted visual language.

TYPOGRAPHIC LANGUAGE

The idea of experimental type design and experimental typography is explored here from the inception of an idea, through the research process and into a 'commercial' application. As two distinct disciplines, experimental type design deals with the design or production of typefaces, while experimental typography investigates the use of type in layouts. Type is the 'symbolic'

representation of language in its mechanical (or digital) form. Type design is not only about the way in which individual letterforms are constructed; it also involves the systematic application of these elements across a set of characters. Conversely, the typographic layout structures the characters – into words, lines and ultimately texts – to produce meaning in the way they are organized visually. The way the typographer presents the 'page' takes into account content and form, the materials, the way the page is produced and knowledge of the target audience.

If we are to accept that there is 'a natural alliance between the visual organisation of a document and its intended use'[6], the typographic experiment questions the relationship between the typographer and the intended audience. The process of communication is, therefore, constantly renegotiated following an established pattern, which moves from the unfamiliar to the customary. Katie Salen explores this process in her design of the academic journal Zed.2 (1995), where the deletion of the letter 'I' throughout meant that readers had to modify their reading of the text. Salen, who was investigating the assimilation of the unfamiliar, concluded, 'as with most situations of "the experimental" the transition from the unfamiliar to the expected occurs almost seamlessly'[7].

Experimental typography is also about the expressive potential in the arrangement of type 'either by achieving a quiet uniformity of similar elements or by the visually exciting use of contrasting ones'[8]. For our purposes, 'expressive' should be defined as the way language is articulated through the use and arrangement of type to enhance communication. This must be made distinct from an emotive or illustrative treatment of letterforms, which often eclipses the clear presentation of a message. Art historian E.H. Gombrich provides a simple analogy using the words 'ping' and 'pong'. According to 'decorum, **pong** would obviously, have to be printed in heavy type and "ping" in normal'[9]. Any other treatment, Gombrich suggests, will result in ambiguity and in turn obscure the intended meaning. Simply put, by adding extra layers of typographic information, our reading of the word is transformed into something other than its original meaning.

While conventional symbols provide the form for understanding language, it is in part in 'the tone of voice and speed of utterance' that nuances of meaning are evoked. In the 1960s, French designer Robert Massin produced innovative graphic interpretations of Eugène Ionesco's experimental writings by using a mixture of typefaces and graphic effects. Ionesco, a writer for the Theatre of the Absurd, had 'reinvented the ways in which plays could be presented and understood'[10]. Massin's aim was to do the same for the book

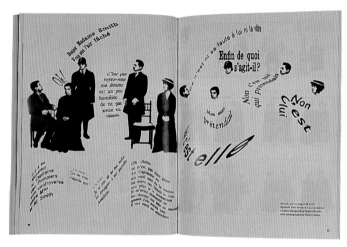

In 1949, British designer Herbert Spencer founded Typographica (Lund Humphries), the international journal for typography and the visual arts. The journal gave insight into contemporary and historical aspects of typography, design, painting, art and sculpture. This spread from issue 11 (1965) shows Robert Massin's interpretation (1964) of Eugène Ionesco's La Cantatrice Chauve (The Bald Soprano) with photographs by Henry Cohen .

The Role of the Experimental

Aufuldish and Bartlett

[z.lan gu a ge

Bob Aufuldish and Mark Bartlett

i

Selected

iii//iii The text that accompanies Bob's design is not *writing* in the normal sense—it
ii/i It is more accurate to say that it was *composed*. I found myself as *writer* in
iii between the ZeitGuys characters, and the esoteric subtleties of French cu
iiii composed a text that attempted to allow for a bridging of image and text,
iiii and writing, and attempted to make a theoretical contribution to cultural th
iiiiiiii pooning it. The audience I imagined was on one hand, those somewhat
iiiii what has become associated with the argot of postmodernism, and those
iiiiiii the cutting edge of graphic design—which was Bob's territory. With tha
iiii composed a text that would give Bob maximum freedom of treating the t
iiii cally, to be free of the need to be faithful to literary content or meaning.
ii Bob's work, I had complete faith that anything he would do would only
iiiii amplify the content I had in mind as a contribution to cultural theory (wh
iiiiii not he did so intentionally). So the project was a genuine experiment-
iiiiiiii means, taking the very real risk that it might fail. If it fails, it is because the
iiiii of the text is so arcane. But this is a matter of time and education. Given eno
iiiii either, the series of designs Bob *composed* are quite accessible. In, fact, I th
ii of them collectively as a primer of cultural theory. They need to be translate

does not mean that he ii iiiiiiii those unfamiliar with that text. But those familiar with it will either be de
mented. Indeed, a few iiii iiiii insulted or die of laughter. If they are insulted, they demonstrate the limit
uns and hidden bits of iiii i the theory. If they laugh, they extend it. And for those clueless as to the m
ost interesting part of iiiii iiiii allusions to this or that theorist, it doesn't matter; Bob's design carries t
mething needed to be iiii iiiiiii meaning, and only an investigative curiosity is necessary.
ore closely juxtaposed ii
ome cases, things I did iiiiii
s that caught me com- iii
in, "Hey, did you pur- i
ii
● the interactive version of this pr

Zed ran for seven issues (1994–2000) and took a thematic approach that tackled typography and design in relation to issues borne out of contemporary culture and society. Zed.2 Real World Design: The Role of the Experimental (1995) explored the function, practice and context of experimental typography, for example, with regard to professional practice.

form. In Massin's visualization of Ionesco and writer Raymond Queneau's anti-play <u>La Cantatrice Chauve</u> (<u>The Bald Soprano</u>), different typefaces take on the voices of each character (1964). The manipulation of type in terms of weight, scale, repetition, distortion and its integrated placement on the page intensified the dialogue and the delivery of the narrative. Massin introduced 'time and space to the printed page', using black pages to capture silence on the stage and typographic contrast and scale to create a rhythm for reading and representing speech. These pages were not illustrative, rather they demonstrated a symbiotic relationship between word and image. The narrative was seen as well as read.

The typographer and designer of **Times New Roman**, Stanley Morison, defined typography in 1928 as having a 'specific purpose; of so arranging letters, distributing the space and controlling the type as to aid to the maximum the readers' comprehension of the text'. His main concern was with the typography in books, and he warned against the use of 'bright' typography or 'typographical eccentricity'. However, Morison did advocate typographic experimentation, writing 'It is always desirable that experiments be made, and it is a pity that such "laboratory" pieces are so limited in number and in courage'[11]. In a similar vein, type historian Beatrice Warde suggested that type is the 'goblet' or vessel that holds meaning through the 'act of making letters

vanish'. For her, the experiment was found 'in devising the crystalline goblet which is worthy to hold the vintage of the human mind'[12]. However, she vigorously criticized what she called the 'stunt typographer' as someone who was 'floundering in self-conscious and maudlin experiments'[13].

The nature of a client's brief – the amount of developmental time offered, the types of production processes used and the social, political and cultural context in which the designer or typographer is operating – will affect the way a designer approaches the experimental and, consequently, the end product. What is considered to be experimental will also vary from one designer to another. Emigre designer Zuzana Licko, whose 1986 typeface **Matrix** was developed during the early period of Macintosh computers, is an important case in point. Licko was an early proponent of digital technology in typography, and effectively managed the low-memory capabilities of the first computers by keeping the font data small. Similarly, Dutch design duo LettError – Erik van Blokland and Just van Rossum – use programming technology and language to experiment with different ways of producing dynamic fonts. For them, the computer is a means of exploring new and playful ways of working; by understanding the software, they do not feel in danger of becoming 'slaves to their digital tools'[14].

CRYSTAL GOBLINS
Based on a variety of 19th-century wood types (above), the Crystal Goblins rotate the serifs of the letterforms and render them as translucent vessels. In her classic essay, The Crystal Goblet, Beatrice Warde argued for the transparency of typography, suggesting that typography should recede in order to foreground verbal content.

J. Abbott Miller's experiments with the sculptural and 'spatial disposition of flat letterforms' are found in his book <u>Dimensional Typography: Case Studies on the Shape of Letters in Virtual Environments</u> (Princeton Architectural Press, 1996). In this set of spreads Miller takes Beatrice Warde's essay 'The Crystal Goblet' (1932) as a starting point for exploring 'the transparency of typography'.

Matrix Book

ABCDEFGHIJKLMNO
PQRSTUVWXYZ
abcdefghijklmnopqrstuvwxyz

Matrix Regular

ABCDEFGHIJKLMNO
PQRSTUVWXYZ
abcdefghijklmnopqrstuvwxyz

Matrix Bold

**ABCDEFGHIJKLMNO
PQRSTUVWXYZ
abcdefghijklmnopqrstuvwxyz**

Zuzana Licko's experiments have always challenged new technology and questioned the capabilities of the computer, as in the typeface **Matrix** (1986).

Cover of <u>Emigre: New Faces</u> (no. 21, 1992), which provided a forum for CalArts students to publish the results of their typographic interpretations, demonstrating that 'designing [is] a direct expression of the content'.

As design became a cultural practice, Emigre fonts and its corollary 'experimental graphic-design journal', founded by Zuzana Licko and Rudy VanderLans in 1984, soon provided the platform for contemporary typographic debates. From the beginning, the journal's layouts were dutifully experimental with early issues 'forcedly expressive'[15], relying on a fanzine-like approach to production. A lack of formal grids, xeroxed imagery, typewritten texts and low production costs created an alternative publication to the prevalent mainstream glossy trade magazines of the time. The design became increasingly sophisticated in its approach to experimental layouts; in particular, <u>Emigre: New Faces</u> (no. 21, 1992), with Jeffery Keedy as guest editor and design students' work from CalArts, exemplified the way designers (and educational institutions) were willing to push the boundaries of conventional text layout. <u>Emigre</u> had become the perfect vehicle for experimental type design and experimental typography.

EXPERIMENTATION AND THE ISMS

Much contemporary typographic exploration owes its development to the historical 'isms' of the twentieth century: Futurism, Constructivism, Dadaism and Modernism. These movements acknowledged an age of significant scientific and technological discovery, where modern industry and commerce were radically transformed. New attitudes to social, cultural and political life emerged and typography became their 'visible artefact'. Artists and designers developed new ways of thinking about graphic languages in which writing, structure and visual forms more accurately reflected the conditions of the modern world.

These early-twentieth-century movements fostered a 'new' relationship between fine art, typography and literature. French poets Stéphane Mallarmé (1842–98) and Guillaume Apollinaire (1880–1918) created 'visual interferences', shaping their typographic experiments to subvert the conventions of literary form. Mallarmé rebelled against the 'mechanisation of reading', likening his books to 'musical compositions' and questioning traditional linguistic practices through his placement and rendering of words. This is best demonstrated in <u>Un Coup de dés jamais n'abolira le hasard</u> (<u>Throwing of the Dice</u>, 1897, published 1914), a seven-hundred-word poem set in **Didot** but employing a range of typographic styles (italic, roman, upper and lower case) and the silence offered by white space to evoke meaning. Apollinaire, however, developed his typographic experiments in <u>Calligrammes</u> (1918), a volume of poems about peace and war written between 1913 and

1916. A calligramme is produced by the words of the poem itself arranged visually to represent its content; for example, the words for the poem <u>La Cravate et la Montre</u> formed a typographic image of a necktie and a watch, while <u>Il Pleut</u> mirrored raindrops falling poetically down the page. Such pictorial forms reflected Apollinaire's interest in unifying content and visual presentation but also his aim to generate work within the context of daily life. Typography was used 'as an active picture rather than a passive frame'[16]. Similar visualizations are the pattern poems created by Italian scholar Aldus Manutius (1450–1515) in Venice in 1499. He produced symmetrical layouts using shaped type, which tapered at the bottom of the page in a number of his classic editions, including <u>Hypnerotomachia Poliphili</u> (1499). More contemporary comparisons have also been made, for instance, between Manutius's goblet and the typography in the form of a parfait glass for Otto Storch's editorial fashion layouts for <u>McCall's</u> magazine in the 1940s[17].

By 1909, Futurist explorations such as those espoused by Filippo Tommaso Marinetti (1876–1944) were resulting in new approaches to structuring language and imagery that were radical rejections of tradition. All previous constraints were unleashed and typography became an expressive visual language mirroring the political and industrial themes of modern society. The Italian Futurists wrote a series of revolutionary manifestos, a 'call to arms', which explained their beliefs about modern life, the machine age, war and technology. The <u>Manifesto tecnico della letteratura futurista</u> (technical manifesto of Futurist literature, 1912) even abolished punctuation, syntax and traditional grammar. The language of the machine age used what the Futurists termed 'synoptic declamation' – speed, rhythm and tone of speech were translated into visual terms thereby 'extending the meaning of words'[18]. The non-linear and 'animated pages' of Futurist poetry, were represented in Marinetti's <u>Les mots en liberté</u> (<u>The Words to Freedom</u>, 1919), his <u>Zang Tumb Tuum</u> (1914) (a reflection on an 'onomatopoetic artillery') and in Carlo Carrà's <u>parole in libertà</u> (<u>Words in Freedom</u>, 1914). The resulting 'free-verse orchestrations of sound and image' were collages of letterforms of varying type sizes, weights and styles. Typographic innovation had produced a new aesthetic sensibility and proved that such experimental poetry allowed texts to be simultaneously read and seen as image and text[19].

Western traditions in writing and the development of language itself have been questioned throughout the twentieth century. Dadaist Kurt Schwitters (1887–1948) argued that one of the principles of the new typography should

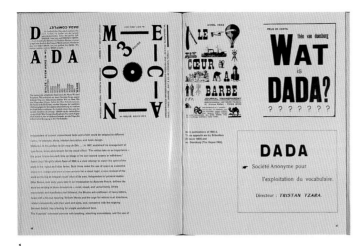

1

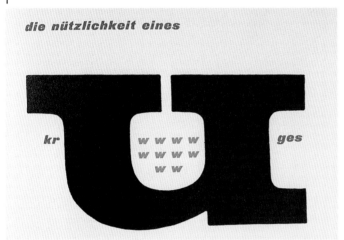

2

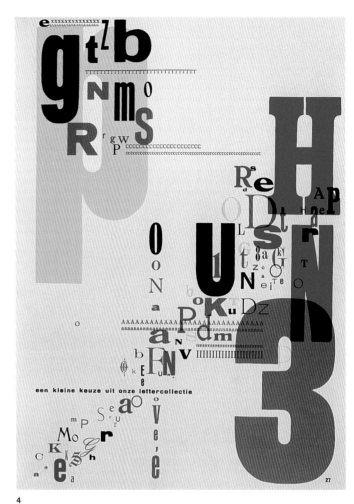

4

3

1 Spread from <u>Typographica</u> (issue 14, 1966) showing a range of publications produced by the 1920s anti-art movement Dada, which notoriously rejected traditional values and typographic conventions. **2** The interplay between expressive form and intended function is a key element in typographic experimentation: that which governs the visual organization of written language breaks away from typographic convention. Willem Sandberg's (1897–1984) explorations into form and space questioned the traditional placement of type by arranging sentence fragments 'freely on the page with ultrabold or delicate script introduced for accent or emphasis'. [Philip B. Meggs. <u>A History of Graphic Design</u> (New York: John Wiley & Sons, 1998, 3rd ed.): 297] In his <u>experimenta typographica</u>, which originally consisted of nineteen booklets although only five were published in the 1940s and 1950s, meaning is enhanced by the letter 'U' in <u>Krug</u> (jug), which transformed into a vessel filled with smaller blue letters. **3** Spread from <u>Typographica</u> (issue 14, 1966) showing the 'lyrical' quality of the typographic <u>Calligrammes</u> created by Guillaume Apollinaire. **4** A page from a printer's catalogue (Trio, The Hague, 1929) designed by Piet Zwart and reprinted in <u>Typographica</u> (issue 7, 1963).

be to 'do it in a way that no one has ever done it before'[20]. His interest in the interaction of signs and sounds (optophonetics), for example, resulted in a typeface in which the weights of the vowels were heavier than the other characters. Herbert Bayer (1900–85), who taught at the Bauhaus, experimented with similar ideas and designed phonetic symbols for syllables in 1959, where ligatures stood for sounds created by the combinations of letterforms. He wanted to produce a computer face that reflected 'his rules for a new orthography' to 'eliminate all discrepancy between spelling and pronunciation' in Western phonetic alphabets[21]. In the 1990s, Tobias Frere-Jones took this one step further for Fuse 15: Cities (1999) by recording people's conversations as he passed through the streets of Boston. These texts formed the basis of a typeface called **Microphone** in which a single letter triggers an entire phrase. The typeface's character is represented by different styles, sizes and spacing; **Microphone** is the language of the street, reflecting how people talk to each other. It also considers new ways of telling stories in which the font becomes the structural framework[22].

TYPOGRAPHY AND ITS SWISS ROOTS

The introduction of new technologies has long been an initiator of typographic experimentation. In the late 1960s, Swiss designer and educator Wolfgang Weingart's choice of tools for 'making by doing' were more suited to the technology available at the time – hand-composed lead type, hand-printing letterpress, wood letters and transparent films. The consequences of combing these media created a new typography and visual aesthetic that has since influenced many contemporary designers and typographers who are engaging with computer technology. In fact, Weingart cites the experiments of Rudy VanderLans and Zuzana Licko, who, he observes, have used the computer successfully as a vehicle for typographic research[23]. In 1962, Weingart embarked upon a five-year period of typographic experimentation with the letter 'M'. He manipulated and constructed three-dimensional renderings to reveal the 'dynamic aspects of the letter's form'[24]. He proclaimed that 'the only way to break typographic rules was to know them', which meant a return to forming an understanding of the basic principles of design and typography. Since the 1970s his students at the Kunstgewerbeschule (School of Design) Basel have been well grounded in type placement, size and weight, exploring Modernism's formal elements while critically analyzing 'letterspacing to experiment with the limits of readability'[25].

Daniel Friedman (1945–95), a graduate of the Institute of Design in Ulm (1967), the Basel School of Design (1968–70) and former pupil of Weingart, spoke of a 'new typography' also 'driven by technological change – the transformation from metal typesetting, often done by hand, to computer-

The complexity of Postmodernism's pluralism is found in Laurie Haycock Makela's Little Miss Alpha Bit (1995), which was inspired by the book Die Scheuche (The Scarecrow, 1925) by the Dadaists Kurt Schwitters, Kate Steinitz and Theo van Doesburg. Haycock Makela's narrative was intended to help young people understand typography and personal expression. Makela's story was reproduced in the academic journal Design Issues (vol. 12, no. 2, summer 1996) with instructions for how a young person could typographically create a score for a song, make a welcome banner using everyday objects, and 'create a shape for the sound of clapping'. In terms of production, Schwitters's original illustrations were made out of what could be found in the printer's typecase, whereas Haycock Makela's characters were created from Matthew Carter's serif typeface Walker, commissioned by the Walker Arts Center (1995). Walker offered a unique flexibility with its 'snap-on' construction of different elements and also signalled a new approach in creating a museum's identity through typographic experimentation rather than traditional branding graphics.

driven photo typesetting'. He developed a methodology for understanding typography, which he said 'would be seen as a foundation of, not a replacement for, personal expression'[26]. His students at Yale learned about typography in terms of linguistic and literary theory combined with experiments in 'making messages dysfunctional'. Friedman encouraged an investigation into the formal conventions of legibility and 'optimal' communication found between the sender and receiver of information by 'fracturing' messages visually. His experiments highlighted the potential problems of creating new linguistic codes that operated in 'a rather closed network'.

Another of Weingart's students, April Greiman placed digital technology firmly at the forefront of the design debate with her computer-generated, self-portrait for Design Quarterly 133 (1986). Greiman used the technology available – the Apple Macintosh had only been around for two years – to combine her interest in photographic explorations with the typographic structures she had learned at Basel. She even included on the poster's back a full description of her design and production process, right down to showing the number of bytes of information (289,322) the image contained. The poster was one of the first forays into the possibilities of expressive layout in the digital era and indeed the confirmation of a 'new wave' aesthetic.

By the 1980s, London design group 8vo – founded by Mark Holt and Hamish Muir and joined later by Michael Burke and Simon Johnston – proposed a new form of 'visual engineering' in which layers of overlapping texts were combined with a range of colours and point sizes. Two of the group's members were Basel graduates, and much of their collective work followed the clarity of structure provided by grids and hierarchical information. In 1986, 8vo published Octavo – a limited-edition typographic magazine that ran for eight issues, ending in 1992 – which reflected their cool Swiss Modernist approach. Perhaps one of the magazine's most important visual experiments was the opening spread of Bridget Wilkin's short essay 'Type and Image'. The piece confronted issues of typographic legibility and claimed that readers 'are preconditioned to respond to type as image rather than type and image'. This premise was reflected in the text, which appeared in multiple layers with unconventionally long line lengths and overprinted with blocks of colour. Ironically, and as if to stress the questions raised in the article about reading, Wilkin's text is set out in 'legible' text columns in the back of the magazine.

CONTEMPORARY THEORY AND TYPOGRAPHY

Issues concerning language and the development of a 'typographic discourse' had become an essential element of experimental typography by the mid-1970s in the work of Katherine McCoy and others at Cranbrook Academy of

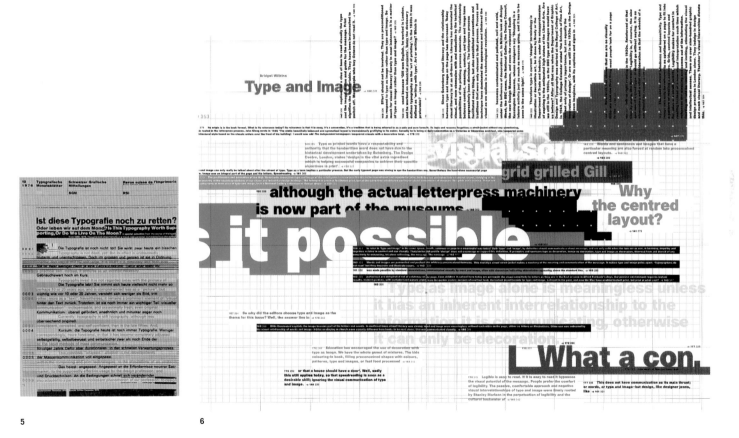

5 Cover of Typografische Monatsblätter (no. 12, December, 1976) designed by Wolfgang Weingart. This issue 'Is this Typography Worth Supporting, or Do We Live on the Moon?' presented an overview of Weingart's work, while the cover revealed his process of moving from concept into film preparation. **6** Weingart's influence is still evident in this spread from Octavo (issue 7, 1990). The limits of readability are challenged by adopting a similar grid and layered approach to Weingart's typographic layout.

Art, Michigan. McCoy, who along with her husband Michael co-chaired the design department, was instrumental in fostering a 'new' typographic approach based upon the ideas found in Postmodernism and Post-structuralist literary theory. In the introduction to Cranbrook Design: The New Discourse, Niels Diffrient explains that at Cranbrook and in the fields of product and graphic design, the challenge is to 'enhance the meaning while not totally abandoning the framework that unites the whole'[27]. Gérard Memoz observed, 'it is significant that this second order of denotation has been explored primarily by authors who, dissatisfied with standardized forms of text setting, evolved alternative formats and conventions'[28]. Moving away from the formalist principles of Swiss Modernism, McCoy and her students explored the relationships between image and text, focusing on symbolic codes and their interpretation as well as meaning that is constructed between the audience and the designed piece. Interested in the process of 'deconstructing' Modernist typographic paradigms and developing a self-critical awareness, she and her students embarked on a succession of typographic formal explorations. From these, she concluded, 'Images are to be read and interpreted, as well as seen; typography is to be seen as well as read'[29]. For McCoy, verbal wordplay as a linguistic technique (e.g. the creation of puns or jokes) is inextricably linked with typographic play.

Wolfgang Weingart's experiments with the letter 'M' (1965–68). The subtleties of the character are explored through a range of materials, construction techniques and compositions.

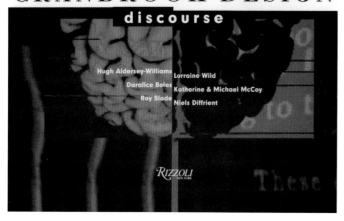

Title page from Cranbrook Design: The New Discourse (New York: Rizzoli, 1990), which documents ten years of Cranbrook work created by students, staff and alumni from the areas of graphic, industrial and interior design. The work was selected for its 'experimental and challenging attitudes to design's status quo'. For the design of the book, Katherine McCoy devised a process, 'I had been looking at early Renaissance book design and finding that those seemingly symmetrical formats were actually very quirky and active ... I wanted to capture some of that in this format.' With this in mind, the pages are seen at first glance as traditional and classic, whereas on a second reading the subtle 'quirkiness' of narrow columns and split levels of texts are revealed. McCoy's assistants were P.Scott Makela, Mary Lou Kroh and Allen Hori.

Dead History Roman

ABCDEFGHIJKLMNO
PQRSTUVWXYZ
abcdefghijklmnop
qrstuvwxyz

Dead History Bold

ABCDEFGHIJKLMNO
PQRSTUVWXYZ
abcdefghijklmnop
qrstuvwxyz

Two main directions of experimental typography emerged in response to the tenets of Postmodernism – the emphasis on irony and historical revivalism. For example, P. Scott Makela declared design history 'dead' in his ironic typeface appropriately called Dead History (1990), while Jonathan Barnbrook's 'ironic commentaries' manifest themselves in anti-American protest with such typefaces as Exocet (1991, see p. 88).

The early experimental 'wave' in the 1980s brought a new critical awareness in type design, which continued well into the 1990s. Jonathan Barnbrook's fascination with medieval history and crucifixes propelled Mason/Manson (1992, see p. 90) into the literary world of Postmodern narratives. Experimental typography, more than a superficial treatment or visual stylization of language, became embedded with secondary levels of meaning. Letterforms still represented language, but were also concerned with 'the possible meaning and interpretation/s of the text'. No longer was it acceptable for typography to remain as an invisible form.

Nowhere was this more evident than in the typographic publication Fuse (issue 1, 1991). Founded by Jon Wozencroft and Neville Brody, Fuse provided designers and typographers with an interactive digital forum for 'visual play'. Each issue is based upon a theme (such as religion, propaganda or, (dis)information) and allows noted designers (such as Phil Baines, Malcolm Garrett, Barbara Butterweck, Pierre di Sciullo, Cornel Windlin) an opportunity to work outside the conventions of traditional typographic briefs. Critic and designer Michael Rock of 2x4 is quick to point out that 'Fuse is a conscious effort to reinvest letters with some kind of magical power'. He suggests that there is a contradiction between the idea of experimentation producing original work when, in reality, it has fostered repetition. Fuse is a

space for experimentation, yet it is wholly dependent on the constraints offered by a Western alphabetic structure. Rock continues 'in lionizing the experimental, Fuse promotes popular notions of artistic genius, originality and authenticity; terms that following Walter Benjamin, traditionally invest art, and the institutions that house it, with value'[30].

In the 1990s, experimental typography borrowed heavily from Postmodernist theory, developing many characteristics from varied approaches: fragmentation, hybridity, parody, pastiche, wit and play. Typographic form sought to carry additional layers of meaning. Ellen Lupton defined this as 'narrative typography' as practised by designers such as Edward Fella and Jeffery Keedy[31]. Keedy, in particular, aimed to 'promote multiple rather than fixed readings'. The Postmodernist reader was an active participant and played an important role in the construction of the message. Robin Kinross writes 'we can't know content free of form. But now at least we are not trying to value the embodiment without reference to content.'[32] This is evident in such typefaces as Hard Times (1991), a nostalgic reflection on Times Roman and Manusans (1990) and reminiscent of the penmanship taught at school. Keedy argues that the vernacular 'is not so much historical quotation as it is nostalgic sound bite'[33].

MASON

Mason (1992, see p. 90), originally named Manson after the mass murderer, highlighted the significance of naming typefaces. Barnbrook explains, 'I was in no way intending to glorify Charles Manson. ...The name Manson, provides a jolt to the people who mistily stare at old typography and talk about "golden" letterforms which are used to set "beautiful", "poetic" text.' [Teal Triggs and Jonathan Barnbrook (1997) Bastard!:The Typo/Language of Jonathan Barnbrook. London College of Printing: Design Open Pamphlet Series 1, autumn]

Can you...? (1991) was designed by British typographer Phil Baines for the experimental publication Fuse 1: Invention. He takes Clarendon as a starting point and strips the characters to their bare minimum to establish how much of the form is required for character recognition. A more recent version (above) has been released called You Can Read Me (1996).

As the complexity of the message reflected the media-induced noise of the modern age, the typographic page became increasingly layered. In 1995, Frances Butler introduced the notion of a 'new demotic typography' in which the printed page is described as 'packed so fully that much of the surface becomes invisible'. The ratio of signal to noise was arguably diminishing. Typographic forms were transformed into abstract shapes, similar to the old demotic hieroglyphs of the Egyptians, which became 'progressively abstract' and less skilfully made as they moved from targeting an élite audience into 'written communication for popular activities'[34]. The new demotic typography redefined punctuation, substituting conventional marks (dots, commas, dashes) with 'idiosyncratic devices' (arrows, backward letters, diagrams, boxed words). Butler's critique of early-1990s experimental typography focused on computer technology, which she suggests facilitated a formless, series of pages containing a 'mix of old and new letterforms, type and script, changing letter direction, overprinted images, changes of scale and ambiguous syntax'[35]. The visual complexity of the typographic page had been defined by a decade of typographic experimentation.

THE NEXT STEP?

Experimental typography has reached a point where it is accepted as an integral part of the design process. Many educational institutions now offer classes dedicated exclusively to experimental typography and encourage students to engage with design research as a process of 'thinking' and of 'making'. Designers and typographers have become more aware of the link between craftsmanship and historical understanding, cultural and technological issues, the aesthetics and function of type and the importance of language and meaning. At the same time, the broader audience has become more sophisticated in its 'ways of reading' and more accepting of the way designers and typographers present alternative models of visual communication.

Yet, has the typographic experiment played itself out? It has become evident that the typographic experiment had ceased to be experimental by the start of the millennium. Rather, much of what is currently produced reflects a continuation of earlier experimental strategies and processes. Almost in recognition of this, Emigre magazine stood back from its writings and investigations into experimental typography and, with the publication of Emigre (no. 60, 2001), shifted to explore the intersection between design and music. The magazine's new format combined a CD/DVD with a booklet showing the work of specially commissioned artists and writers who had created images and texts in response to the music. Emigre returns to design writing in 'an appropriate new format' with the publication of Emigre (no. 63,

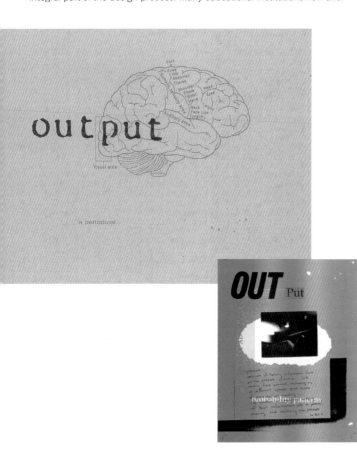

Steven Heller's critical article 'The Cult of the Ugly' (Eye, vol. 3, no. 9, 1993) fuelled the debate about legibility and aesthetics, which soon became synonymous with design and typography in the 1990s. The student networking project 'Output' (1992), initiated by Joani Spadaro while at the Herron School of Art, Indianapolis, 'became a lynchpin for a discussion of stylistic abuse' with Heller arguing that experimentation was open to criticism when it was 'released into the world'. Nevertheless, 'Output' thrived as a forum for students to exchange ideas and the project was adopted by students at the Cranbrook Academy of Art and, later, by Diane Gromala (see pp. 50–53) and her students at The University of Texas at Austin. An international issue of Output was developed as a collaboration between students at North Carolina State University and Ravensbourne College of Design and Communication, London and became one example of what Frances Butler terms the new demotic typography.

2003). While Emigre's hiatus from typographic experimentation was short-lived, it was nevertheless significant and represents a much-needed period of reflection. Contemporary typography is no longer restricted to the confines of the two-dimensional surface either in print or on screen. With a nod back to the early avant-garde, the discipline now embraces a multitude of strategies ranging from the implementation of sound and choreography to architectural and virtual spaces.

METHOD

The book presents an overview of work produced by designers and typographers working primarily in the period from 1990 to 2002. It is divided into five main sections, each introduced by a short contextual essay that presents general themes and historical precedents. 'The Medium is the Message' examines how the experimental has affected the physical and metaphorical construction of letterforms and typographic layouts. 'Mapping Meaning and Defining Spaces' considers the way in which meaning is mapped and language is understood as a result of the typographic experiment. In a similar way, 'Typo-Anarchy and the DIY of Design' reflects on the language of the everyday and how it has been the inspiration for many designers and typographers, presenting some of the ways in which popular culture has defined an alternative typographic aesthetic. 'Visual Poetry'

investigates the poetics of the printed page and the aesthetic concerns of form in narrative structures like books and in art installations. Finally, 'Smaller Screen (Bigger Picture)' looks at how the typographic experiment presents itself on a small screen and in the cinema, but also how the typographic experiment has been applied within the arena of our public spaces.

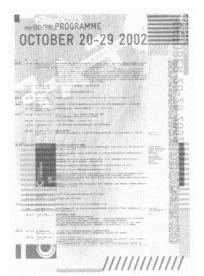

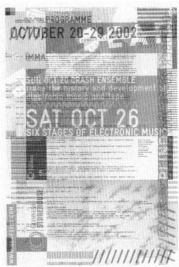

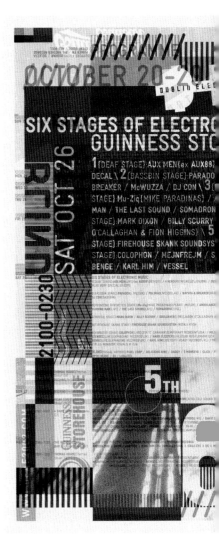

These promotional posters advertising DEAF (Dublin Electronic Arts Festival, 2002) were flyposted in three stages on the streets of Dublin prior to the event. Printed on transparent paper, and designed by Niall Sweeney at Pony, each installment was overprinted on the previous flyer, intensifying the level of visual noise and typographic information. The grid, graphic marks and layers of transparent ink outwardly reflect the processes associated with digital and electronic media as a whole.

Notes

1 Daniel Friedman (1978). 'A Process in Typography.' Reprinted in David Jury, ed. TypoGraphic Writing (Stroud: ISTD, 2001): 62.
2 Peter Cook. Experimental Architecture (London: Studio Vista, 1970): 152.
3 A.L. Rees. A History of Experimental Film and Video: From the Canonical Avant-Garde to Contemporary British Practice (London: British Film Institute, 1999): 1.
4 Carol Dunlap. The Culture Vulture (Washington D.C.: The Preservation Press, 1994): 18.
5 Rick Poynor. Typography Now Two: Implosion (London: Booth-Clibborn Editions, 1996): 6.
6 Sue Walker. Typography and Language in Everyday Life (Harlow, UK: Pearson Education Limited, 2001): 3.
7 Katie Salen. 'Editor's Note.' ZED.2: Real World Design. The Role of the Experimental (Richmond: Virginia Commonwealth University, 1995): 4.
8 Carl Dair. Design With Type (Toronto: University of Toronto Press,1967): 48.
9 E.H. Gombrich. 'Expression and Communication.' Meditations on a Hobby Horse and Other Essays on the Theory of Art (London: Phaidon Press Ltd., 1994 reprint): 57.
10 John Gall and Steven Bower. 'Massin Ahead of Time.' Print (July/August, 1996): 82.

11 Stanley Morison. First Principles of Typography (Leiden: Academic Press, 1928, reprint 1996): 4.
12 Beatrice Warde. 'The Crystal Goblet.' The Monotype Recorder (vol. 44, no. 1, Autumn 1970): 22–23.
13 Ibid., 25.
14 Els Kuijpers, ed. LettError (Maastricht: Charles Nypels Foundation, 2000): 21.
15 Rudy VanderLans and Zuzana Licko. Emigre (The Book) (New York: Van Nostrand Reinhold, 1993): 13.
16 Ellen Lupton (1994). 'A Post-Mortem on Deconstruction.' Reprinted in Steven Heller and Marie Finamore. Design Culture: An Anthology of Writing from the AIGA Journal of Graphic Design (New York: Allworth Press, 1997): 114.
17 Carl Dair. Design With Type (Toronto: University of Toronto Press, 1967): 43.
18 Katherine McCoy. 'American Graphic Design Expression.' Design Quarterly (no. 148, 1990): 5–6.
19 Steven Heller and Georgette Ballance, eds. Graphic Design History (New York: Allworth Press, 2001): 153.
20 Kurt Schwitters quoted in Richard Hollis. Graphic Design: A Concise History. (London: Thames and Hudson, 1994): 56.
21 Arthur Allen Cohen. Herbert Bayer: The Complete Work (Cambridge: The MIT Press, 1984): 215.

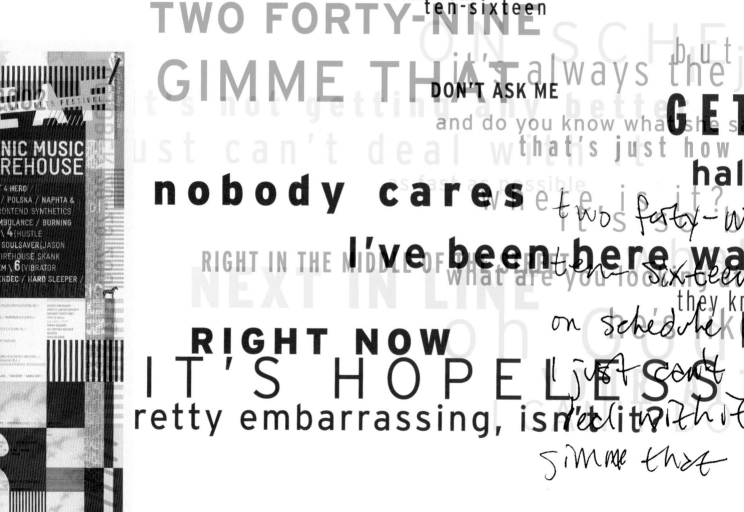

22 Tobias Frere-Jones. 'Experiments in Type Design.' Reprinted in Steven Heller and Philip B. Meggs, eds. Texts on Type: Critical Writings on Typography (New York: Allworth Press, 2001): 233.

23 Wolfgang Weingart. Interview with author, London, 2001.

24 Wolfgang Weingart. Typography: My Way to Typography (Baden: Lars Müller, 2000, reprint): 233.

25 Ibid., 269.

26 Daniel Friedman. Radical Modernism (New Haven: Yale University Press, 1994): 44.

27 Hugh Aldersey-Williams, et al. Cranbrook Design: The New Discourse (New York: Rizzoli International, 1990): 12.

28 Gérard Mermoz. 'On Typographic Reference: Part One.' Emigre (no. 36, 1995).

29 Katherine McCoy. Design Quarterly (no. 148, 1990): 16.

30 Michael Rock. 'Beyond Typography.' Eye (no. 15, vol. 4, 1994): 34.

31 Ellen Lupton. Mixing Messages: Contemporary Graphic Design in America (London: Thames and Hudson, 1996): 57–58.

32 Robin Kinross. Fellow Readers: Notes on Multiplied Language (London: Hyphen Press, 1994): 27.

33 Jeffery Keedy. 'I Like the Vernacular Not.' In Barbara Glauber, ed. Lift and Separate (New York: The Herb Lubalin Study Center of Design and Typography, 1993): 6–11.

34 Frances Butler. 'New Demotic Typography: The Search for New Indices.' Visible Language (29.1, 1995): 91–92.

35 Ibid., 94.

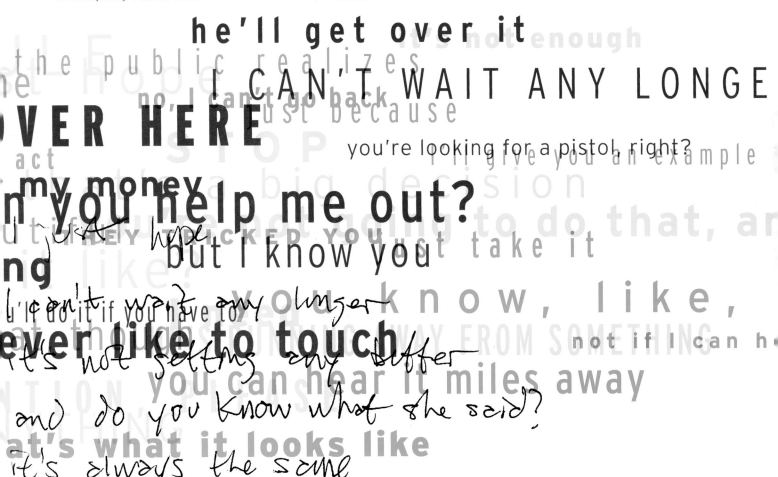

Samples of the font **Microphone** (1999) designed by Tobias Frere-Jones for Fuse 15: Cities. Frere-Jones based the digital font on conversations he had recorded on the streets of Boston. 'Hidden' under a single character was a phrase, which was treated typographically to reflect the variety of voices in his short story. Rather than treating text as content to be rendered, **Microphone** treats text as a sequence or 'plot' generator.

THE MEDIUM IS THE MESSAGE

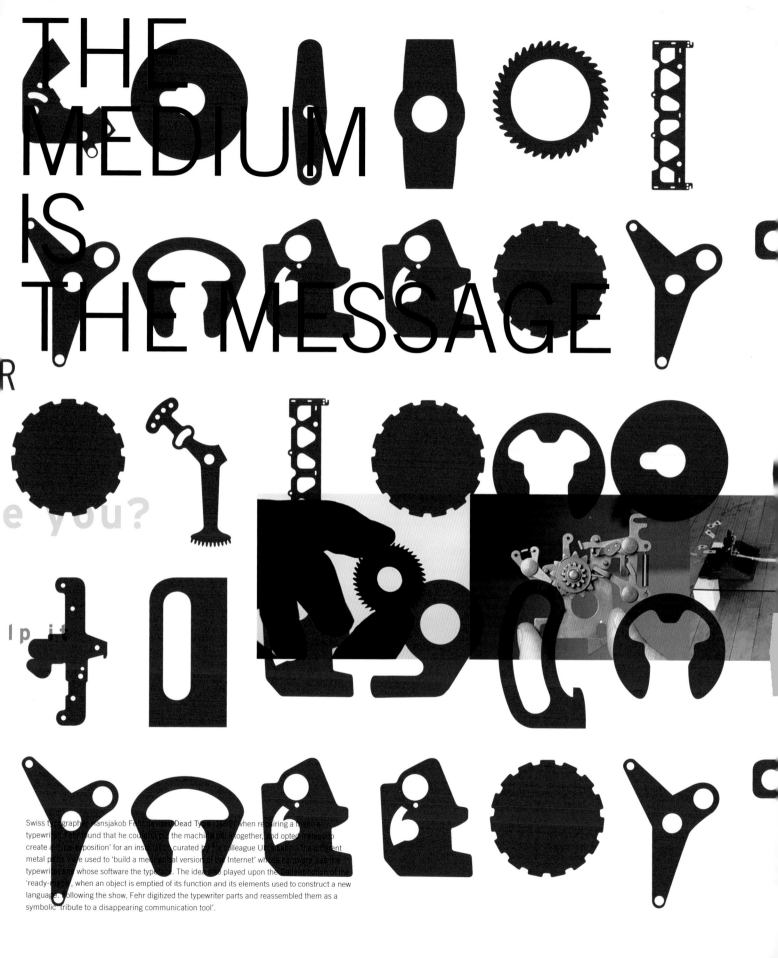

Swiss typographer Hansjakob Fehr devised Dead Type (1999) when repairing a friend's typewriter. Fehr found that he couldn't put the machine back together, and opted instead to create a 'type composition' for an installation curated by his colleague Ulrich Lehni. The different metal parts were used to 'build a mechanical version of the Internet' whose hardware was the typewriter and whose software the typeface. The idea also played upon the Dadaist notion of the 'ready-made', when an object is emptied of its function and its elements used to construct a new language. Following the show, Fehr digitized the typewriter parts and reassembled them as a symbolic 'tribute to a disappearing communication tool'.

TYPOGRAPHY AND TECHNOLOGY

In 1964, cultural philosopher Marshall McLuhan (1911–80) coined the phrase 'the medium is the message'. He proclaimed 'technology was an extension of our senses' and with each new medium we encountered new ways of experiencing perceptual transformations[1]. For McLuhan, it was the form of electronic media – which he categorized as 'hot media' (radio, photography, cinema) and 'cool media' (telephones, cartoons, television) – that triggered the rapid speed at which information was produced and consumed. His theories foreshadowed the impact late-twentieth-century communication technology has had (the Internet and World Wide Web). As McLuhan suggested, we have moved from a mechanical age into an electronic age[2].

McLuhan remarked that the electronic medium was merely the receptacle in which meaning was contained. He observed, 'many people would be disposed to say that it was not the machine, but what one did with the machine that was its meaning or message.' He often quoted as an example the electric light, which he felt 'escapes attention as a communication medium just because it has no "content"'. However, at the point when the electric light takes the form of neon signage and spells out a word, 'it is noticed as a medium'. This new medium constitutes a new environment, which controls 'what people who live within it do, the way they think, and the way they act'[3].

This has implications on the way we consider shifts in the environment of the typographic page. One of McLuhan's contemporaries, Howard Luke Gossage, proposed that an environment is established by the medium of print itself. He explains that print presents a linear way of thinking, placing one word after another, one sentence after another, one paragraph after another. The way something is read is, in part, determined by its method of production. Yet, in what McLuhan terms an 'ear-orientated society' – television, for example – sounds are received and expressed simultaneously. The resulting effect may eschew a linear reception of reading and, instead, present a multiplicity of readings[4].

From the early days of moveable type, through phototypesetting and to the explosion of desktop publishing and screen-based design, technology has contributed to the way in which communication methods have been produced, developed and disseminated. Technology may be associated historically with the notion of progress, but debates in graphic design during the late 1980s centred on issues of technological dehumanization and the downsizing of the design printing industries[5]. However, technology provided opportunities for the development of letterforms. Sharon Poggenpohl remarks that in the 1940s letterforms 'were designed for an industrial manufacturing process, either Linotype or Monotype, which case either lines of type or individual characters

in hot metal from a master mold.'[6] This method was soon followed by phototypography in the late 1950s, which allowed optical and photographic manipulation and distortion of type. L.W. Wallis suggests that, among others, the development of the Berthold AG phototypesetter gave rise to 'an excess of 150 exclusive and original type families' many of which were designed by Gunter G. Lange[7]. Dry transfer lettering also emerged during this period with such companies as Letraset establishing the simple principle of the water slide transfer (1956) before coming up with the dry transfer method (1961). A number of type designs were created especially for Letraset including Premier Shaded (1970), Octopuss (1970) and Aachen Bold (1969) by Colin Brignall and Paddington (1977), Talisman (1981) and Victorian (1976) by Freda Sack.

The IBM Selectric Composer – a typewriter with limited memory capacity developed in the 1960s – preceded the digital revolution in typography, with designers like Wim Crouwel creating experiments with the new machine-readable letterforms. Crouwel, writing in 2001, reflects, 'During those early years one could see from the results that there was a lot of experimentation, of exploring all the potential of this new technology. The screen was expressively replaced by paper, which became an evil we could not avoid as we rushed to express our excitement about the new electronic medium.'[8] When dot-matrix and digital typography took shape in the 1970s, the shift of letterform design

1

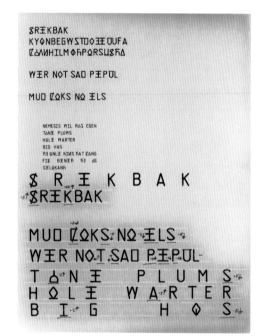

2

1 The typefaces reproduced in J. Abbott Miller's book <u>Dimensional Typography: Case Studies on the Shape of Letters in Virtual Environments</u> (1996) provided a new twist on experimental typography in the last half of the twentieth century. Taking as his starting point such classical typefaces as Didot (1783), and Univers (1957), Miller gives life to seemingly flat characters. The resulting sculptural 'lifeforms' prompt us to consider the possibilities of new spatial and temporal letterform environments. Miller also applies his method to typefaces by his contemporaries: Rhizome, for example, elaborates on the thorns and thistles of Lucas de Groot's Jesus Loves You (1995), its appearance giving rise to its name as a 'root-like system'.

from the realm of the analogue to the digital began. Technology facilitated a new type of cottage industry. Type foundries, such as Emigre (1984) who were dedicated to the development of typography for a new age of computing technology, emerged and fostered a democratic approach to the creation of typeface design.

TYPOGRAPHIC CONSTRUCTIONS

Also of interest is how the message is constructed and conveyed, not only in the way letterforms are assembled (and the technological impact) but also how they are structured on the page. British designer Anthony Froshaug argues that typography is a grid resulting from the use of 'standard elements', which implies the development of a modular relationship. He suggests 'for each text to be translated into typographic terms, determine not just how the text appears, but what it means to say.'[9] A set of conventions emerged that was made up of a series of standard elements, a typographic construction process that is evident in many of the typefaces designed over the last decade; for example, Matthew Carter's Walker (1995) and many of Zuzana Licko's early fonts, which were built upon the primitive bitmapping of screen-based letters.

The grid presents one way in which information is organized and the modern grid provides a modular framework for typographers to design letters and also to establish structural hierarchies and an overall visual coherency. The modern grid evolved in part out of Le Corbusier's system of architectural proportion called 'Modulor'. The system is based on the golden section and Fibonacci numbers, but extended the concept to embrace the relationship between the scale and proportion of the human figure. The result was a series of grids that divided space into a harmonious and 'infinite series of mathematical proportions'. Although primarily intended for a wide range of architectural compositions, the idea was adopted by typographic designers in Germany and Switzerland following a growing interest in what the mechanical age might offer in combining a utilitarian approach with an aesthetic position[10]. Of this period, Allen Hurlburt writes 'the pattern of a grid will be guided by the function of the content and the design concept'[11]. Type historian Robin Kinross argues that the Swiss typographer's obsession with the grid was the result of a 'frequent need to publish text with illustrations in two or three languages; thus the development of the multi-column, square-format book'[12].

However, Modernism soon gave way to Postmodernism and the grid seemed to disappear. British Postpunk rejected any concern for Modern design aesthetics choosing instead random juxtapositions of images, cut-out letterforms and handwritten graffiti. Once absorbed into the academy and ultimately the mainstream, the punk aesthetic was institutionalized, visibly

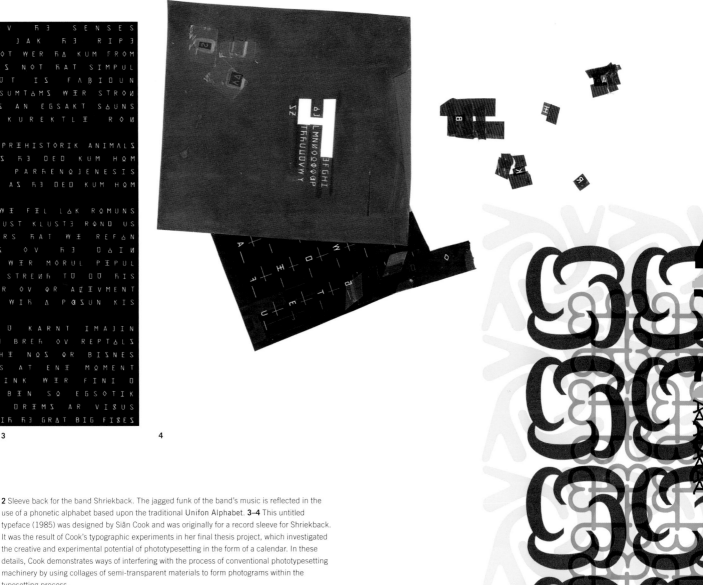

3 4

2 Sleeve back for the band Shriekback. The jagged funk of the band's music is reflected in the use of a phonetic alphabet based upon the traditional Unifon Alphabet. **3–4** This untitled typeface (1985) was designed by Siân Cook and was originally for a record sleeve for Shriekback. It was the result of Cook's typographic experiments in her final thesis project, which investigated the creative and experimental potential of phototypesetting in the form of a calendar. In these details, Cook demonstrates ways of interfering with the process of conventional phototypesetting machinery by using collages of semi-transparent materials to form photograms within the typesetting process.

sanitized and stripped of any anarchical meaning. Typography had transformed itself from Jamie Reid's Situationist-driven approach to Neville Brody's controlled appropriation of the Modern Movement. And, as if to make this point, Brody (who had reached notoriety as designer of The Face magazine) and colleague Jon Wozencroft subverted the formal grid system of The Guardian newspaper (1988) in their article on the typeface Helvetica by filling the 'page with tall columns of tiny Helvetica, huge arbitrary arrows and meandering pontification rendered in fathomless prose'[13]. Visual strategies adopted by Postmodernism tend to focus on individualized solutions, which define a specific visual vocabulary that is devoid of 'critiques of cultural institutions' and more about style. This, Mike Mills argues, draws upon a vocabulary previously 'pioneered by the 1920s avant-garde'[14].

While computer technology (e.g. PostScript) allowed a more democratic approach to typeface design, it ironically pushed screen-based designers 'back into the constraints of grids, gutters and Web "pages"'[15]. This despite the need for interactivity with hypertexts 'accessed in random and non-hierarchical sequences'[16]. While the construction process of the conventional narrative was declared inappropriate for the screen, the print-based world decided to expose the design and production processes of narrative through the overt layering of typography and 'structural games'. Postmodernism

meant that images and signs were consumed for their 'own sake' rather than for the 'deeper values' of the signs themselves. Essentially, it was Postmodernism that fostered a 'designer ideology', a term that increasingly reflected a notion of surface.

Designers sought to name their 'self conscious explorations of language and design', adopting the theoretical position of Deconstruction as espoused by philosopher Jacques Derrida in De la grammatologie (Of Grammatology, 1967). Already applied to literary and architectural criticism, Deconstruction has never been fully realized as a theoretical construct for design, although it has presented designers with a new way of thinking about verbal content and visual form. Jorge Glusberg writes, 'Producers and consumers of texts (cultural objects) thus intervene to play a part in the elaboration of significance and meaning'[17]. Designer and curator Ellen Lupton writes 'A study of typography and writing informed by Deconstruction would examine structures that dramatize the intrusion of visual form into verbal content, the invasion of ideas by graphic marks, gaps and differences.' Visually, Deconstruction is usually defined by 'a style featuring fragmented shapes, extreme angles, and aggressively asymmetrical arrangements'. She argues, however, that for her, Deconstruction is a 'process – an act of questioning'[18].

In response to the lack of legal protection for typeface designs in the United States, Zuzana Licko designed Hypnopaedia (1997) to help raise awareness about this issue. Her intent was to heighten public understanding about the different nature of letters as ornamental shapes and the alphabetic characters they represent. Patterns of woven textures are created by the infinite variety of interlocking letter shapes that are produced by a 'concentric rotation of a single letterform from the Emigre Fonts Library'.

Sijan (Sewer, 1995), designed by Petr Babák, explores the possibilities offered by designing with a sewing machine. Babák outlined the basic shape of the forms on cloth and then asked a seamstress, who had no previous typographic training, to trace the forms with her sewing machine. The appearance of the stitching gives a homely feel and contrasts craft technology with its contemporary contexts.

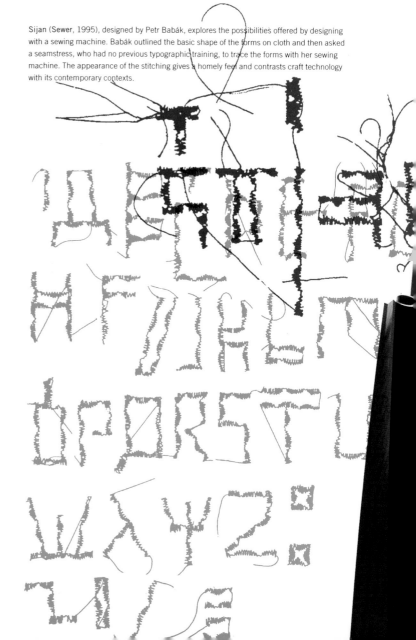

But where has this led us to today? The conventions of reading, in terms of legibility and readability, have been questioned in the construction of letterforms and their place in the typographic layout. Once accepted formulaic and simplistic typographic structures have been re-examined in light of the complexities offered by a new information age and new systems of writing.

Notes

1 Marshall McLuhan. Understanding Media: The Extensions of Man (London: Ark Paperbacks, 1st ed. 1964, reprint 1987): 7.

2 Michael A. Moos, ed. Media Research: Technology, Art, Communication (Amsterdam: G+B Arts International, 1997): xv.

3 Marshall McLuhan. Understanding Media: The Extensions of Man (London: Ark Paperbacks, 1st ed. 1964, reprinted 1987): 7, 9.

4 Gerald Emanuel Stearn, ed. McLuhan Hot & Cold (London: Penguin Books, 1968): 26.

5 D.L. Ogde. 'A Clockwork Magenta and Orange.' In Michael Bierut, William Drenttel, Steven Heller and DK Holland, eds. Looking Closer: Critical Writings on Graphic Design (New York: Allworth Press, 1999): 218–19.

6 Sharon Helmer Poggenpohl. 'Secondhand Culture.' In Michael Bierut, William Drenttel, Steven Heller and DK Holland, eds. Looking Closer: Critical Writings on Graphic Design (New York: Allworth Press, 1999): 144.

7 L.W. Wallis. Type Design: Developments 1970–1985 (Arlington: National Composition Association, 1985): 29.

8 Wim Crouwel. 'Introduction.' TypoGraphic Writing David Jury, ed. (Stroud: ISTD, 2001): 10.

9 Anthony Froshaug. 'Typography is a Grid.' Designer (no.167, January 1967). Reprinted in Michael Bierut, Jessica Helfand, Steven Heller and Rick Poynor, eds. Looking Closer 3: Classic Writings on Graphic Design (New York: Allworth Press, 1999): 179.

10 Allen Hurlburt. The Grid (New York: Van Nostrand Reinhold, 1978): 17.

11 Ibid., 21.

12 Robin Kinross. Modern Typography: An Essay in Critical History (London: Hyphen Press, 1992): 132.

13 Rick Poynor. Design Without Boundaries: Visual Communication in Transition (London: Booth-Clibborn Editions, 1998): 106.

14 Mike Mills. 'The (Layered) Vision Thing.' Eye (vol. 2, no. 8, 1993): 8–9.

15 Nicky Gibson. 'A New Medium.' TypoGraphic (no. 56, 2000): 13.

16 Jessica Helfand. Six (+2) Essays On Design and New Media (New York: William Drenttel, 1995): 18.

17 Jorge Glusberg, ed. Deconstruction: A Student Guide (London: Academy Editions, 1991): 7.

18 Ellen Lupton and J. Abbott Miller. 'Deconstruction and Graphic Design.' Design Writing Research (New York: Kiosk, 1996): 10, 17.

Christian Küsters takes as his definition of an experiment, 'an operation carried out under controlled conditions in order to discover an unknown effect or law, to test or establish a hypothesis, or to illustrate a known law' and applies it to the discipline of typography as 'the style, arrangement or appearance of type' to explore the relationship between letterforms. AF Metropolis (2002) forces the viewer to look beyond the conventional 2-D surface in the way its letters automatically create 3-D space when placed next to each other.

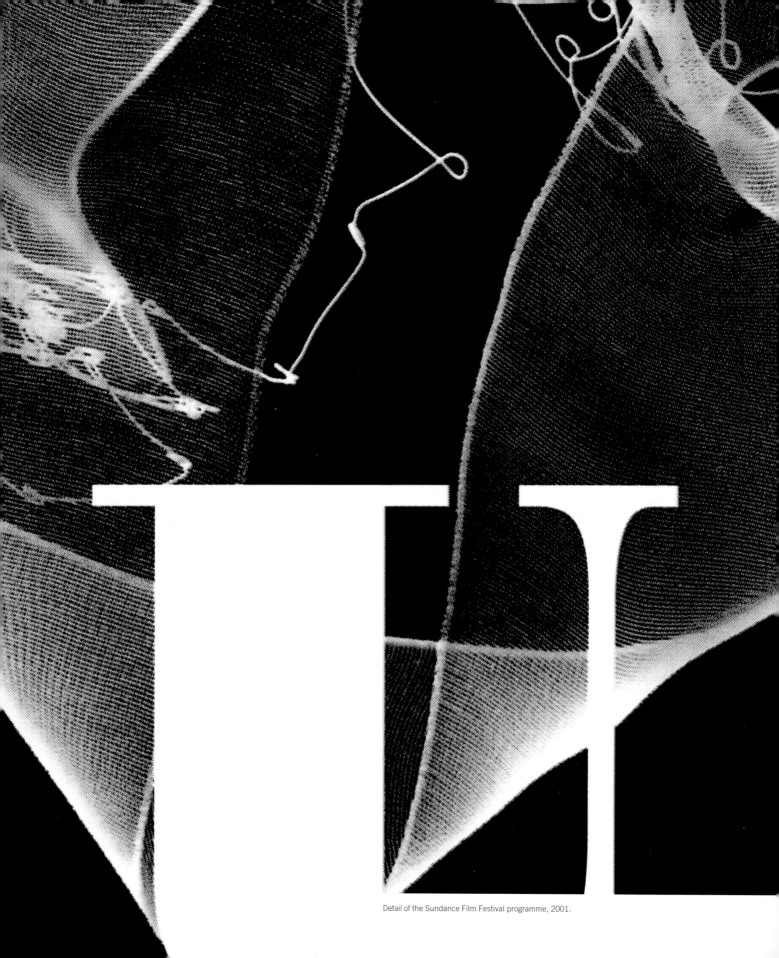

Detail of the Sundance Film Festival programme, 2001.

MARTIN VENEZKY

'Ah yes, experimental typography.
That is an awfully difficult thing to define since each designer has his or her own way of handling it.

I can only define experimental work on the basis of how I like to investigate these things. I am interested in type that responds to forces greater than the simple margins of the page and choice of font and size. That force could be magnetism or wind or moisture or paranoia or obsession. It could also be the relationship that type has with other objects within its range, whether they float into the body of text or hover in the margin.

I also like to think of type as an object that can be assigned properties – material, weight, space.

These are all formal investigations, although their relationship to the content of the text makes them resonate with certain meanings. The gap between form and explicit meaning is also an area of experimentation, as well as the relationship of image to text. These are areas that I often investigated in Speak.'

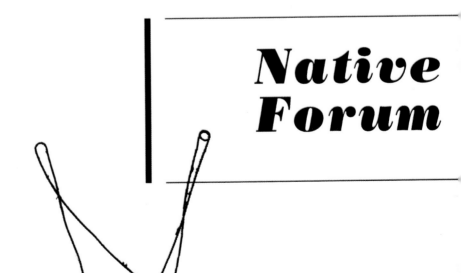

b. 1957
Studio: Appetite Engineers
Country: United States of America

A graduate of Cranbrook Academy of Art (MFA, 1993), Martin Venezky is professor of typography at California College of Arts and Crafts in San Francisco. He has served as art director of Speak magazine (1995–2000) and in 1997 he was selected by I.D. magazine for its prestigious ID40 list of influential designers. His work has appeared regularly in the American Center for Design's '100 Show' and featured in the Cooper-Hewitt, National Design Museum's 2000 National Design Triennial. He also had a solo exhibition at the San Francisco Museum of Modern Art (SFMOMA) in 2001. Clients include Speak, Reebok, Warner Bros., Chronicle Books and the San Francisco Museum of Modern Art.

1–5 Range of graphic applications for the Sundance Film Festival identity (2001). A flexible visual language needed to be applied effectively to over thirty products, ranging from catalogues and posters to sportswear and signage. The main theme behind the identity was to create a sense of 'building' from the initial construction of the letterforms to the page structures and, finally, to the event itself. 1 and p. 27 Details for a section of the Film Guide called 'Native Forum'. Visual explorations initiated the development of structures from simple materials like soap, wire and ribbon, which were then photographed and manipulated in the darkroom to reveal different methods of presentation. 2 Cover of Film Guide. 3 Double-page spread from the festival programme, which combines photographic imagery and 'fanciful, typographic structures'. 4 Inside cover and title-page spread from A Guide to the New Digital Initiatives at the Sundance Film Festival. 5 Two details from the programme. These were also used as postcards and their typographic structure was built by photographic images of the artists. 6 Frame taken from 'www.appetiteengineers.com', Venezky's studio website. The bear is Appetite Engineers mascot.

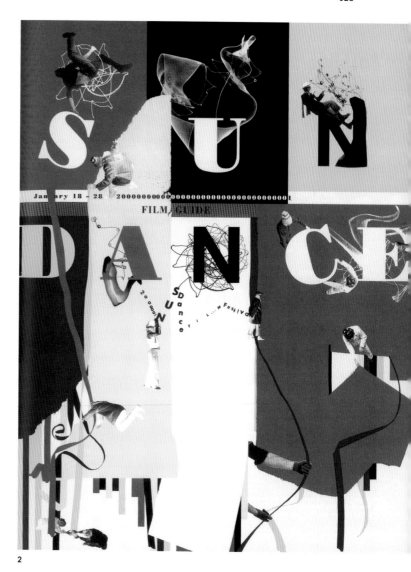

2

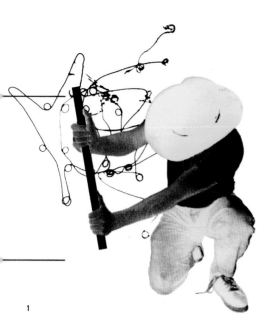

1

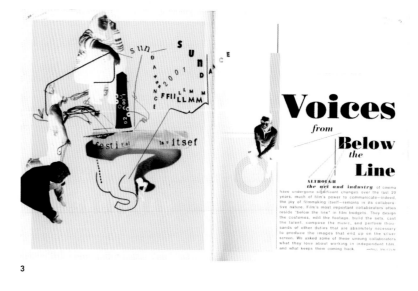

3

Many of Martin Venezky's typographic compositions owe their approach to the work of the early avant-garde, who were interested in conveying the 'visuality of written forms of language'[1] within the context of artistic and commercial publishing. Having traversed both worlds, Venezky has successfully found his place with clients whose briefs allow his unique brand of typographic rhythmic repetition, manipulated photographic imagery and strong graphic devices to create playful forms of communication. His work is a synthesis of Italian Futurism and the approach of such Dutch designers as Piet Zwart (who brought together the 'playfulness' of Dadaism and 'formal clarity' of deStijl). This is most obvious in his designs for <u>Open: The Magazine of the San Francisco Museum of Modern Art</u>. Venezky explores ideas about physical manipulation and compositional placement, always aware of the need for an essential clarity of communication. He is concerned with the notion of process, and includes in this the physical construction of letterforms. In <u>Speak</u> magazine, Venezky investigates how letterforms are constructed, using low-tech and high-tech production methods: sewing, photographic reproduction, stencil and collage. His letterforms are created out of found objects – fabric, lace, wire – with final sculptures scanned back into the computer to provide a dynamic spatial quality to the two-dimensional page. This strategy is frequently coupled with the use of a visual narrative to form a coherent structure to the project; for example, Venezky's identity for the Sundance Film Festival brought together nearly forty pieces of print work, including T-shirts, postcards, programmes, registration materials, press packs and posters to describe the process of film-making from the creative stages through to the final production with silhouetted actors performing on stage. Venezky used a series of nearly one-hundred collages handcrafted from such simple objects as wire, soap and toys, which were then photographed, cut out and recontextualized. Figures are involved in the process itself – carrying letters and painting walls. Typography and images are seen as integrated. The viewer's attention is drawn to the physical role of the letterform, its formal properties and, consequently, to the construction of language and meaning itself.

Notes
1 Johanna Drucker. <u>The Visible Word: Experimental Typography and Modern Art, 1909–1923</u> (Chicago: The University of Chicago Press, 1994): 10.

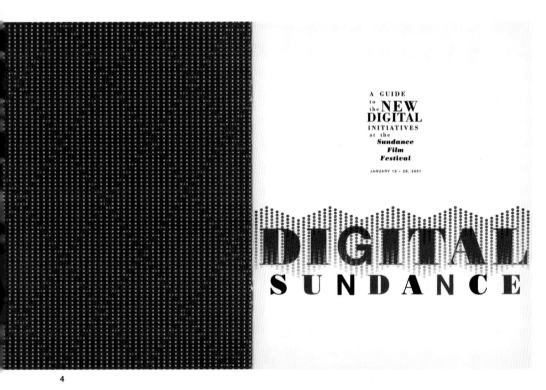

4

5

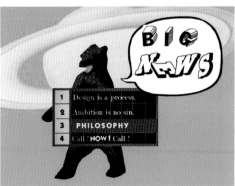

6

7–10 <u>Speak</u> magazine (1995–2000). The San Francisco arts and culture magazine ran for 21 issues and was described by Venezky as a 'laboratory in which to experiment with form and content, and the designer's relationship to text, the author and the audience'. The magazine also became a forum for contemporary experimental typefaces. **7** Detail from a subscription page. **8** Opening page for an article by Greil Marcus called 'Birth of the Cool', <u>Speak</u> (1999). **9** One of a number of permutations of <u>Speak</u> magazine's logo and address. **10** Double-page spread, table of contents <u>Speak</u> (2000).

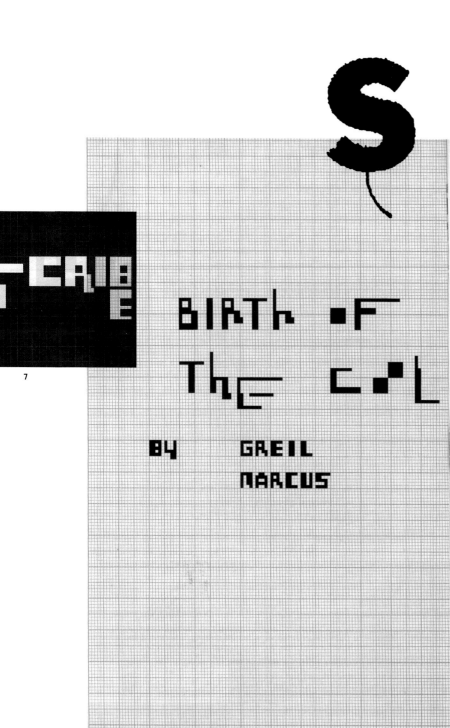

7

8 9

SPEAK MAGAZINE
5150 EL CAMINO REAL
SUITE A·24
LOS ALTOS, CALIFORNIA 94022
415 428 0150 MAIN
415 428 0151 ART&EDIT
415 428 0152 ADVERTISING
415 428 0153 FAX

11

This Is What an Artist Must Do

Ten Modern Art Manifestos

compiled by Melinda Silva

Abstraction,
representation,
narrative, nature, technology. . . .

10

The **world** seems **differ**ent today than it did

10

years ago — it looks much smaller.

With the advent and dissemination of cell phones, e-mail, and, of course, the World Wide Web, people communicate and confront information in ways that would have been unimaginable only a decade ago. While the merits and pitfalls of the Information Age are still actively debated, a number of contemporary artists have embraced technology in response to this cultural shift. In the spirit of 010101: Art in Technological Times—which has been on view online since January 1, 2001, and will be in the SFMOMA galleries from March 3 to July 8—**open** decided to find out what happens when you bring together artists involved with everything from online art to sculpture-making machines for a discussion in an Internet chat room. We found that even across three time zones and two continents, contemporary artists approach technology and culture in the twenty-first century with a striking mix of optimism and cynicism.

12

13

11–13 <u>Open</u> magazine. Venezky wanted to create a new visual language by building elements out of type and by playing with type's pattern, rhythm and architecture. The grid is composed of rigid and organic elements. **11** Page from <u>Open</u> (no. 4, winter/spring, 2001). **12** Page from <u>Open</u> (no. 3, fall, 2000). **13** Typographic detail from <u>Open</u> (no. 4, winter/spring, 2001).

Detail from a poster for the Flux music festival (1998).

HAMISH MUIR

'Every type job is an experiment.

Formal "information-based" problems require an analysis of underlying information structures and hierarchies through which forms of typographic expression are suggested and then modulated visually to an appropriate level during the design development and in the finished piece. Typographic systems, with rules and logic.

The experiment lies in trying to find appropriate ways of modulating the information. Almost a measured scientific approach.

The same general approach can be applied to less formal problems, but as these may require more expressive outcomes (and are often about dealing with relatively small amounts of information – posters rather than books), the design's final visual form may be as much to do with working against rules and logic as with working with them. The experiment is in finding the point where the form is in dynamic tension with the underlying information structures and hierarchies. A much more intuitive, creative approach.'

b. 1957
Studio: 8vo (1985–2001), independent designer
Country: United Kingdom

Hamish Muir graduated in visual communication from the Bath Academy of Art (1976–79) and then attended the advanced graphic-design course at Basel School of Design (1980–81). As an assistant to Paul Williams (now Stanton Williams Architects), Muir worked initially in exhibition and 3-D design. He then became principal of 8vo graphic-design consultancy in London (1985). When the studio closed in 2001 he returned to freelance work and teaching. Muir has lectured internationally on 8vo's work and related design issues at conferences and art schools in the US, Europe and the UK. 8vo's work has been written about extensively and featured on television and in exhibitions, including 'Design: 8vo', London; 'Five years of design work for the Museum Boymans-van Beuningen', Rotterdam (1993–94); and '8vo Engineering', a five-year retrospective at the Hochscule für Gestaltung, Offenbach am Main (1989). Muir was also co-editor of Octavo, an international journal of typography, all eight issues of which were designed and edited by 8vo (1986–92). Muir also received the International Typography Almanac Grand Prix in Robundo, Japan (1991).

While at 8vo, Muir built up a considerable international reputation with projects in such areas as publishing, record packaging and information design. Clients included high-profile corporations, museums, telecommunication and public-service companies, such as American Express, Thames Water (UK), Scandinavian Airlines System and Orange Telecommunications.

In addition, Muir has designed posters, catalogues and record sleeves for a number of important cultural institutions, including the Haçienda nightclub (Manchester, 1985–91), the Design Museum (London, 1990) and Factory Records (Manchester, 1986–92). However, it was in the promotional work for the Flux music festival in Edinburgh (1997–99) that Muir experimented with a flexible typographic 'system' that could more or less be adapted to the amount of information given. It could also be applied for multi-venue and single-venue use. The objective was to design three large posters listing all the gigs and their venues to be used for fly-posting and then individual A2 posters for each venue and for displaying in theatres, restaurants and shops. The acts were not going to be finalized until just before the artwork deadline so the system had to allow for their easy incorporation. To an extent, this freed Muir from having to intervene on a purely aesthetic level. He reflects 'the typography system itself was obviously subjected to a design development process but one that was not

1

2

weighed down by worrying about what the "final" thing would look like exactly.'
He continues, 'If this had been a purely "let's make a nice poster" design job,
the typography would have been a lot more convoluted. As it is, it's incredibly
simple – one size of type (except Flux), range left with a simple way of coding
information using colour highlight bars to make the whole thing more
approachable (modulated?). The same thing in straight range left black on
white doesn't read at all. So it's definitely not decoration. It's structural.'[1]
Ultimately, the system encouraged the posters to design themselves, creating
a unique and appropriate visual aesthetic.

Notes
1 Hamish Muir, email to author, 2002.

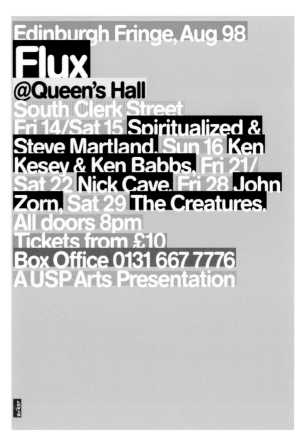

6

1–5 Flux identity 1 Poster 2 Programme 3 Press advert 4–5 A2 posters
6 Example in range left, black on white

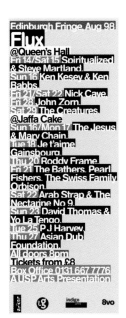

3 4 5

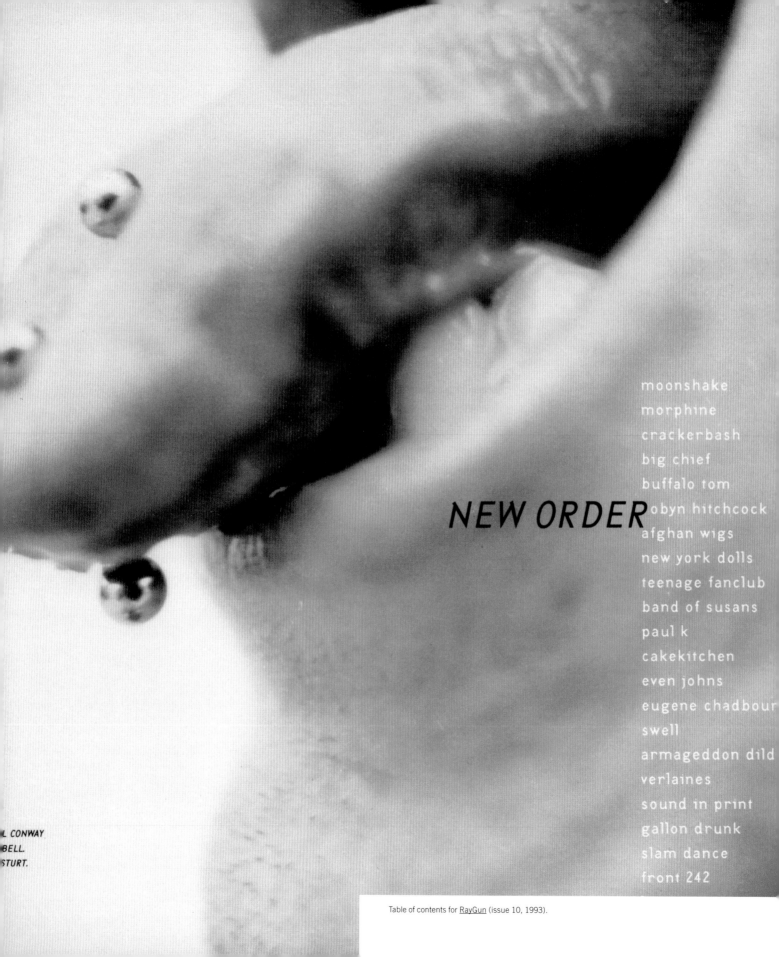

NEW ORDER

L CONWAY
BELL.
STURT.

moonshake
morphine
crackerbash
big chief
buffalo tom
obyn hitchcock
afghan wigs
new york dolls
teenage fanclub
band of susans
paul k
cakekitchen
even johns
eugene chadbour
swell
armageddon dild
verlaines
sound in print
gallon drunk
slam dance
front 242

Table of contents for RayGun (issue 10, 1993).

DAVID CARSON

'Experimental is something I haven't tried before … something that hasn't been seen or heard.'

Carson's contents pages not only highlight his experimental typographic work, but also provide an important chronicle of his experimental approach. Seen here are spreads from <u>Surfer</u> magazine (1991).

b. 1957
Studio: David Carson Design
Country: United States of America

David Carson is principal of David Carson Design, which has offices in
New York and Los Angeles. He is a graduate of San Diego State University,
where he received a BFA (Hons) in sociology. Carson is best known for
his design and art direction for music and lifestyle magazines, including
RayGun (1992–95), Beach Culture (1989–91), Transworld Skateboarding
(1983–87) and Surfer (1989–91). He has exhibited at Die Neue
Sammlung in Munich (1995–96), the Museum für Kunst und Gewerbe
in Hamburg (1996) and the 1997 Triennale Pavilion in Milan. He is
coauthor, with Lewis Blackwell, of The End of Print (1995) and the
designer and subject of two other publications David Carson: 2nd Sight
(text by Lewis Blackwell, 1997) and Fotografiks: David Carson (text by
Philip B. Meggs, 1999). Clients include American Airlines, American Express,
Atlantic Records, Nike, Pepsi, MTV, Sony, Levi's, MGM, Magic Johnson Aids
Foundation, Gingko Press and Sears. He has also worked on advertising
campaigns for Microsoft and Giorgio Armani and TV commercials for
Lucent Technologies.

Carson's contents pages for magazines reflect a way of working that has
become the designer's signature style. As an art director and designer, Carson
has focused on magazines produced for the youth-culture market. Whether
in the early Transworld Skateboarding magazine or in more recent work for
the Puerto Rican surfing magazine Surf in Rico, Carson has been able to
convey the attitude of each subcultural group, much in the way Neville Brody
and Terry Jones did for the 1980s British youth magazine market. Carson
states that the table of contents should 'get somebody intrigued and in a
way excited about what is to come – and, to not give it all away. Equally, to
not allow them to simply read through the entire contents page.' He continues
that it is 'more of a teaser than a road map', preferring to leave the reader to
explore their own way through the magazine[1].

This relationship between text and image, and the way in which text is
frequently treated as image has become a trademark of Carson's work.
Words may have lost their original content (always unsettling for the
magazine's authors), but Carson's typographic experiments mean that forms
can be embedded with new and different sets of codes (much in the same
way CalArts students experiment with meanings). The contents page was
often considered in a similar way to other editorial spreads in the magazines

1 Speak (issue 1, 1996). Carson placed the table of contents as a centrefold in the first issue of the
magazine. 2 RayGun (issue 9, 1993). 3–4 David Carson designed the title page for Marshall
McLuhan's The Book of Probes (Gingko Press, 2003).

he designed, so much so that these pages would become interchangeable. Carson experimented with the contents page as a centrefold in the first issue of Speak (1996) magazine (for which the art direction was taken over by Martin Venezky from issue two). Such questioning of magazine conventions continued into the 1990s when Carson used the contents page to highlight a piece of art or photograph in issue 9 of the music magazine RayGun. The page became a showcase for commissioned work, and Carson removed the page numbers to leave the page entirely uncluttered. In other issues, the table of contents offered the reader a visual game: article titles were listed on the right-hand side, while all the page numbers were on the left-hand side. The page numbers had no obvious connection to the articles. 'You have to sort out the right ones. It is a slightly different orientation rather than saying I am making things hard to read.'[2]

Carson continues such themes in his book design, most notably in his table of contents for a longer edition of Marshall McLuhan's The Book of Probes (Gingko Press, 2003). The new book has over 700 unnumbered pages; yet, in the table of contents, Carson has left the page numbers for the original 540-page book set against each chapter heading. The reference goes nowhere. For typographic purists this raises a number of questions about

Carson's role as communicator or indeed, as graphic author. It is fitting for Carson, whose work attempted to break typographic conventions, that Marshall McLuhan wrote forty years earlier, 'Print altered not only the spelling and grammar but the accentuation and inflection of languages, and made bad grammar possible'[3].

Notes
1 David Carson, interview with author, London, 2001.
2 Ibid.
3 Marshall McLuhan. The Gutenberg Galaxy: The Making of Typographic Man (London: Routledge & Kegan Paul, 1962): 231.

Advertising 258-288
Probes II 306-361
_Sense 362-393
_LanguageAnd+ 394-425
_The Laws of Media
454-473
_Probes III 474-509
_About the Author, Artist, Editor 510
_Books by Marshall
_Acknowledgements Copyrights
McLuhan 511

Detail of <u>Wire</u> (1994), showing the construction of the piece with assorted wire and cable ties.

GYÖNGY LAKY

'Letters are shapes that convey meaning when assembled in certain ways. Equally, this could be a statement applied to any form of visual art – painting, drawing, or sculpture. The artist is able to explore vast possibilities of expression by forming and arranging shapes that will be "read" and, of course, interpreted by the viewer. So, for me, experimental typography, as I use it, is a play back and forth between the unspoken impact of the physical form of individual letters and the literal meanings formed in the mind by the specific groupings. The visual physicality of the impact of my word sculptures is conveyed through their shape, material, scale, texture, structuring techniques, color, etc. The tangible nature of the letters becomes inextricably intertwined with its meaning as a recognized word. Then experimentation with form and meaning, and their interplay, may continue in the mind of the viewer because my artistic choices have altered the usual reading of a word.

I called a recent sculpture of the word 'yes' Negative, and though I wondered why I had done this I found that there was something at the edges of how I read and understood my three letters that was not just a clear, positive yes. There was a visceral reading that was prickly and uncomfortable, possibly even dangerous or threatening. The letters were formed in the shape of cacti and studded with small, sharp nails. This was not a smooth and easy yes, I had created a difficult and scratchy yes just by manipulating the typography … the physical form and detail of the shapes. What became interesting to me was that there was a second reading I could make that was quite different from what I have just described. This was also a funny and fuzzy yes which could then be read as an endearing and charming yes – quite a different meaning from my initial reading. Much of my work, however, is based on an underlying theme of environmental consciousness so, in fact, neither of the meanings I have stated here are the initial concept of this work.

As a sculptor I am able to experiment with the dimensional and physical character of a letter and push and alter its meaning as it participates in a word. I am fascinated by the potential for multiple simultaneous meanings.'

Oil Korrect (1998). Apricot prunings and vinyl-coated steel mains (45.7 x 45.7 x 17.7 cm).

b. 1944
Studio: independent artist
Country: Hungary/United States of America

Gyöngy Laky is a sculptor who works across such disciplines as art, design, engineering and basketry. She came to the US with her family from Budapest during the Cold War and received her undergraduate degree (1970) and her masters degree (1971) from the department of design at the University of California, Berkeley. She has been professor of design at the University of California, Davis in the College of Agriculture and Environmental Sciences since 1978 and was chair of the department of art (1995–97). A founder of Fiberworks, Center for the Textile Arts in Berkeley (1973), Laky lectures and exhibits her work internationally. Her recent work has been shown in the outdoor sculpture exhibition 'Kunst in der Landschaft V' in Austria (2000), the Renwick Gallery of the Smithsonian American Art Museum (2002) and the 5th Annual Festival of Tapestry and Fibre Art in Beauvais, France (2002). Her work also features in the video Ten American Makers (UK) and has been written about in The New York Times, Fiberarts, Baseline, American Craft and Artist Magazine. Laky's work is also represented in a number of books and is the subject of a monograph in the 'portfolio' series published by Telos Art Publishers (London, 2003). She is a past recipient of a National Endowment for the Arts Fellowship and was one of the first textile artists to be commissioned by the Federal Art-in-Architecture programme in the US.

An expert in basketry and fibre art, Laky investigates the connection between early forms of writing and calligraphy with more exploratory aspects of drawing. Her sculptural forms present formal and material constraints, the 'kinds of decisions that type designers face everyday regarding stroke width, relation to baseline and the like'[1]. Her first large-scale sculptural language piece was a question mark (1985) composed of twigs in bas-relief of one to two inches. She has a growing interest in the 'symbolic life force of letters and the words that they make', which is exemplified by the sheer physicality of her three-dimensional sculptural forms. She presents such words as 'OK', 'art', 'time', 'eternal vigilance' and 'no' subtly in her woven vessels or more overtly in installations in the environment. Laky's constructions challenge 'readerly expectations', primarily through scale, but also by taking the reader out of the conventions of the two-dimensional printed page and into a more physical and spatial engagement with letterforms. There is an element of surprise and a duality of meaning that brings the reader back time and time again[2]. On a secondary level, meaning is created through the materials themselves; for example, apricot prunings are held together with steel nails that spell out the word 'OK' (1998). On first reading, 'OK' indicates that all seems right with the world, but closer examination reveals an unsettling tension due to the juxtaposition of what is man-made with that which is found naturally in the environment. While many of her words appear in a gallery setting, Laky also repositions her typographic forms in the natural landscape, as is the case for Protest: Naught for Naught ('Kunst in der Landschaft V', 2000), where the word 'no' was constructed and put in a meadow. The significance of the word was obvious – Austria was holding its election and a right-wing candidate had been voted in. Laky used 'no' as a statement of political protest.

Notes
1 Juanita Dugdale 'Gyöngy Laky: Matter and Message.' Baseline (no. 32, 2000): 37.
2 Derek Beaulieu. 'A Word in Another Language I Can Understand: An Interview with Gyöngy Laky', www.alienated.net/article.php?sid=31.

1 Proximity (1997): acacia, apricot, brass nuts and bolts (161.1 x 157.4 x 22.8 cm). 2 Sound (1998): apricot, brass nuts and bolts (152.4 x 144.7 x 7.6 cm). 3 Of Course (1998): apple prunings, vinyl-coated steel nails (139.7 x 139.7 x 5 cm). 4 Wake (2000): apple and pear prunings, nails (127 x 127 x 5 cm). 5 Detail of Protest: Naught for Naught (2000). 6 Protest: Naught for Naught (2000): orchard prunings and screws ('N': 121.9 x 121.9 x 40.6 cm. 'O': 304.8 x 304.8 x 91.4 cm).

5

6

1

2

3

4

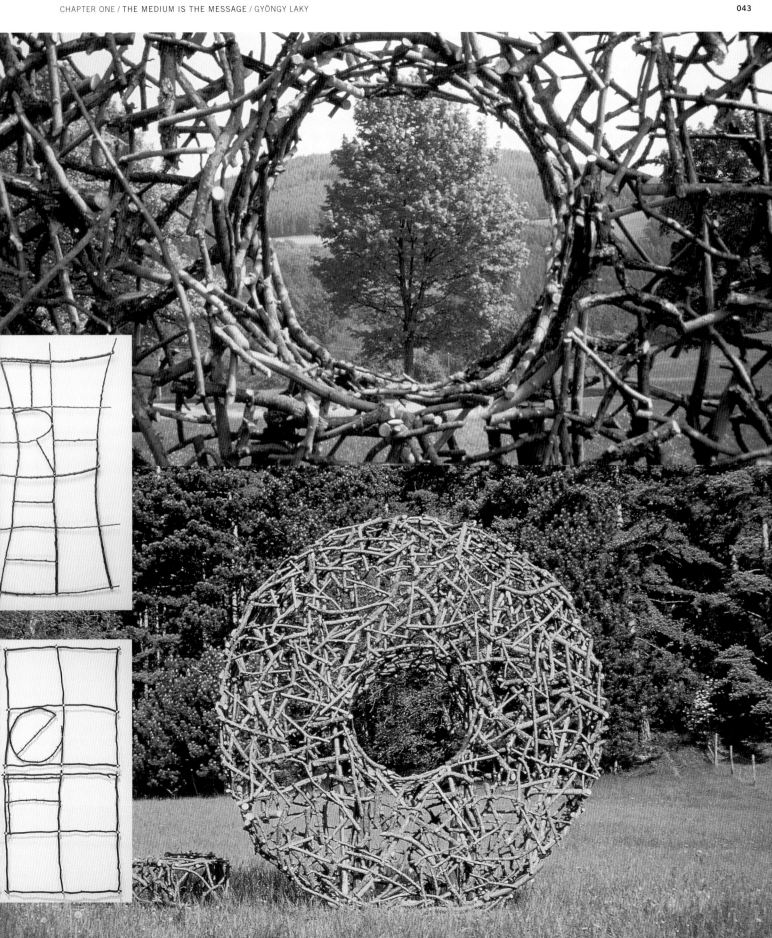

Stages investigating the formal properties of composition and language using the crowd dynamic as a starting point and translating it into typographic signifiers.

KATSUYA ISE & STUDENTS

'Characters are the systematized and visualized form of "language", which is the greatest technology invented by human beings. Looking at every form relatively, this is how I relate to the world (and this is a theme of my research). It means that I intend to re-understand natural forms, artificial forms or the forms generated through our images, as mere form, beyond each context in which those forms exist. Branches of trees, a Ferrari 360, a piece of screwed up paper fallen on a roadside and **Helvetica Medium**, for instance, all of those are considered as the same thing. As a physical phenomenon and a chemical substance, an environment and a context, a trend and the economy and technology, everything is generated and exists in various dynamics. It is very interesting to think about how the balance of these dynamics creates each form.

From this viewpoint, it can be understood that characters are rather unique forms. And this, for me is my fundamental attitude toward experimental typography and teaching experimental typography. Characters are pure visual form and communicate information and meaning. In other words, the process of "reading" is necessary to achieve this. The pure visual form, however, contains varying images. An "O" can be a circle, the sun, the moon, or a pancake that I ate yesterday. I understand that the gap between the process of reading and the images as pure visual form is a distinctive feature of the form as characters. As is often the case, however, most students I teach at the university believe that characters are nothing more than things to be read, (things that should transmit information correctly).'

Katsuya Ise
b. 1960
Institution: Joshibi Junior College of Art and Design
Country: Japan

Katsuya Ise is an associate professor on the information media design and design courses in the department of art and design at Joshibi College. His pedagogical approach has developed from a long-term interest in the relationship between form and process. For his class on experimental typography, Ise encourages students to re-examine the relationship between the tools with which we write and that which is written upon. Letters, he suggests, are formed as the result of physical action combined with the unique properties of the materials used; for example, the 'pattern chalk makes when scratched on a tin plate'. Elements located in the immediate environment are used as a palette for typographic experiments.

The project 'Dismantling the Book', shown here, encourages students to break down the authoritarian idea of books and characters. The students take apart paperbacks bought from used book stores to find a completely different face of the book and to discover visual diversity. Characters are set free as pure visual form; Ise explains, ' "A" may be an original cow, and "wind" will be fluttering in the classroom with the wind'.

Student: Masumi Kobayashi
b. 1976
Project: Seeds Letters (1999)
(watercress seeds)

Kobayashi's piece is a culmination of his experiments with characters over
two years. He began by researching characters in encyclopaedias, which
reminded him that the written character has three functions: 'to preserve,
transport and reproduce language'. This raised the question, what would
happen if the character's form was allowed to change of its own will?
Kobayashi explains, 'So, onto the shapes of the characters originally
created by man, I added information from the natural world in the form of
watercress seeds.' As the seeds grew, the shape of the characters altered
without any human input. Kobayashi reflects, 'The experiment made me want
to rethink what artificial shapes, natural shapes, the shapes of the characters
and the characters themselves actually mean to us.'

踊る女文字一覧表

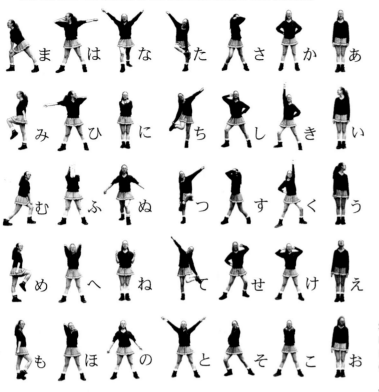

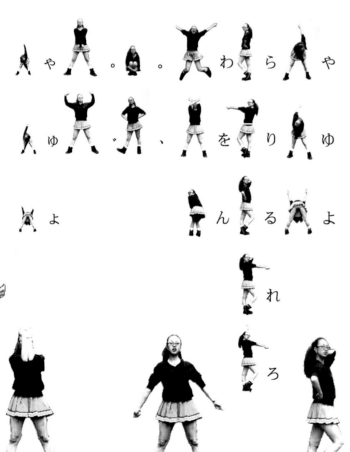

Student: Reiko Futatsuki
b. 1977
Project: *Dancing Female Letters* (1998)
(performance by designer)

When contemplating the assignment, Futatsuki realized, 'I hate books. I hate characters'. So, her aim was to make characters more interesting. She had been a member of baton clubs for a number of years, which gave her the idea to use the pauses in baton movement to construct fifty letters of the writing system Hiragana. She became a 'typo-dancer' and videoed the results, which she then scanned into the computer to make graphic forms. She says, 'I learned from dancing that characters are not only for being read but also can amuse us when watched.'

Student: Eriko Ichikawa
b. 1975
Project: Phonogram (1999)
(paper, brick, stone, bamboo, timber, pen, needle, pencil, brush)

Ichikawa reflects, '"Kakumono" (that which is used to write) multiplied by "Kakarerumono" (that which is written on) plus a little something extra equals my typeface.' Based on responses to a questionnaire asking people to come up with a form for each sound between A and N of the Japanese alphabet, she compared the differences between the typeface forms to create a set of phonograms.

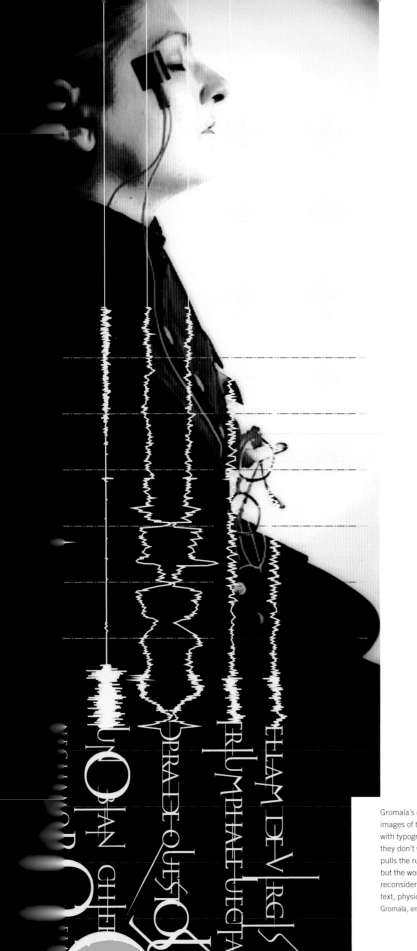

Gromala's early work in virtual reality (VR) used text and body – three-dimensional inhabitable images of the inside of her body (from Magnetic Resonance Imaging) that were texture-mapped with typography. The typography was interactive, but it turned out that when users 'fly' in VR, they don't want to read, not even erotic text. She writes, 'My specific focus is on typography that pulls the rug out from under our everyday sensibility so that we can rethink not only typography, but the world in which it resides and through which it operates. I am concerned with reconsidering legibility in our technologically mediated context – legibility of the typeface and text, physiological and sensory legibility, and the cultural legibilities of our bodies.' [Diane Gromala, email to author, 2002]

DIANE GROMALA

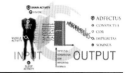

'Experimental typography can be any development or use of typography that is out of the usual bounds of use – from recontextualized tattoos to holography, virtual reality, performance art and so on – so its definition is a moving target. (Experimental typography in the artistic realm is sometimes quite compelling, though often illegible, which is some of its point. That's OK, but it seems like a one-liner. I'm not much interested in typography that is novel for novelty's sake, or gratuitously decorative [unless it is in extreme excess], or bears a cute name.)'

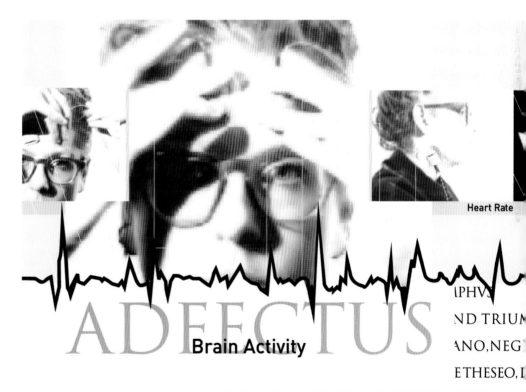

b. 1960
Institution: Feral Computing, School of Literature, Communication and
Culture, Georgia Institute of Technology
Country: United States of America

Diane Gromala is an associate professor in the School of Literature,
Communication and Culture, where she teaches the graduate programme
in information design and technology. She is also a faculty member of GVU,
the Graphics, Visualization and Usability Center and has previously taught
at the University of Texas at Austin (1990–94) and the University of
Washington (1994–99), where she was director of the New Media Research
Lab. Graduating from the University of Michigan with a BFA in graphic design
and photography (1982), she went on to receive her MFA from Yale University
(1990), combining graphic design with courses in the humanities
departments (philosophy, cultural studies, media studies). Gromala worked
previously as an art director and designer (1981–90) for among others,
MacWorld and Apple Computer, Inc. She has been active in SIGGRAPH
(Special Interest Group on Computer Graphics) and is also the recipient
of a number of awards and research grants. Gromala lectures internationally,
on virtual environments, media studies, graphic design and the bridging of
disciplines between art, design and computer science. Her writings have
appeared in collected anthologies as well as in FrameWork: a journal of visual
culture, Emigre and Movement Research Performance Journal. In the 1990s,
Gromala worked in virtual reality, both as an artist to provoke a sense of flying
and as a designer of the virtual environments used for pain therapy. Her
virtual artwork has been presented in Canada, the US, Europe and the
Middle East and aired on the Discovery Channel and the BBC.

BioMorphic Typography is a family of fonts that change (or morph) in
realtime, according to a user's continuously changing physiological state,
making apparent the ways in which design and particularly typography can
bring us back to our bodies. This is achieved by wearing a biofeedback device
that measures heart rate, breathing rate and galvanic skin response. It is not
one specific font, but comprises a pastiche or reappropriation of many fonts
that are in constant flux. The idea is to enable users to gain an awareness not
only of their bodies, but of those very physical states that usually lie below
their conscious radar. In the writable version, users type and see the font
change in realtime in fairly intimate settings. Gromala comments, 'It is curious
the wearable version seems to elicit the worst in people. Like the famous
Milgram experiment, other people seem compelled to provoke the user, to see
how what they say to the user changes that user's now visible, physical state.'

The first font in the BioMorphic Typography family is Excretia (2000), which emphasizes those
aspects of our bodies we want to forget: excrement, the skin and nails we shed, the dead protein
(hair) we wear, the air we dismiss, and so on.

PHALE UECTABULO,

I AMOROFI AMPLEXI

INCREDIBILE BELLECIA

SCU LANTISE, DEMIFFE

UA HERA, ETCÚ DINUINI

O DELECTABILMENTE

OLORE TRA LE DELICATE

MODAMENTE SEDEUA

AMENTE DI MOLLICULA

MAPPING MEANING AND DEFINING SPACES

MMMteurs-Cyber/MMMteurs-Real (1995) was designed by Moniteurs, a Berlin-based group whose members Heike Nehl, Sibylle Schlaich and Heidi Specker worked on corporate-design projects, music projects, magazines and interface design for TV and online services. This typeface, designed for Fuse 14: Cyber (1995), enables you to switch between the real world and cyberspace. They state that their 'interest is in the first stage of cyberspace' and especially in an attempt to bring emotion to a medium that is 'ill-prepared to transport feelings'.

'Writing moves words from the sound world to a world of visual space, but print locks words into position in this space. Control of position is everything in print' – Walter Ong (1982)[1]

Design theorist Gui Bonsiepe has long argued for research into a 'semantic typography', suggesting that typography is a 'constituent element in the reception and production of texts'. The main aim of semantic typography is to 'arrange the structure of the text visually and to bring forth meaning'. He proposes that the graphic designer is an interpreter of text and must recognize the 'layers of meaning' and the 'knowledge that every interpretation is the exercise of power, and an act of violence or caprice on the text'[2]. Meaning is produced from the arrangement of texts constructed from words, sentences and paragraphs, and also from the text's compositional position. On one level, it is the author who constructs the narrative, while, on another, it is the hand of the designer or typographer, in their role as a mediator of the message, that develops a second-level narrative. If typography is defined as the visual expression of ideas or messages and the formal organization of language, then it becomes a form of discursive practice and cannot be developed or understood in complete isolation. Texts and typography are receptacles for social and cultural meaning. As a vehicle for the dissemination of messages, typography becomes a fundamental part of the 'grammar of visual design' and, as such, is central to the process of interpreting and mapping meaning.

This idea is developed further by Theo van Leeuwen and Gunther Kress who suggest the 'grammar of visual design plays an equally vital role in the production of meaning'. They draw significant parallels between linguistic structures and visual structures, understanding that both realize meaning through an expression of language. This may be achieved through 'different word classes and semantic structures' or in terms of the area of 'visual communication, expressed through the choice between, for instance, different uses of colour, or different compositional structures'. The process of experimentation comes into play when the 'grammar' or the set of rules are broken, such as the rules established through education or the laws of a society. For visual communication, the same process should be applied; not to do so merely closes down the possibility for change[3].

Also relevant are the writings of social scientists Fiona Ormerod and Roz Ivanic, who argue that a text is not just a form of visual and verbal representation 'but also a material object with distinct physical features which are, in themselves, semiotic'. A text is a material object and is a reflection of any physical processes associated with its physical production and use.

Equally a text is a 'textual object' and 'through its linguistic, visual and physical characteristics, carries meaning about a topic and reflects the author's meaning-making processes'⁴. In the same way, it may be proposed that there is a meaning-making process in which the designer or typographer also establishes meaning.

The typographic experiments of British designer Paul Elliman (see pp. 60–65) challenge conventional approaches to the development of language systems and their architecture. His experimental font Alphabet (1992) for Fuse was created by using photo-booth portraits of friends. He employed the human body as a physical 'sign', taking into account gestures and expressions to give the reader clues to the letter the photo represented. Elliman creates an alternative visual 'grammar' and corollary 'syntax', which are defined by signs and their formal relationship to other signs, ultimately forming 'visual statements'. Alphabet reads, on one hand, as a visual sign and, on the other, as a set of individual photographs. In other words, an additional layer of meaning can be explored other than literal representation. Here, the viewer is presented with a second linguistic narrative based upon deciphering the sitter's cultural and social identity as signified by the clothes they are wearing. The use of the photographic image also provides an opportunity to scrutinize ethnic origins, personalities and individual temperaments.

Cultural signifiers are inherent to typography and, in particular, typeface design. Language facilitates the recognition of cultural contexts not only through the word, but also through its alphabetic forms (for example, Japanese and Arabic characters). Since the 1990s, typographers have also explored the potential for forming a hybrid of culturally specific forms, which may be distinct from the words they create. This brings new kinds of cultural meaning. Boutros 'Ahlam' (2002), for example, is an Arabic typeface by Nadim Matta, designed in response to the rapid transformation of Beirut and its visual landscape. Boutros 'Ahlam' (translates as 'dreams') also mimics traditional bamboo calligraphy to acknowledge the historical importance of this Arabic craft tradition. Matta attempts to defy the taboos surrounding Arabic type, especially those that suggest no modifications should be made to the holy Islamic scripture. With this in mind, Matta defines experimental typography as a 'pioneer in a certain area, daring enough to defy taboos, break traditions prompt people to rethink preconceived notions and things taken for granted'. However, he explains, 'I would like to add that no design is experimental if it doesn't encounter some repulsion from the audience at the beginning, but the true challenge of experimentation would be in turning this resisting audience into a receptive one whilst being careful not to force or impose this reception.'⁵

Entebbe (1990) is a black typeface designed by Alexander Branczyk of xplicit ffm for his invoices to 'ensure they would be paid'. The rough 'cut-n-paste' letterforms are reminiscent of the lettering of ransom notes and the favoured typeface of the Punk movement in the 1970s.

Swiss designer Cornel Windlin was inspired by standard British car registration plates to create Alpha Headline (1993–97). An earlier version was created in 1991 and used on a number of Windlin's design projects. The British designer Phil Bicker also used the typeface on the redesign of the photography publication Creative Camera. Windlin has designed a number of experimental typefaces, notably, Moonbase Alpha (1991), which was developed for Fuse 3: Disinformation.

Typography functions in the construction of a reader's experience by combining visual and textual strategies to enhance the message and the meaning. The rhythm and pace of reading may be regulated, for example, through letter and word spacing. Spatial form in the literary discipline is an essential feature in the interpretation and experience of 'descriptive or temporal space'. The compositional placement of text is also extremely important and effects what happens on the page in the same way that punctuation – commas, exclamation marks, full stops – direct the reading and spoken experience. Bold, italics or underlining can make a statement more emphatic, or, as Katie Salen has suggested, can be used as subversive elements or can be employed 'to violate conventional interpretation'. This has implications for the mapping of meaning but also defines the aesthetics of the 'page'. Salen proposes, 'each work has its own set of constraints, its own limits and its own rules, its meaning can never be fully determined by its visual form. Rather, the language that it speaks can change the way it is experienced by the interpreter.'[6] Ultimately, it is the shared understanding of codes and the context in which these codes are positioned that will allow a 'correct' reading of the text (client's message).

As a typeface becomes less legible and distinct, the blurring between any discernment of the word and image increases. The typeface is read more as an image than a word. The designer's 'notion of an interpretive text' has permeated much design in the last decade. However, it has been acknowledged that to communicate a message, type must be 'understood within the context of an entire visual construction'. In a shift from Postmodernism to exploring theories of Deconstruction, designers and typographers have begun to address the 'way of looking at design' rather than the 'look of design'[7]. The typographic experiment has played an important role in transforming our way of thinking.

Notes

1 Walter J. Ong. Orality and Literacy: The Technologizing of the Word (London: Routledge, 1982): 121.

2 Gui Bonsiepe. Interface: An Approach to Design (Maastricht: Jan van Eyck Academie, 1999): 66.

3 Gunther Kress and Theo van Leeuwen. Reading Images: The Grammar of Visual Design (London: Routledge, 1996): 2.

4 Fiona Ormerod and Roz Ivanic. 'Materiality in Children's Meaning-making Practices.' Visual Communication (vol. 1, issue 1, 2002): 67.

5 Nadim Matta, email to author, 2001.

6 Katie Salen. 'Speaking in Text: The Resonance of Syntactic Difference in Text Interpretation.' Visible Language (27:3, 1993): 297–300.

ALPHA HEADLINE
AABCDEFGHIIJJ
KKLMNOPQRRSTU
VVWWXXYYZ*$?!£
1234567890;&ß
THE QUICK BROWN FOX JUMPS OVER THE LAZY DOG.

7 Stephanie Zelman. 'Looking Into Space.' Gunnar Swanson, ed. Graphic Design & Reading: Explorations of an Uneasy Relationship (New York: Allworth Press, 2000): 57.

1

2

1–2 Alan Záruba created Cogito (2001) for an exhibition on the theme of the injection of technology into the human body microstructure, designed by Dutch group Total Design at the National School Museum, Rotterdam (2001). The brief was to create a typeface that would allow people with specific abilities in terms of memory and reading to decipher the face's internal logic system. The name was taken from René Descartes's 1638 phrase 'Cogito ergo sum'.

3–4 Boutros 'Ahlam' (2002), an Arabic typeface designed by Nadim Matta as a tribute to the type designers Mourad Boutros and Arlette Boutros, whom he had met as part of his 'industrial collaboration' while a student on the MA Typo/graphic Studies programme, London College of Printing. Early sketches show the development stages. The typeface is intended primarily for display usage. Inspiration was found in the organic shape of the flame and the forms of Naskh – a traditional Arabic typeface – which are blended to produce a 3-D twist. 5 This experimental typeface project (2000) took place online, allowing collaborative fonts to be generated by 'typographic whispers'. Five template characters for the lowercase letter 'a', designed by Erik van Blokland, Tobias Frere-Jones, Jonathan Hitchen, David Crow and Yaki Molcho, started the process. Using online LetterFormer software, other participants took the characters as the basis for creating the next letter in the modular alphabets. The global project was conceived by Ian Mitchell – an award-winning multimedia designer and lecturer at Liverpool School of Art & Design – and was supported by the type collective Beaufonts.

3

4

5

6

bloody
useless

6 Pussy Galore (1995), by the Women's Design + Research Unit (WD+RU, London), was an experimental typeface created to raise awareness about women and language. The computer keyboard became an interface for the user to engage with the positive and negative aspects of a 'woman's' language.

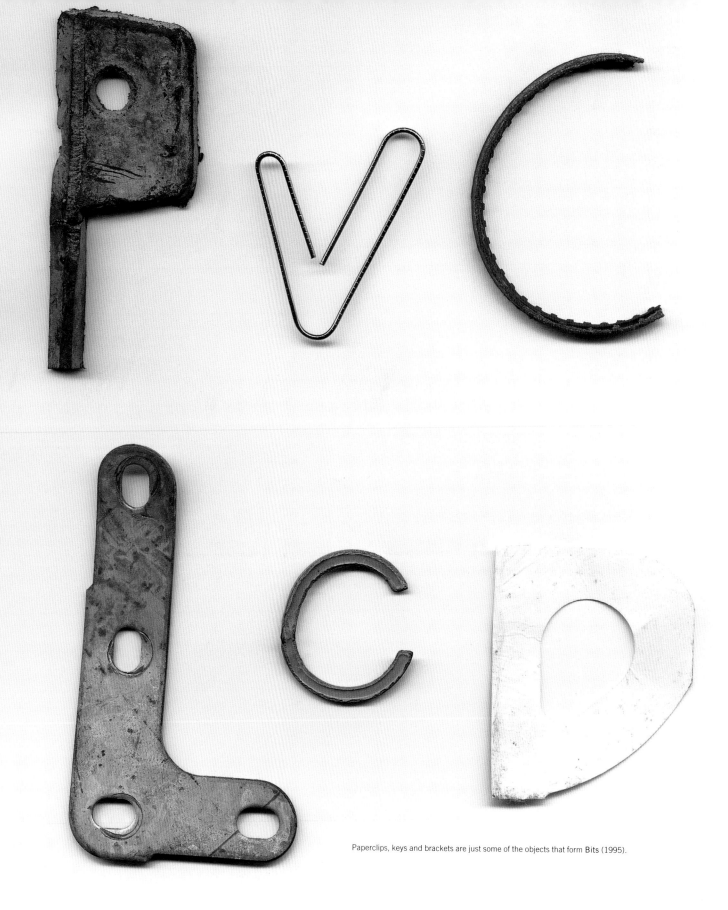

Paperclips, keys and brackets are just some of the objects that form Bits (1995).

PAUL ELLIMAN

'I always mixed up words like typography, topography and typology. Is that experimental or just a useful misreading?'

1

b. 1961
Studio: independent designer
Country: United Kingdom

Paul Elliman describes his design work – with typefaces, test patterns and even the human voice – as emphasizing the rough material edges of new technology. He attended Portsmouth Polytechnic (1980–82), where he switched from sociology to complete an art foundation course. Essentially a self-taught designer, Elliman was a member of the City Limits magazine collective (1984–86). He then became design director of the British music magazine Wire (1986–88), before embarking on a career as a freelance designer. In 1992, he was controversially awarded Design & Art Direction gold and silver medals for the design and publication of an electronic journal that used fax and email. In the same year, he received a Barclays New Stages prize for a collaboration with British choreographer Rosemary Butcher. Recent work has included commissions from Princeton School of Architecture, a collaboration with cycling activists Critical Mass and a series of cover designs for everything Magazine, a London-based arts magazine.

Much of Elliman's work has emerged from an interest in the socio-linguistic elements of the city and the way in which meaning is constructed, perceived and mapped. Elliman combines findings from urban life with the structured, systematic reading of the alphabet; Bits, for example, featured in Fuse 15: Cities (1995), is constructed from roadside debris – metal, plastic and cardboard – scanned into the computer and transformed into a digital typeface. Based upon a fascination with the city, Bits illustrates Henri Lefebvre's reading of the city as a 'found object created by its citizens'. It is the relationship between language, writing systems and the city that Elliman exposes in his 'collection of industrial materials'. He states that typography is a 'figure in the shift from industrial age to post-wherever-we-are-now. From Lucretius to the laptop I'm writing this on, everything can be expressed in bits – in one sense of the word or another.'

Both projects presented here – Bits and the earlier 'photo-booth alphabet' – refer to a number of interrogations of the city by other artists and designers; for example, the Situationist International, with their definition of psychogeography as the 'theory and practice of drifting through an urban environment'. Bits recalls Claus Oldenburg's Ray Gun collection (a series of gun shapes), the collections of British artist Tony Cragg, the combination of language and found materials in the work of the Italian group Arte Povera and American artist Richard Tuttle and the 'letter' photographs of Walker Evans and Lee Friedlander. The Bits project takes its own direction by engaging with

3

4

1 Elliman's use of the body as a form in which meaning is held and communicated is also seen in his collaboration with the British choreographer Rosemary Butcher (1992). Elliman designed the set for the performance 'Body as Site'. 2 Elliman was influenced by Hollis Frampton's portrait of the artist Frank Stella. 3 and 6 Elliman refers to his photo-booth alphabet for Fuse 5: Virtual Fuse (1992) as 'some of my friends as letters of the alphabet'. The alphabet draws on formal, expressive and associative depictions of alphabetic signs. In one example, the descender on the letter 'P' is created by the sitter's straight long black hair draped over her shoulder. Both projects were inspired by the decoration of early medieval manuscripts (such as the Book of Kells), in which human bodies merge with letters to give alphabetic writing a living presence. However, Elliman's unwillingness 'to separate the body from the writing' is just as much a reflection on contemporary uses of technology and the idea that 'every mark and image and human act, in a very cybernetic sense, is more or less understood as an extended writing'. 4 and 5 Elliman's collection of photo-booth images.

5

6

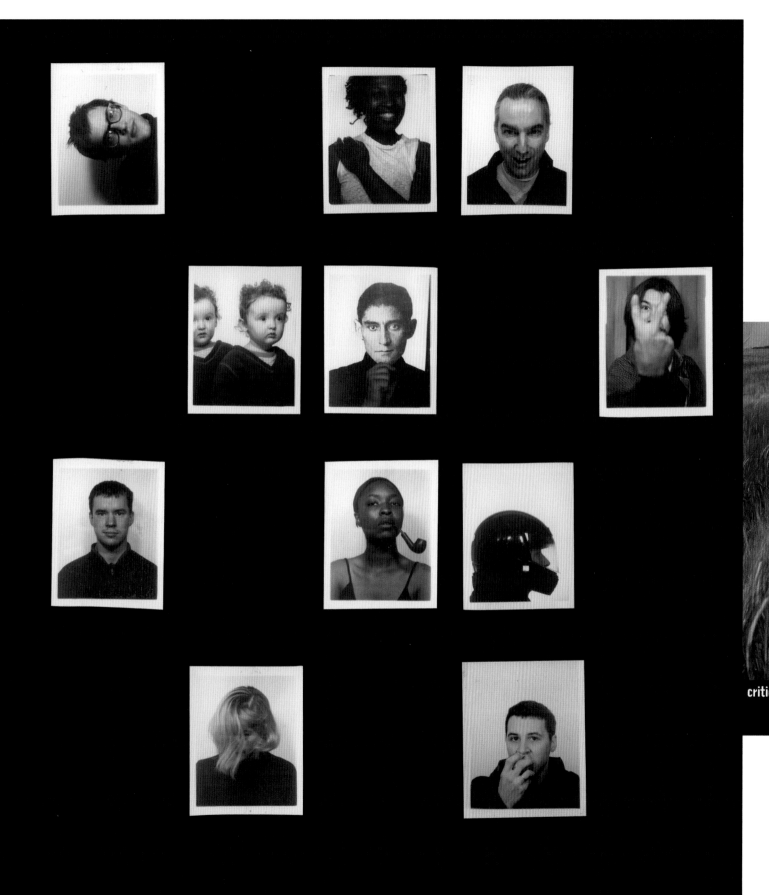

the nuances of typographic form, specifically addressing the relationship between language and the endless material productions of the city. Regarding Bits as a long-term project, Elliman has accumulated hundreds of characters for an organic font that seems to defy many of the usual typographic standardizations. 'I try to draw these things as fast as the city can throw them at me, but it's almost impossible to keep up', he says. An updated version of the typeface is released through Lineto, Zurich (2003).

Elliman's social experiences may be messy, complicated and often dysfunctional, but they do not lack technological sophistication; a recent version of Bits uses OpenType software that avoids the repetition of characters. His 'grrr.list' message board uses a Perl script to search for any Internet postings that include the term 'grrr', compiling and re-presenting them as a 'live' discussion board (albeit one with unwitting contributors). He once proposed to choose readers for the BBC Radio 4 'Shipping Forecast' where the lone voice of the announcer is a kind of figurehead to the vast deployment of technology. This is the area of human communication that interests him most: inseparable combinations of the human and the technological, the linguistic and the social.

Exhibitions of Elliman's work include 'Lost and Found: Critical Voices in New British Design' (The British Council, 1999) and 'Century City' (Tate Modern, London, 2001), with smaller gallery shows at Galerie Jan Mot in Brussels and Galerie Nils Staerk in Stockholm (both 2002). He has contributed to Fuse, has published essays in the magazines Eye and Dot dot dot and is currently writing a series of essays called 'Invisible Language' for IDEA magazine.

Elliman has taught in the cultural studies department at Central Saint Martins College, London; the School of Visual Communications at the University of East London; and at the University of Texas at Austin. He has also been a guest speaker and visiting critic at a number of schools. He has been a project tutor at the Jan van Eyck Academie in the Netherlands since 1996 and assistant professor at Yale School of Art since 1998. He was an advisor at the Shanghai University, and is a critic at the Royal Melbourne Institute of Technology.

al voices in new British design

Bits was featured in <u>Fuse 15: Cities</u> (1995) and has appeared in <u>Anything</u> (architectural journal, MIT Press, 2001), <u>everything Magazine</u> (fine-art journal, everything Publications, 2001), and the catalogue for <u>Lost and Found: Critical Voices in New British Design</u> (The British Council/ Birkhäuser, 1999).

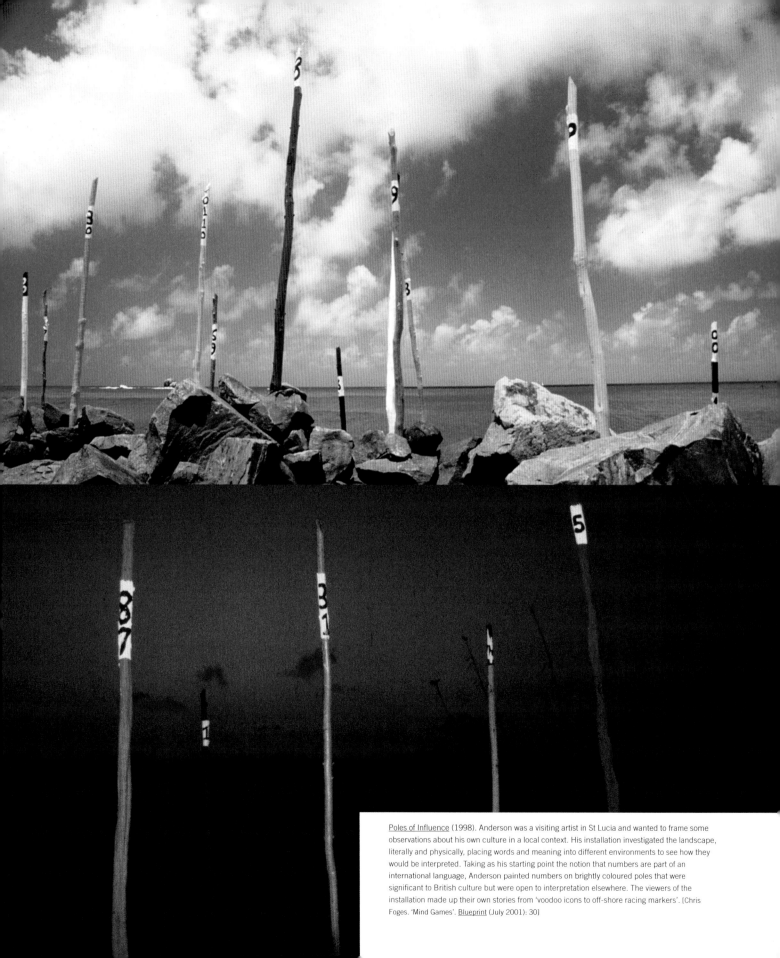

Poles of Influence (1998). Anderson was a visiting artist in St Lucia and wanted to frame some observations about his own culture in a local context. His installation investigated the landscape, literally and physically, placing words and meaning into different environments to see how they would be interpreted. Taking as his starting point the notion that numbers are part of an international language, Anderson painted numbers on brightly coloured poles that were significant to British culture but were open to interpretation elsewhere. The viewers of the installation made up their own stories from 'voodoo icons to off-shore racing markers'. [Chris Foges. 'Mind Games'. Blueprint (July 2001): 30]

PETER ANDERSON

'Experimental typography is the way we describe looking at things. It is the way we find a new language, a questioning of how we present information and the way we interpret it. The form has taken on the responsibility of the content.'

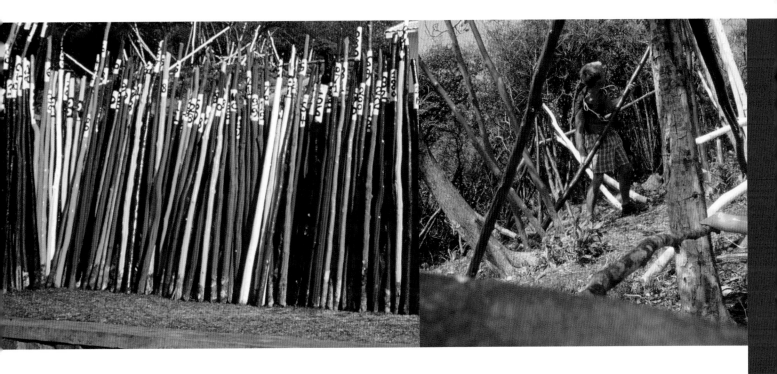

b. 1970
Studio: Interfield Design Limited
Country: Northern Ireland/United Kingdom

Peter Anderson, originally from Belfast, studied at Central Saint Martins College, London (1989–92) and completed his postgraduate degree in fine art printmaking and photomedia (1992–94). He teaches on the BA graphic-design programme at Camberwell College of Arts. Anderson is a designer and a fine artist, whose typographic work spans the two disciplines seamlessly. Anderson has work in the collections of the Tate Gallery, the Victoria and Albert Museum, the Museum of Modern Art in New York and the Sackner Archive of Concrete and Visual Poetry in Miami. His larger-scale commissions have included interactive artworks for Paul Rankin's restaurant Cayenne in Belfast. In 1997, Peter Anderson and Ray Leek, who specialize in print-based electronic and fabrication design, co-founded Interfield. They have worked with corporations ranging from Moschino to the Deutsche Bahn and from the Hilton International to Adidas. Anderson has also created title sequences for TV documentaries, including For In Excess: The Death of Michael Hutchence, Raised from the Deep and The Cleverest Ape in the World.

In an exhibition of thirty prints titled 'Gravitaz', held at Hamilton's Gallery in London (1996), Anderson explored his interest in fusing together words and images to create 'something new'. Collaborating with stylist Claire Todd and fashion photographer Platon, Anderson attempted to create a 'new visual language for fashion information'[1]. The text is an integrated part of the fashion photograph – the typographic narrative emerges organically as extensions or 'roots' to the model's legs. In other experiments, text becomes image fusing together the two main elements of the fashion page – the credits and the garment. Anderson is concerned with information design, but adds an expressive quality to his approach often choosing to 'draw with words'. Such an attitude worked well for his brief from The Independent newspaper for 'Visions of the Future Millennium Special', for which he collected the name of every computer virus and drew a blood cell made up of the names.

While Anderson's early work integrated text and imagery, his collaboration with mainstream sport's company Puma allowed him to experiment with language formed by an absence of text. In this case, Anderson preferred to use the object itself – the training shoe – as a vehicle for communicating meaning. He set up a week-long event in the display windows of London's Lilywhites sports store (a recognizable space of consumer culture). At the

1

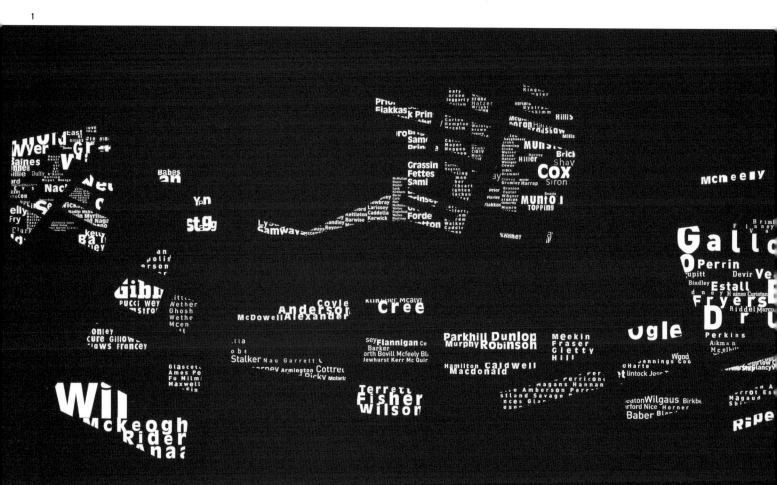

launch, Anderson handed out individual slices of trainers, each coded as industrial components. The attendee was charged with locating and matching other slices to reconstruct the whole trainer[3]. Additional narratives were also constructed about the shoe's inner workings and performance as well as a less overt commentary about the politics of consumer culture.

Artists' books have influenced the way Anderson considers storytelling in terms of content development and typographic representation. This is evident in the identity and interior of the Belfast restaurant Cayenne, which Anderson designed and launched in October 2000. He describes the project as achieving gesamtkunstwerk in its coherent structure and identity. From the typographic beer mats to the sculptural wall in the entrance way created out of entries from the Northern Ireland phonebook, everything is intended to invite interactivity between the space and its patrons. One of the more interesting aspects of the interior is the artwork created for the windows and called Enormous Bellies – nonsensical stories written by Anderson himself[4]. Despite his penchant for writing and his leaning toward the artistic, Anderson remains firmly in the role of designer.

Notes

1 Julia Thrift. 'Type, Fashion, Fusion.' Eye (vol. 6, no. 22, 1996): 46.
2 Jonathan Bell. 'Peter Anderson.' Graphics International (issue 98, September 2002): 16.
3 Ibid., 16–17.
4 Ibid., 16.

1 Mountain People is a lenticular artwork above the bar of the Cayenne Restaurant. It is created from a confusion of letters, numbers and symbols made from the coordinates of the cairns and high points of the mountains around Belfast and from various reference points, longitudes and latitudes of cities worldwide. **2** Anderson comments that he wants to 'challenge the notion of writing as well as presentation' [Peter Anderson, interview with the author, 2001, London]. By using the language of the everyday, he attempts to be more inclusive of his audience; for example, the Cayenne Restaurant combines typography, sound and lighting into a coherent environment and identity.

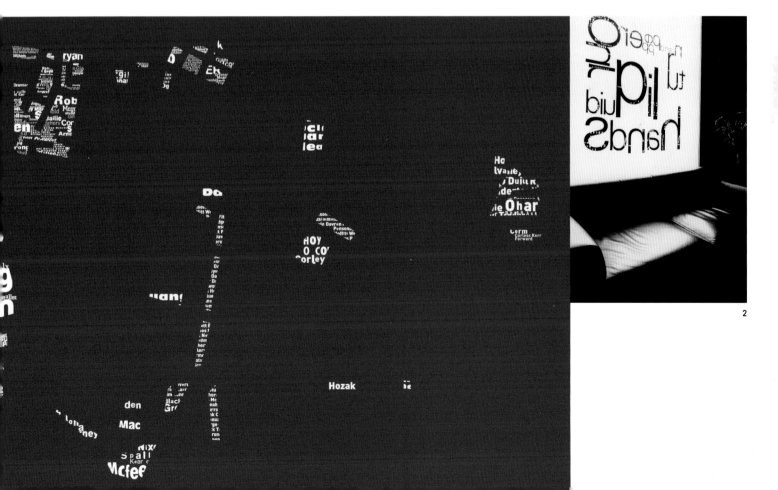

2

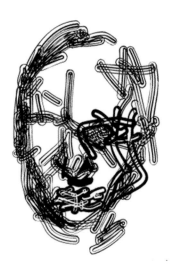

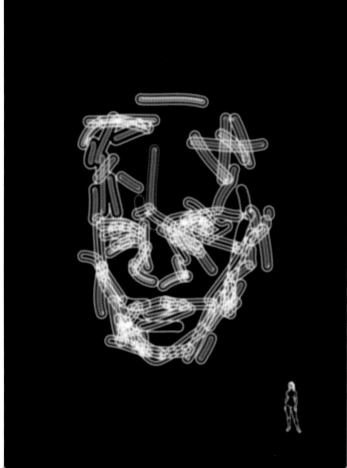

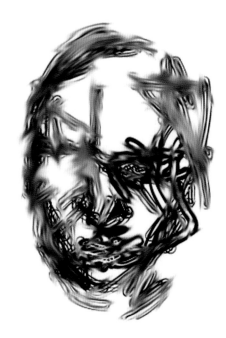

DAVID CROW

'For me experimental typography should challenge convention in some way. Perhaps it challenges the convention that there is a predetermined number of units in which to arrange language, or it seeks to create a language or dialect of its own. Perhaps its purpose is not to inform an audience but to entertain them through play. Digital font authoring has given us the opportunity to create new playful relationships with the keyboard. The synergy between the key you type and the mark it creates is open to the designer to explore new codes. What you see is no longer what you get. Can the visual language clustered around a particular set of ideas or issues be unitized to a set of signifiers that do not rely on the conventional alphabets? Is it possible to generate systems, which can be understood across the boundaries defined by political forces? Boundaries, which are marked by differences in written and spoken language. Boundaries, which might encourage the bearers of language to organize these differences into hierarchies, carrying with them the ill-founded attitudes of the bigot.'

Mega Family Fuse 16: Genetics (1996). Crow was asked to consider the genetic growth of typography and he took the view that this growth was cellular. He concentrated on typography as leisure and play, with the resulting font a game for two players in QuarkXPress. The keys hold details from two portraits, one male and one female, and the user is invited to type in upper- and lower case to create siblings.

b. 1962
Institution: Liverpool School of Art & Design
Country: United Kingdom

David Crow grew up in the Scottish border town of Galashiels. He received his BA (Hons) in design for communication media at Manchester Polytechnic (1985). At Manchester Metropolitan University he was awarded a Postgraduate Diploma (1994) and an MA in communication design (1995). After completing his undergraduate degree, Crow worked with Malcolm Garrett at Assorted Images, where he designed record sleeves for such bands as Duran Duran and promotional material and advertising for a variety of clients. In 1987, he was appointed senior designer for Island Records in London before going freelance and working with such clients as Sony (UK and USA), CBS, Virgin Records, RCA Records, City Limits magazine and the Royal Shakespeare Company. Crow has been involved in a number of exhibitions, including 'TypoJanchi' at Seoul Design Museum, South Korea (2001); 'Graphic Authorship, Artists in Print' at Camberwell College of Arts, London (2001); and 'Forest of Signs, Art in Motion' at the Santa Monica Museum of Art (2000). He is currently head of the graphic-arts department at Liverpool Art School, Liverpool John Moores University, UK (1995). While in college, he set up the experimental magazine Fresh, which took the form of a collection of writings, images and ephemera heat-sealed in a plastic bag. A second magazine followed in 1986 called Trouble, with the first issue appropriately named 'The First Sign of Trouble'. His spoof on a 'corporate identity manual' explored the notion of authority, parodying the instructions found in a real identity manual.

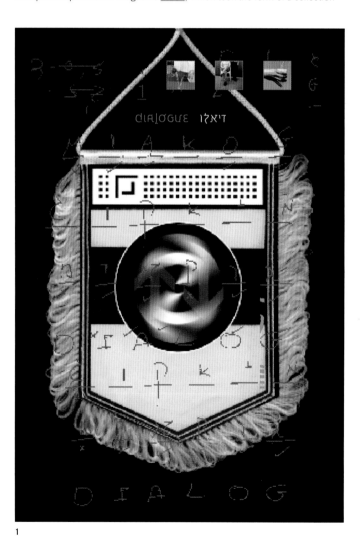

1

2

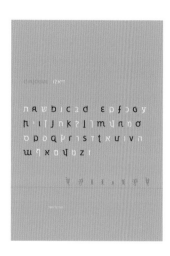

3

1–3 Dialogue (1999). A collaboration with Yaki Molcho in Tel Aviv responded to the discord of the dual language signing in Israel, wanting to show unity rather than difference. Most other attempts to do this merely turn Roman Chars upside down and back to front, thereby losing any sense of the Hebrew tradition. Molcho and Crow tried to find common elements between the two traditions to create a font that could carry two languages in apparent harmony. As Hebrew appears to hang and Roman sits on the baseline, they decided to centre the characters. However, the difficulty of the task means that the typeface remains unfinished.

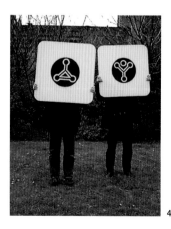

4

4 Crow contributed Creation 6 (1994) to Fuse 8 on the theme of religion. It mixes images of consumerism with religious icons and runes. Ancient runic marks are used for anything relating to people (man, woman, child) and found images represent events (festivals, the great flood). These can be customized to give more detail, such as 'old man'. Crow tried to make enough marks to describe the Genesis story in the style of Russian formalist Vladimir Propp (1895–1970).

Der Standard (2000) is based loosely upon Barthes' notion of the 'unknown' language. Crow wanted to see whether the emotive quality of an abstract mark could be read by an audience from another culture. A group of four people were asked to place stones on an A0 grid to give Crow the anchor points for a drawing; they then made choices from a customized toolbox to help him decide on the line quality. Each of the four participants chose an adjective to describe their marks. The resulting marks and the list of adjectives were published in Der Standard, the Austrian daily newspaper, and readers were asked to match the marks to the adjectives and to mail their answers to Crow, along with their own designs.

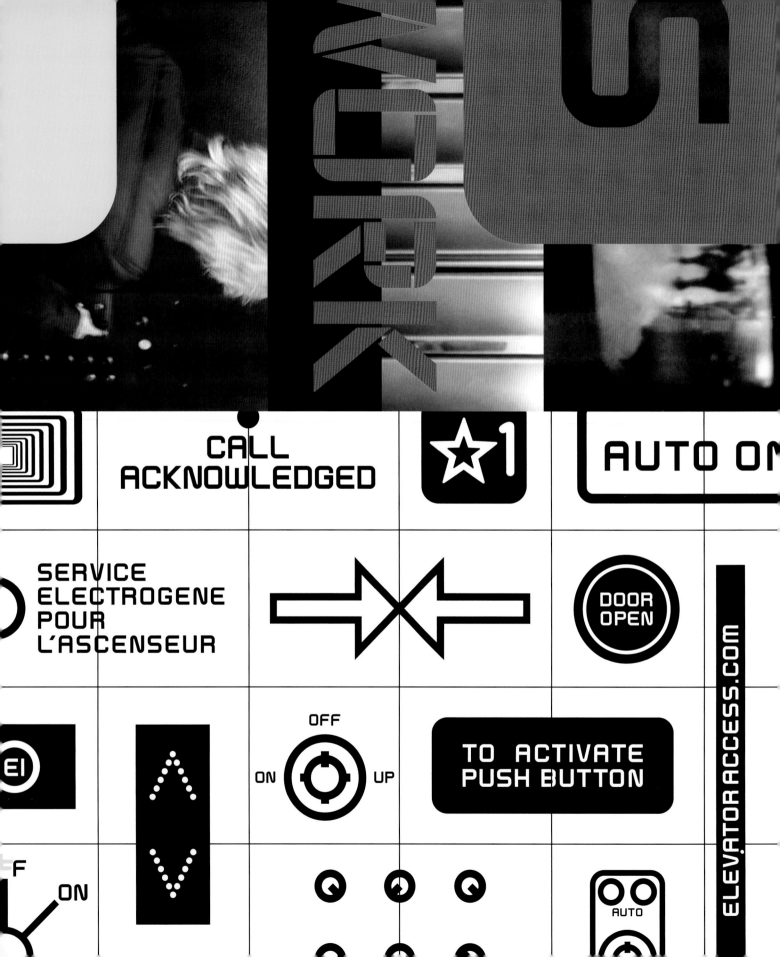

CALL
ACKNOWLEDGED

☆1

AUTO ON

SERVICE
ELECTROGENE
POUR
L'ASCENSEUR

DOOR
OPEN

EI

OFF

ON ⊕ UP

TO ACTIVATE
PUSH BUTTON

F

ON

AUTO

ELEVATORACCESS.COM

ELEVATOR

Powell: We think of the evolution of typography as a continuum, or process. In general, we think of typography as a pattern of information, where you see the repetition of similar forms and ideas.

Salonen: And experimental typography is a random event – it's a departure or deviation from the everyday pattern of things. Eventually, the deviation may or may not be assimilated by the culture. If it's assimilated, the typography isn't experimental any more – it's part of the norm, and the norm evolves into a new pattern.

Powell: What causes the deviation in the first place is triggered by lots of things – cultural events, ideas, technologies and so on.

Salonen: When the system arrives at a new pattern, it starts a new cycle with the potential for future departures. We see this repeating cycle within the continuum of typographic evolution.

Summer Powell
b. 1972
Liisa Salonen
b. 1949
Studio: Elevator
Country: United States of America

Summer Powell completed her BFA in graphic design at Oregon State University (1994) and Liisa Salonen completed a Bachelor of Science in design at the University of Michigan (1971). Both continued with graduate studies at Cranbrook Academy of Art (1997). While at Cranbrook, they were art directors on projects at Words + Pictures for Business + Culture with P. Scott Makela and Laurie Haycock-Makela. Powell art-directed Nike projects at Wieden & Kennedy Europe in Amsterdam in 1997 before moving to New York, where she was design director of 'Droog.com' (1999–2000). She directed concept, design and monthly features for the e-commerce site, which marketed clothing and content to teenage males. She joined Icon MediaLab in 2000, where she co-directed the design of Motorola's online visual design system, and was art director for the Motorola style guide for all their web design over a five-year period.

Liisa Salonen is adjunct professor of interactive, interface and motion design at the College for Creative Studies in Detroit. Major projects have included American Photography (vol. 13); and Digital Campfires, a CD-Rom collaboration between Cranbrook Academy of Art and the Media Lab at Massachusetts Institute of Technology. She co-instructed a workshop at the École cantonale d'art, Lausanne, Switzerland with Laurie Haycock-Makela. Salonen was also co-curator of 'Exhibit A: Evidence of Pleasure', an international design exhibition that explored the impact of new technologies on design communication for digital and real environments (2001).

Elevator was founded in 1999 by Powell and Salonen. They design in a range of applications from print to new media, and have directed projects for the entertainment, culture, fashion, teenage, architecture, technology, pharmaceutical and sports markets. Recent projects include the launch of 'www.elevatoraccess.com', an extranet for SmithKline Beecham, TNN logo development and Showtime logo development for FutureBrand.

Salonen and Powell explore the differences and similarities between the natural and the artificial, the human and the technological. Underpinning such an approach is a set of theoretical constructs, drawn from semiotics

DEPARTURES

ARRIVALS

LEVEL 1 / DEPARTURE (DEPART): going away; a deviation; a fresh course of action. Webster's Dictionary of the English Language, 257.

LEVEL 2 / Soldiers were taking hair samples and slotting people's passports. Chia assumed that was to prove you really were who you said you were, because your DNA was there in your passport, converted into a kind of bar code. William Gibson: Idoru, 18.

LEVEL 3 / FONT: CODE BLUE
a b c d e
A B C D E

LEVEL 4 / Information is produced by a complex dance between predictability and unpredictability, repetition and variation. N. Katherine Hayles: Virtual Bodies and Flickering Signifiers.

LEVEL 5 / FONT: TECHTYPES

LEVEL 6 / ...simulation threatens the difference between "true" and "false," between "real" and "imaginary." Jean Baudrillard: Simulations, 5.

and popular culture; for example, from Jean Baudrillard's writings about the differences between the real and the imaginary, and from the ideas surrounding the relationship between repetition and variation in N. Katherine Hayle's book Virtual Bodies and Flickering Signifiers. These types of oppositions are readily identifiable in the experimental work produced by Salonen and Powell. The font Techtypes combines modular patterns and random language, resulting in a semi-legible typeface that is extended into a spatial environment using projection and recorded sound. The resulting atmospheric quality is unique and effective – something that is not lost when the work is transferred to the web or to interactive design projects.

'Diagram' (2002) demonstrates the process by which Elevator operates. Playing on the idea of the 'lift', each level opens the door to a different project and learning experience. It also shows the way in which their experimental typefaces have been applied to commercial projects.

DEPARTURES

ARRIVALS

LEVEL 12 / WWW.ELEVATORACCESS.COM
AUTO / RESET / ON-OFF-UP / ON/MARCHE / OPEN / TO ACTIVATE PUSH BUTTON / PRESS TO TALK / PUSH/RUN / CALL ACKNOWLEDGED / SHAFTWAY /

LEVEL 11 / FONT: CAPACITY 1000, 2000, 3000, 4000, 5000, 6000, 7000
DOORS OPEN
PRESS TO TALK
AUTO ON

LEVEL 10 / If you want the chiropractor, 22nd floor – take a left and two rights; law firm, go to 15th, the oak paneled doors on the left. Dim sum is on second by the stationers. Dog grooming and apartments 14 through 22 are on the 18th floor. Copy shop is on the first floor with the tailor and falafel stand. If you want the stock brokers, go to 7th and ring the bell.

LEVEL 9 / FONT: COMPARTMENT
ABCDE ABCDE ABCDE

LEVEL 8 / CONTINUUM

BASEMENT	TO	PENTHOUSE
LOW	TO	HIGH
EARTH	TO	ETHER
STREET	TO	STRATUM
NATURAL	TO	MECHANICAL
HUMAN	TO	TECHNOLOGICAL
MEMORY	TO	COMPUTER
PATTERN	TO	RANDOM
CHEESE	TO	VELVEETA

LEVEL 7 / CONTINUUM: something capable of being divided infinitely, as is assumed of space and time; a continuous series of identical components. Webster's Dictionary of the English Language, 211.

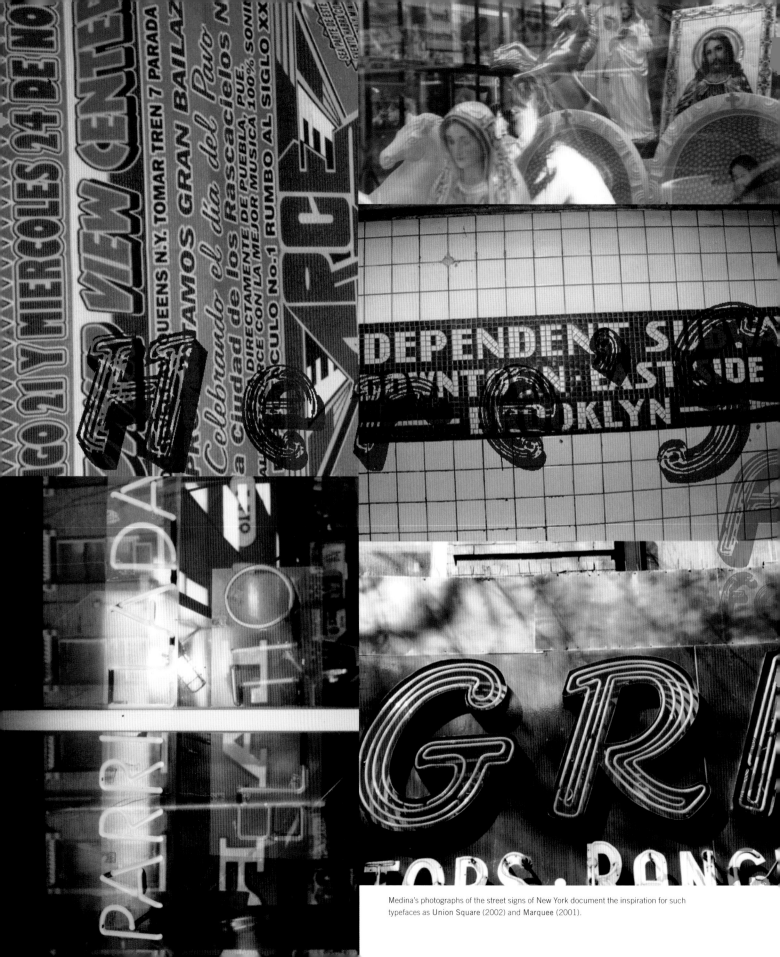

Medina's photographs of the street signs of New York document the inspiration for such typefaces as Union Square (2002) and Marquee (2001).

PABLO A. MEDINA

'I recently saw Malcolm McLaren speak and share an anecdote that was told to him years ago by his art-school painting teacher. "All great artists have been failures. Not miserable failures, but tremendous, brilliant failures." Experimental typography, in a sense, is a conscious failure with the hope that something beautiful and new will be born.'

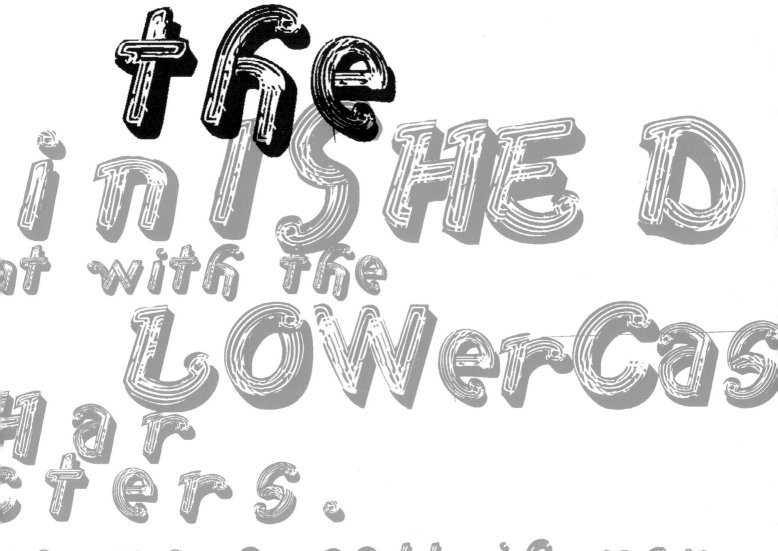

Developmental sketch for the typeface 1st Avenue (1999).

b. 1970
Studio: Cubanica
Country: United States of America

Medina received a BFA in painting and drawing and an MS in communication design from the Pratt Institute in New York. He has taught at the Maryland Institute College of Art and is currently a professor of design and typography at Parsons School of Design in New York. Cubanica is his experimental type foundry and art and design studio dedicated to the exploration and interpretation of culture. His work has been featured in several exhibitions including the Art Directors Club 'Young Guns III' biennial in New York (2001) and the Cooper-Hewitt, National Design Museum's 'National Design Triennial' (2000). A number of magazines – How, IDEA, Extreme Fonts and Communication Arts online – have analyzed his work. In addition, his photographs have been published in Upper & Lowercase magazine. Clients include ESPN The Magazine, The National Hockey League (USA), Teen People magazine, Ogilvy & Mather, Persea Books, The Art Directors Club and The Museum of Modern Art, New York.

Pablo A. Medina draws upon the language of the everyday, but more specifically responds to the cultural codes of his Cuban heritage. His design company Cubanica, translates as 'that which is derived from Cuba', and Medina's work is inspired by Cuba's reinterpretation of European Modernism; its eclecticism and warmth. As a graduate student at the Pratt Institute, Medina's thesis project Outside Typography (1996) dealt with the 'style of design and typography that takes influences and inspirations from

2

1

1–7 Medina wrote the poetry and designed the typeface for these visual poetry posters. The typefaces used are: **1** Cuba (1996) **2** Vitrina (1996) **3** Sombra (1997) **4** 1st Avenue (1999) **6** Marquee (2001) **7** North Bergen (1996). **5** Developmental sketches for the posters.

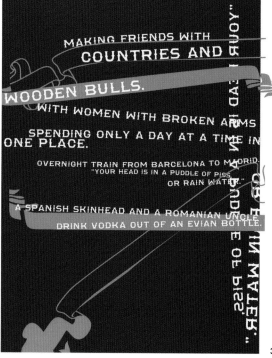

3

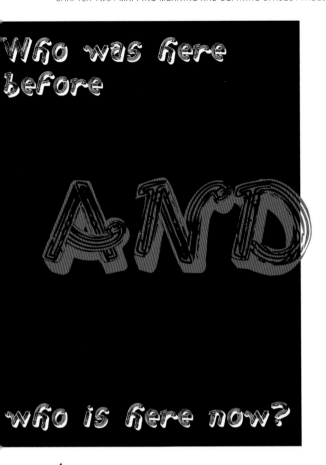

Who was here
before

AND

who is here now?

4

VISITOR
FLOR CUBA

5

At AGE 9, I SAW "Kill or be Killed" on

42nd Street.
Ten Years Later,
At That Same Theater, ALEXIS ROSELLA wrote "Almost full

moon....A LUXURIOUS voice on the
ANSWERING MACHINE."

6

Corner magazine stores spell out

A-M
-E-R-
I-C-A.

Typography naively slips into sidewalks.

7

low design or a non-design'. This led to the creation of his first three typefaces: North Bergen, Cuba and Vitrina, which explore and re-imagine the cultural environment of North Bergen, New Jersey. The letterforms for Cuba (1996) were appropriated from a storefront sign, 'La Flor de Cuba', while Vitrina (1996) is the Spanish for 'storefront window'. The typography clearly references the traditional forms of urban sign painting, but goes on to question cultural and social values and how meanings migrate from one context to another. This idea continues in his more recent work. Taking the everyday as its visual dialect, Union Square (2002) was created from the pattern of mosaics found in New York's subway signage system. Such recontextualization of the popular graphic vernacular shifts its meaning from being utilitarian to something more focused.

While some have been critical of vernacular typography arguing that it is nostalgic and that it robs the past 'of its authenticity and historical context (or specificity)'[1], it could be that Medina uses his work to highlight the politics of the everyday. In much of his work, the letterforms connote cultural and social values, creating a tension between the codes of cultural communities and the commercial world. New York is the immigrant city extraordinaire, and Medina's work is part of a growing new graphic vocabulary that celebrates the street and the politics of cultural representation.

Notes

1 Jeffery Keedy. 'I like the Vernacular – Not.' Published in Barbara Glauber, ed. Lift and Separate: Graphic Design and the Quote Vernacular Unquote (New York: The Herb Lubalin Study Center of Design and Typography, Cooper Union for the Advancement of Science and Art and Princeton University Press, 1993).

Photographs and developmental sketches for Union Square (2002), Cuba (1996) and Vitrina (1996).

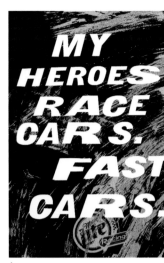

1 2 3 4

Material for the Miller Lite racing campaign (November 2000). **1–2** Miller Lite racing advertisements. **3–4** Miller Lite racing posters.

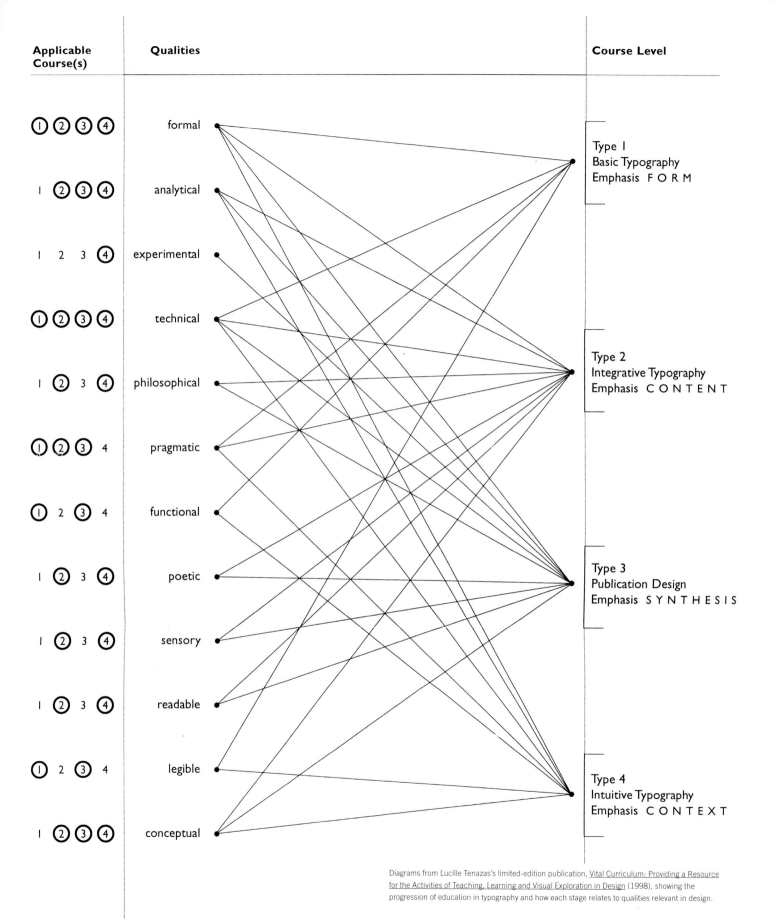

Applicable Course(s)

Qualities

Course Level

① ② ③ ④ formal

1 ② ③ ④ analytical

1 2 3 ④ experimental

① ② ③ ④ technical

1 ② 3 ④ philosophical

① ② ③ 4 pragmatic

① 2 ③ 4 functional

1 ② 3 ④ poetic

1 ② 3 ④ sensory

1 ② 3 ④ readable

① 2 ③ 4 legible

1 ② ③ ④ conceptual

Type 1
Basic Typography
Emphasis F O R M

Type 2
Integrative Typography
Emphasis C O N T E N T

Type 3
Publication Design
Emphasis S Y N T H E S I S

Type 4
Intuitive Typography
Emphasis C O N T E X T

Diagrams from Lucille Tenazas's limited-edition publication, <u>Vital Curriculum: Providing a Resource for the Activities of Teaching, Learning and Visual Exploration in Design</u> (1998), showing the progression of education in typography and how each stage relates to qualities relevant in design.

LUCILLE TENAZAS

'In 1998, I produced <u>Vital Curriculum</u>, a small publication made in an effort to encapsulate the ideas, philosophy and curriculum I've developed over the last fifteen years teaching at California College of Arts and Crafts. I called it <u>Vital Curriculum</u> as it explores ideas of authorship, process and the relevance of one's personal experience of empathy as a dynamic condition in the designer's assessment of their role in culture.

<u>Vital Curriculum</u> outlines projects and challenging questions to promote new investigation, providing teachers and students with a mechanism to reconsider and transform their thinking and form-giving practice.

In response to the book's emphasis on the designer's necessary development of empathy and personal voice, Lorraine Wild wrote, "The reason I think <u>Vital Curriculum</u> is so important is that Tenazas explicitly describes a teaching process that deals with the issues of 'personal voice' or authorship within the discipline of graphic design. Tenazas has gone far in articulating a methodology that allows the development of the personal voice in design practice, but which still insists upon communication with an audience as a goal."'

ANATOMY OF TYPOGRAPHY

Letterform Analysis
Classification of Typefaces
Prominent Type Families
Typographic Syntax
 Scale
 Value
 Contrast
 Figure-Ground

 3 4

b.1953
Studio: Tenazas Design
Country: Philippines/United States of America

Born and raised in Manila, the Philippines, Lucille Tenazas came to the United States in 1979 to enrol on the graphic-design programme at California College of Arts and Crafts (CCAC). She went on to complete an MFA at Cranbrook Academy of Art and then moved to New York City, where she worked as a designer for Harmon Kemp, Inc. At Cranbrook, she was introduced to Katherine McCoy's discursive approach to typography not so much as Postmodernist play but as discourse. Tenazas's early student experiments were more interpretive; for example, in the 'Barry Drugs' project (1981), Tenazas took one commercial main street and recorded the street signs to create a layered collage of photographs and type. Tenazas's approach presented more of an 'expressive formalism' than the seemingly complex narratives offered by colleagues at the time. Yet it is in her grasp of the more formal principles of design – hierarchy, balance, colour – and her acute understanding of language that the project revealed 'an empathy for the visual language of European Modernism alongside West Coast vitality, colour and form'[1].

Returning to the West Coast in 1985, she set up her own multidisciplinary communications-design firm, Tenazas Design, and her clients include the San Francisco Museum of Modern Art, Metro Furniture, Champion International Corporation, Chronicle Books, the National Endowment for the Arts, San Francisco International Airport and Rizzoli International Publications. As Tenazas's career developed she became actively involved in raising the profile of graphic design internationally. She was national president of the American Institute of Graphic Arts (AIGA, 1996–98) and remains an active AIGA member at national and local levels. She has also been on numerous juries and panels. In 1988, Tenazas was elected a member of the prestigious Alliance Graphique Internationale (AGI). She has been the recipient of many design awards and was honoured in I.D. magazine's I.D.40 (1995). She has had retrospectives at the San Francisco Museum of Modern Art (1996) and the Ayala Museum in the Philippines (1998).

Tenazas continues to develop her interest in the structure and construction of language. English is her second language, so she is acutely aware of the subtle nuances of meaning presented through intonation, emphasis and phrasing. Through such an understanding, she is able to explore grammar as a linguistic and a visual language. In a set of postcards to announce the

Postcards for the 'AIA/SFMOMA Annual Architectural Lecture Series' (1997–2000). Tenazas reveals the internal skeleton of the building by using the shape of the floor plan and also the shape of the text itself. The result is a spatial layering of text and meaning.

'AIA/SFMOMA Annual Architectural Lecture Series' (1997–2000), she created a coherent identity that was visually sensitive to the architectural concepts and aesthetics of each guest speaker's work. The postcards also reflect elements of her earlier work for the Center for Critical Architecture, in which the minimalist photographs of Richard Barnes were juxtaposed with Tenazas's typographic wordplay. In both cases, architectural and typographic space was defined by the careful positioning of words on a formal grid and was further enhanced by the appropriate use of colour, scale and line. The juxtaposition of image and text 'challenges our perceptions of depth'. Typographically, the work is understated and Tenazas chooses to reflect the structural integrity offered by the squares, circles and triangles that underpin each building. On a second reading, another layer of information is revealed: text operates simultaneously as a visual element for composition and a symbolic form. Tenazas writes that generally her intent is to 'evoke meaning through mental associations that are not immediate, but are arrived at over time and are more profound that the initial reading: a verbal wordplay that is open to interpretation'[2].

Tenazas has also contributed to the development of design through teaching. She is chair of the MFA programme in design at the California College of Arts and Crafts, has been a visiting faculty member at the California Institute of the Arts and Rhode Island School of Design and is also a visiting professor at Kingston University, London. Throughout her commercial practice, Tenazas has been able to successfully reconcile the relationship between self-expression and the more conventional problem-solving methods. The way she teaches is no different, presenting a curriculum that fosters an understanding of history, typography, communication theories, concepts and language dynamics and also explores the ways in which these areas are synthesized into 'commercial' or final applications. Tenazas is committed to the idea that students can only take on the problems a client may pose by understanding more fully their own identity and establishing their own voice.

Notes
1 Teal Triggs. 'Layers of Language.' Eye (no. 17, 1995): 65.
2 Lucille Tenazas, 'www.TenazasDesign.com', 2002.

F

N

✠

S

A B C D E F G H I J K L ᛖ

N ⊕ P Q R S Exocet (1991) is a very popular typeface, especially with font pirates, illegal Internet sites and computer-game manufacturers. The face is based on drawings made from early Greek and Roman stone carvings.

JONATHAN BARNBROOK

'Typographic problems are so wide-ranging that it is almost impossible to define one idea of "experimental". An experiment is a result of producing something innovative within defined parameters and those parameters can differ greatly. Many people confuse experimental with "decorative playing", which is not really experimental as it follows a process that has been around since the Futurists and Constructivists. From being an extreme expression of a philosophy, it is closely linked today with ideas of "fashion" in typography.

True experimentation comes not only from "playing", although this can produce equally valid experiments, but by being aware of the communication problems and solving them in a creative way. This sounds quite a pragmatic answer but in practice it doesn't have to be. Solving a communication problem can consist of directing people correctly in an airport, designing a beautiful record cover or inventing a totally new language and alphabet. The problem with much uninspiring work is that people have defined the problem in such a boring way that they are almost inevitably going to come up with something average as a solution. In addition to asking ourselves "are we communicating effectively?" we should be asking "how am I adding to culture?", "how is this a process for self-development?", "Am I commenting on something I feel strongly about?", "Is there a possibility to change something through this piece of work?", "Am I creating something original?". These questions may sound naive in everyday practice, but they are not. We have just forgotten them over the past few years and are drowning in a society increasingly turning away from ideological and social meaning in the visual world in pursuit of consumerism. It is possible with almost every piece of work to add a thought-provoking or experimental edge to it in some way.

Having said all of this it is also important to remember the "fuck it" philosophy of experimentation. That at any point, at any time you can read as much history or techniques as you like but you should also be able to say "fuck that, fuck the whole lot of it" and produce work that you think is exciting and in the spirit of the time.'

b. 1966
Studio: Virus Foundry
Country: United Kingdom

Jonathan Barnbrook graduated with a BA (Hons) from Central Saint Martins College (1985–88) and received his MA from the Royal College of Art in London (1990). He then began freelancing as a designer and typographer and moved into TV advertising when he joined Tony Kaye Films as a director (1992). In 1996, Barnbrook launched his own type foundry, Virus, named for its subversive potential and multiple readings (something that is so 'small it can break down a huge organization').

Clients include the Institute of Contemporary Art (ICA) in London, the Los Angeles Museum of Modern Art, Booth-Clibborn Editions, the Barbican Centre in London, Volkswagen, Toyota and BBC Radio Scotland. In Japan, Barnbrook was commissioned by the Beams retail fashion chain to produce his 'Virus Collection' – T-shirts, textiles, postcards, posters, a watch and a reworked version of the font Bastard (1997) into Katakana (2000). He has also worked on kohkoku, the Japanese magazine, published by the Hakuhodo advertising agency, whose square format was the inspiration behind the typeface Coma (2002). He has collaborated with a number of cultural figures in the UK, including the artist Damien Hirst to produce the book I Want to Spend the Rest of My Life Everywhere, with Everyone, One to One, Always, Forever, Now. (Booth-Clibborn Editions, 1997). Barnbrook also worked with Jason Beard to create promotional material and catalogues for his exhibitions. More recently he worked as guest art director with editor Kalle Lasn on Adbusters magazine for the 'Design Anarchy' issue (2001). Barnbrook has written about his work, has lectured internationally and has received numerous awards, including the Judges' Special Prize (1995–96) for non-members from the Tokyo Type Directors Club.

His interest in wordplay is evident in the design and names of his typefaces, for example, Mason (1992), which attracted international press attention in its renaming from Manson (after the mass murderer Charles Manson). His other typefaces conjure up similar associations with ironic takes on contemporary culture: Exocet (1991), Prozac (1997), Patriot (1997) and Apocalypso (1997). His most recent release Melancholia (2002) is named for its poetic reference to the 'mental disease to do with depression'. Barnbrook's work is politically charged. He uses visual metaphors and language as tools for challenging readers' expectations, values and cultural understanding.

1

2

3

4

5

1–5 Book design for Illustration Now (1992), an annual of the best in European illustration, which used as its design theme the way Europe markets itself. By adopting ironic visual references to consumerism, Barnbrook provides a critical commentary on European involvement in wars and the European obsession with defending countries that have lots of oil. Such an approach fuelled the debate on the designer's role as mediator of information, raising the question: to what extent is personal commentary embedded in client-based work? Exocet (1991) was designed specifically for the book.

6

7

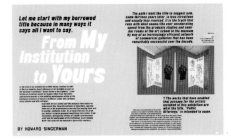

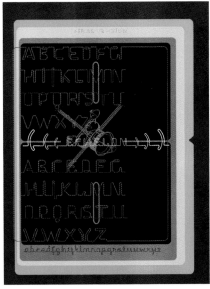

9

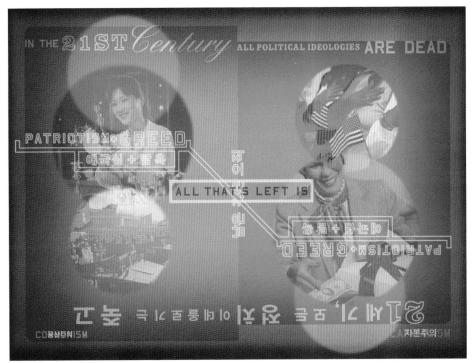

8

10

6–8 Cover and pages from the catalogue Public Offerings (2001) on an exhibition of art from the 1990s at The Museum of Contemporary Art in Los Angeles. The book has two 'fronts', with the work in the exhibition beginning at one end and essays about the exhibition starting at the other. 9–10 Expletive (2002) is a modular font based on a circular form: the characters can go above and below the baseline. As the name suggests, the possibility of violence in language is explored.

12

11

13

11–13 The 'North Korea' project (2001) was designed for a South Korean magazine, Monthly Design (June 2001), about issues surrounding the Stalinist dictatorship in North Korea. The work criticizes the regime and discusses ideas of freedom and the power individuals have over dictatorships.

JENNY WILSON & STUDENTS

'Technology has provided a freedom that creates new challenges for teachers and learners in the area of typography and graphic design. "No limits", is often interpreted by students as no rules to be aware of and no standards required. The result can be the anarchic chaos of personal preference with no concern for the end user. Nevertheless, the opportunities for typographic experimentation and typeface design are boundless. Typefaces are designed and sold by independent producers on the Internet. Anything is possible. As a consequence of the proliferation of new, idiosyncratic typefaces, students of visual communication must become highly critical and discerning in their selection and application of type. This requires a level of understanding that must transcend momentary fashions in order to recognize what has value.

This project gives our second-year students the opportunity to design a new typeface and font. The project ensures that each student discovers the intricacies of individual letterforms and the shared characteristics that give each letter identity within the system of an extended font. Students are encouraged to look beyond the printed page and the mere manipulation of existing fonts for their ideas.'

Sophie Cape's title sequence for Masterpiece (2001) was a live project for Special Broadcasting Services (SBS), a national Australian TV station, and was completed for her final major project on the visual communication programme. The brief was to design a title sequence to profile people within the 'arts' (architecture, art, dance, literature and music) who were considered masters in their field, either past or present. SBS asked for a sequence that was 'graphically appealing and memorable, capturing the audience's attention in such a way that they felt the need to watch it again to see what they had previously missed'. Cape's solution was to present something 'aesthetically rich and tactile', which she created through 'endless experimentation' in mark making. The process itself and the resulting sketches were incorporated (including mistakes) into the final sequence and adapted to film while still maintaining a sense of 'temporality and spontaneity'. Most of the initial work was completed using conventional techniques and not the computer. Typography anchored the mark making and provided consistency. The typeface Cropped, designed by Todd Brei, is an adaptation of Times New Roman and captures the classical feel but adds a modern twist.

Tutors: Jenny Toynbee-Wilson
b. 1942
Louise McWhinnie
b. 1963
Institution: Faculty of Design, Architecture and Building, University
of Technology, Sydney
Country: Australia

Jenny Toynbee-Wilson and Louise McWhinnie teach typography to
undergraduate students on the visual communication programme. Classes
introduce students to the intricacies of typeface design and also attempt 'to
develop students' ability to discriminate and select type based on an
awareness of typeface detailing and value in application'.

The project to design a typeface and font provided an opportunity for students
to study the construction of letterforms and also to explore content through
personal interests, work, cultural backgrounds, people, icons, handwriting
and experimental mark making. Clare Stephens designed Got'cha based
upon the stereotypical view of the bothersome Australian fly; Luisa Cooper's
Cast takes the well-known site of Sydney Harbour Bridge as the basis for its
structural development, as does Ian Chong with Powerhaus; and Hannah
Chipkin continues the theme of the local in Sub-urban 2011. Maobi
designed by Irene Chen and Taglish (a combination of English and Tagalog)

by Arnel Javier Rodriguez examine not only language and its cultural roots but
also the calligraphic form. Origami is explored as the process of constructing
a form and as a cultural signifier in Teresa Leung's Fold Here. The more
mundane objects found in daily life are represented by the letterforms of
Marian Lowe in Silverware (based on restaurant cutlery) and by Leora
Krowitz's Off With Her Head (based on a deck of playing cards). As Toynbee-
Wilson and McWhinnie write, 'Through the process, students become acutely
aware of such typographic elements as consistency of style, posture and
proportions in addition to issues of legibility and readability. Detailing each
letter focuses attention on stroke width, terminals and counters and hand-
drafted letters are scanned and refined on the computer before being
vectorized.'[1]

Note
1 Jenny Toynbee-Wilson and Louise McWhinnie. 'Designing a Typeface and Font', notes to
author, 2002.

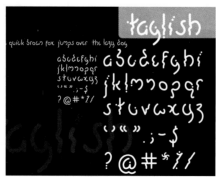

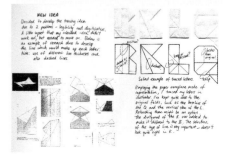

1

2

3

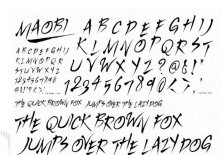

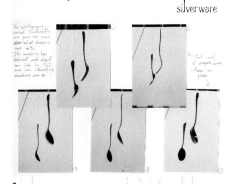

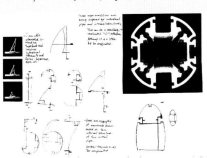

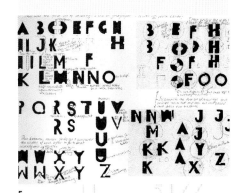

1 Clare Stephens Got'cha (fly screen)
2 Arnel Javier Rodriguez Taglish (English and Tagalog)
3 Teresa Leung Fold Here (origami)
4 Irene Chen Maobi
5 Luisa Cooper Cast (Sydney Harbour Bridge)
6 Marian Lowe Silverware (restaurant cutlery)
7 Leora Krowitz Off With Her Head (playing cards)
8 Hannah Chipkin Sub-urban 2011 (Sydney street maps)
9 Ian Chong Powerhaus

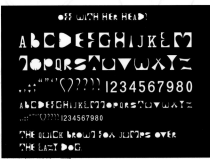

quick brown

W LAZY Q T

quick brown dog

jumped over th

dog laz dog

The Cholla Typeface Family (1998–99) was named after a species of cactus.

SIBYLLE HAGMANN

'All expressive typeset matter may be considered experimental. Such type wants to be looked at; it has its own voice and plays a revealing role on the typographic stage. In contrast, typeset matter whose letters follow the first and foremost goal of functioning as semantic signifiers, as quiet messengers of language and meaning cannot be experimental. When these latter typographic appearances are spoken out loud, they form an even and steady stream of sound, comparable to a news presentation on TV. As we know, these presentations aim at making sense and informing, whereas experimental typography may lack coherence, words may scream or look angry. Their cells, the individual letters, may look unhealthy and deformed. The diagrammatic sound line for such a text would fluctuate up and down, have gaps and be otherwise rhythmically uneven or wavy. In the real design world, this kind of typography has unfortunately a very low survival rate. It is usually an unwanted guest, occasionally welcomed when it sells, but only to be pushed away later.

Today, the successors of the last experimental typography wave of the '80s and '90s have mostly calmed down. As much as I wished and hoped that my clients would ask me to experiment with their text, it seldom – if ever – happens. What remains is the freedom to experiment with the core ingredient of text and typography, namely the definition and design of each individual letterform. Text is like a mass of people dressing and behaving in a certain way. Personally, I am interested in the design of the coats that letter skeletons carry. In this sense, my typographic experiments are happening in the micro dimension. Just as in the macro dimension, it is only by questioning and selectively rejecting established rules, standards and dogmas that such experiments can continue.'

b. 1965
Studio: Kontour
Country: Switzerland/United States of America

Born in Zurich, Sibylle Hagmann completed her foundation year (1984) and a BFA in graphic design (1989) at the Basel School of Design. She went on to receive an MFA from the California Institute of the Arts (CalArts) in 1996. Hagmann is founder of the design studio Kontour in Houston, Texas (2000), having worked previously as a senior designer at Zintzmeyer & Lux AG (1993–94) in Zurich and as an art director and senior designer at the University of Southern California, where she was responsible for the graphic identity for the USC School of Architecture (1996–2000). She has lectured in the United States and Switzerland and has taught at the University of Southern California and the Art Center College of Design, Pasadena. She currently teaches graphic communications in the department of art at the University of Houston.

Hagmann's work has been shown in a number of design books and in Emigre magazine (no. 50) and I.D. magazine in which she received an honourable mention for the design of the Art Center College of Design's 1999/2000 admissions catalogue and for the employment of the typeface Cholla. She has also received an award from Bukva:raz!, the first international type design competition organized by ATypI, and certificates of excellence in type design from the Type Directors Club, New York (1997, 2000).

Hagmann credits her interest in typography to Adrian Frutiger and Hans Eduard Meyer (Syntax, 1968). The typeface Cholla was begun while Hagmann was still in graduate school and combines the CalArts' craft heritage with Hagmann's own Swiss design sensibilities. Cholla is a unique species of cactus and is defined as any large, upright cylindrical-stemmed member of the genus Opuntia. It is indigenous to the sandy soils across large expanses of the United States, but has flourished when introduced to other parts of the world[1]. Hagmann encountered the cactus on a journey through the Mojave Desert. The font was eventually completed for a commission by colleague Denise Gonzales Crisp for the Art Center College of Design, Pasadena, and released in 1999. Crisp recalls, 'I had an affinity for it, and I had faith in Sibylle, and that we could develop something right for the school.'[2] Hagmann and Crisp worked collaboratively to develop twelve weights for the Cholla family, ranging from Cholla Sans Thin to Cholla Slab Bold. All weights are unified by the tapered curve, perhaps reflecting the jointed stems and conical leaves on the young cactus stems. Cholla is also reminiscent of a

Exploratory sketches for Cholla.

recognizable CalArts approach, which is seen in earlier experimental typefaces by Conor Mangat (Platelet, 1993) and Barry Deck (Template Gothic, 1990). Each typeface hints at hybridity and formalized juxtapositions; Cholla, for example, connotes not only aspects of human forms but also of machine technology. It also has similarities to early classical modernism and the more recent West Coast design vernacular[3].

Notes

1 Del Weniger. <u>Cacti of Texas and Neighboring States</u> (Austin: University of Texas Press, 1984): 230–31.
2 Deborah Griffin. 'Lemon Chiffon Cadillac: An Interview with Sibylle Hagmann and Denise Gonzales Crisp.' <u>Emigre</u> (no. 50, 1999).
3 Ken Coupland. 'West Coast Latitudes.' <u>Eye</u> (no. 31, 1999): 26–37.

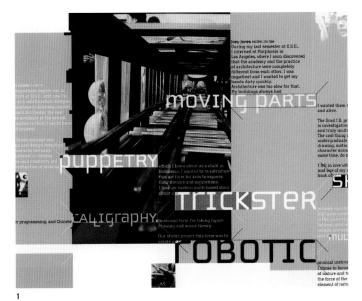

1–2 Recruitment pieces for the Art Center College of Design graduate programme. 3 Invitation to the 'Ninth Annual Living Surfaces Conference' at the American Center for Design, Chicago (2001).
4 Art Center College of Design admissions catalogue (1999/2000).

Automne

Été

Été tardif

Printemps

Hiver

Poumon
Peine

Cœur
Joie

Rate
Anxiété

Foie
Colère

Reins
Peur

Sécheresse

Feu

Humidité

Vent

Froid

Le corps, ses émotions
et son environnement
climatique

médecines chinoises (2001) was created for the Grande Halle de la Villette in Paris to show the
'hierarchy of organs and their relationships with feelings and weather'.

PIERRE
DI SCIULLO

'If I happen to use the words "experimental typography" in a conversation, it doesn't necessarily mean much. To be honest, I hardly consider typography to be a discipline as such. Some graphic designers are so fond of working on the text form that it becomes their main activity – they are called typographers. Among them I can still distinguish between experimenters and imitators, inventors and traditionalists. Personally, the relationship between text and image excites me, and this is already a question of vision or reading in the broad sense. My work quickly made me aware of the fact that the relationship between text and image exists in the visible text itself, casting the text towards the reader. It is the alchemy between language forms and the forms of language. So, in the long run, what I am interested in is reading, reading with all its different aspects and implications.'

b. 1961
Studio: **Pierre di Sciullo**
Country: **France**

Recognized internationally for his research and experimental work, Pierre di Sciullo explores the inherent relationship between language and typography. Since 1985, he has been working as a freelance graphic designer. In 1983, he founded the publication Qui? Résiste?, developing the magazine as a showcase for his writing, graphics and experimental typeface design. While the magazine has appeared irregularly over the years (ten issues), it has established itself as an important typographic forum. Much of di Sciullo's work is research oriented and he has received numerous grants and commissions to support his explorations.

Di Sciullo lectures and teaches internationally and his work has been featured in a number of publications, including Emigre (no. 18, 1991) and Eye (no. 23, 1996). He is a contributor to Fuse, in which he explored phonetics in the typefaces **Spell Me** (issue 17, 1994) and **Scratched Out** (issue 5, 1990). Among his other experimental typeface designs are **Sintétik** (1992) and **Quantange** (1988), both phonetic fonts applied to the French language; **Gararond** (1995), a homage to the historic typeface **Garamond**; **Basnoda**

(1993), which allows the user to write vertical palindromic sentences; and perhaps his best-known typeface **Minimum** (1993–95), a geometric-inspired font. His work has been exhibited at the Jan van Eyck Academie in Maastricht (1995) and in 'Approche' (1996), a group exhibition of French designers. Clients include the scientific adventure park in Mons (Belgium), the French Ministry of Culture, the French Ministry of Foreign Affairs, Reporters Without Borders and Prima Linea Factory. In 1995, Pierre di Sciullo received the Charles Nypels Prize for his contribution to the advancement of typography.

The typeface **Aligourane** (1995–2002) was commissioned by Maman Abou, a Tuareg printer from Niger, and was intended as a newspaper font, although it was never adopted due to political and financial difficulties. Consideration was given to printing small to save space and paper and to increase the readability of the traditional African writing system Tifinagh with its geometric and symmetrical letters. **Aligourane** is also designed to enable the Tuaregs to employ their own system of writing using contemporary printing processes and screen-based computer technology. With plans for a new printing factory in Agades – the centre of the Tuareg people in northern Niger – di Sciullo is confident that the newspaper will soon be printed.

The Aligourane

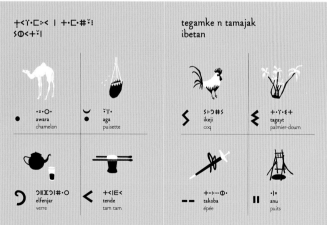

1 A rough of a spread for the alphabetization program of **Aligourane** (1997). **2** Aligourane is a set of five non-copyright fonts designed for the Tuaregs in their traditional writing system (called Tifinagh, 'Phoenician letters'). With five weights, a new vowel system and regional variants for some letters, **Aligourane** enables information organization, makes reading easier and saves paper, allowing for one of the few remaining African writing systems to live on.

3

4

3–4 médecines chinoises (2001) shows the synthesis of several levels of information; the human figure is at the centre of this symbolic universe.

The 'Santé' ('Cheers',1997) project created a signage system for a medical university and was commissioned by the French Ministry of Education.

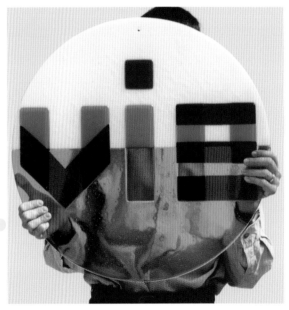

The project 'Vie' ('Life', 1999) is based on research into glass.

'a/e' (2000) is a project about signage and an investigation into glass. The 'Claque' project ('Click', 1999) focuses on research into glass.

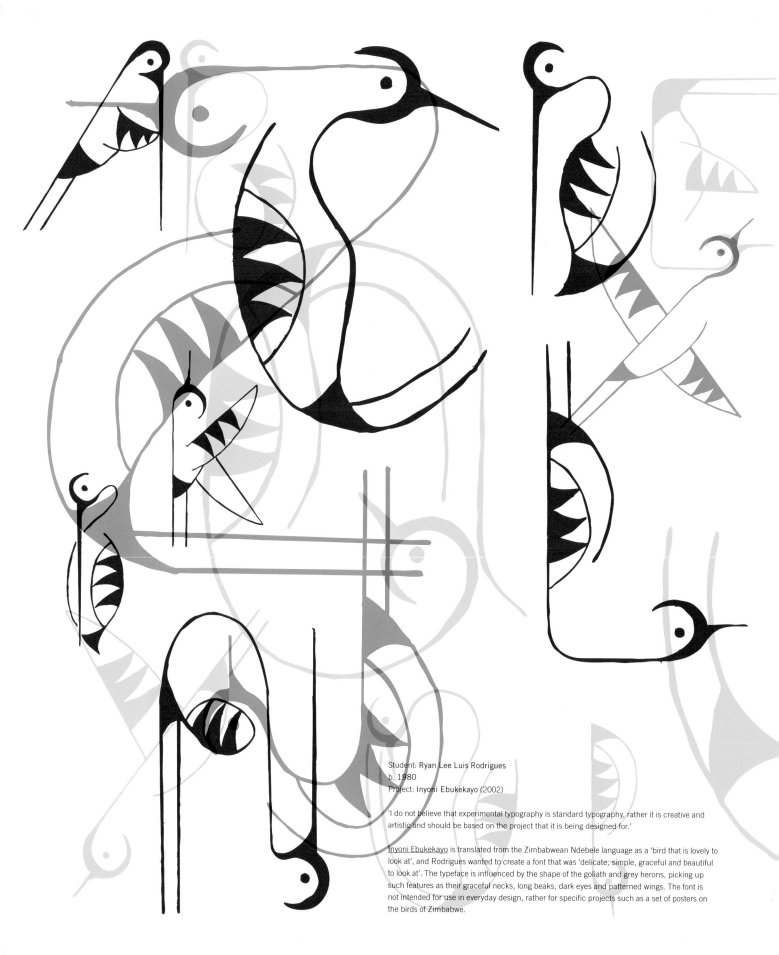

Student: Ryan Lee Luis Rodrigues
b. 1980
Project: Inyoni Ebukekayo (2002)

'I do not believe that experimental typography is standard typography, rather it is creative and artistic and should be based on the project that it is being designed for.'

Inyoni Ebukekayo is translated from the Zimbabwean Ndebele language as a 'bird that is lovely to look at', and Rodrigues wanted to create a font that was 'delicate, simple, graceful and beautiful to look at'. The typeface is influenced by the shape of the goliath and grey herons, picking up such features as their graceful necks, long beaks, dark eyes and patterned wings. The font is not intended for use in everyday design, rather for specific projects such as a set of posters on the birds of Zimbabwe.

SAKI MAFUNDIKWA & STUDENTS

'This question reminds me of the interview I did with the great Paul Rand at his Connecticut home just two months before he died. I had gone to seek his wisdom about an idea I had of returning to my country to start its first design and new-media training facility. At that point, we were both teaching at the Cooper Union, where my course had become "experimental typography". I asked him what he thought of the course and he cut me off before I could finish my question, "It must be one of those USELESS classes where they teach them NOTHING! Type is meant to be read, what's the experiment about?" Well, I muttered, isn't it that we progress into the future through experimentation? "The new? The 'new' just happens! It happens when you know what you are doing!" he bellowed, "all these kids doing this crap calling it 'experimental', it is all shit! And I don't like it!"

Much as I respect the man and his work, I did not agree with him at all – the Roman alphabet is not the Holy Grail of typography, so I am a staunch supporter of experimentation in or with typography. This includes the design of "new and radical" typefaces, experimental mutations of existing typefaces and experiments in or with legibility. I am also a proponent of new faces being crafted from and inspired by other writing systems. What I call "breaking out of the box" of Eurocentric design.

ZIVA students must graduate with that freedom. It is an option that they can revert to when the need arises. Not all of them will become good typographers, but if one or two "get it" then we will have fulfilled our dream.'

Tutor: Saki Mafundikwa
b. 1955
Institution: ZIVA (Zimbabwe Institute of Vigital Arts)
Country: Zimbabwe

The Zimbabwe Institute of Vigital (the fusion of visual and digital media) Arts is a private, self-funded, two-year design and new-media college in Harare, Zimbabwe, founded in 1999 by designer and educator Saki Mafundikwa. During the programme, one of the projects is the creation of a typeface inspired by nature or the environment. The aim is to introduce the nuances of letterforms and the possibilities of designing fonts professionally. They are encouraged to move beyond the use of the Roman alphabet to develop their drawing skills and to understand the context of writing and the history of writing systems. Students are involved in interactive design projects, which ensure they gain a better understanding of the differences between type for print and type for the screen.

Student: Diann Christine Shantell Selman
b. 1981
Project: Zvuma (2002)

'Experimental typography is a concept for a font, developed and based upon tests and experience, not on conjecture, to produce a typeface that is harmonious, pleasing and appealing when printed.'

As a creator and collector of beaded jewelry, Selman's typeface pays tribute to beaded adornments from across the African continent. The typeface's name – Zvuma – is adopted from the Zimbabwean word 'shona', meaning 'beads', and incorporates African patterns and natural raw materials used in the creation of African jewelry. Inspiration is also drawn from the leaves of local flora – the accessibility of seeds and wood in the local plant environment make them key influences in African jewelry design. Selman has incorporated different parts, shapes and sizes of beads in her typeface design. The alphabet is aimed at 'anyone of any age who is interested in original African design based on reality'.

Student: Shannah Adams
b. 1981
Project: Gecko (2002)

'For me, experimental typography means either further developing ideas or creating your own ideas against or with the basic principles of typography. The end product is not necessarily to present some thing professional, but to have broadened the limits imposed on the individual or typography itself.'

Adams's typeface Gecko is inspired by the geography and inhabitants of Africa, and by the designer's personal feelings of what constitutes 'home'. He writes, 'In Zimbabwe geckos are very friendly and live everywhere, even in high-density urban areas. They are the only lizards that have very definite features, such as their padded feet. Geckos also protect man as they eat such unwanted, yet very common, creatures as flies and mosquitoes.'

TYPO-ANARCHY AND THE DIY OF DESIGN

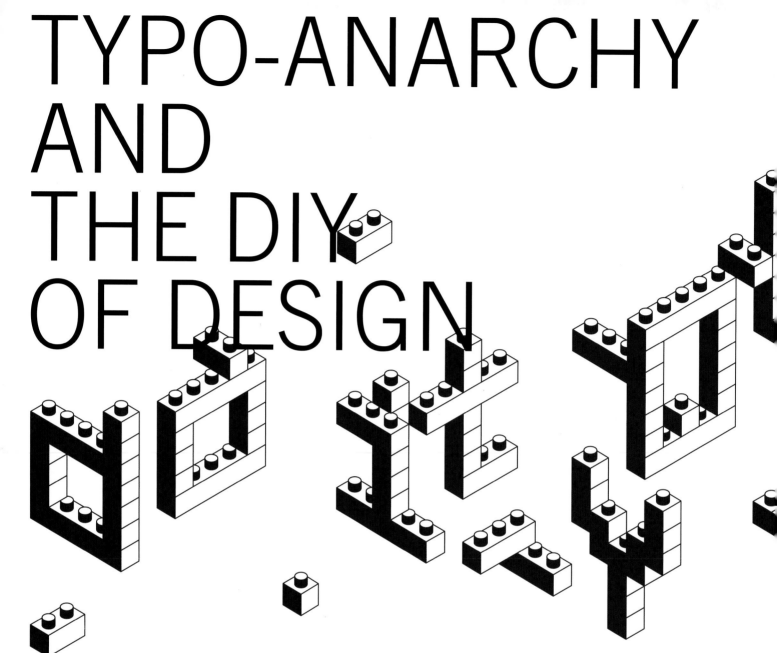

Lego am and Lego pm (1999) were designed by Urs Lehni, Juerg Lehni and Rafael Koch as part of a student project at the Schule für Gestaltung, Lucerne. Lego was first used as a headline face for an exhibition poster and has since appeared in a newspaper advertisement for the Schauspielhaus theatre in Zurich. The typeface was later released by Lineto, with a small 'cut-n-paste' design application that allows users to build letters, images or even whole environments using a library of preset 'lego' elements.

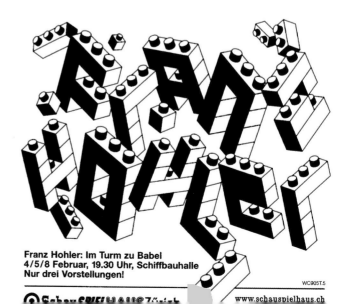

Franz Hohler: Im Turm zu Babel
4/5/8 Februar, 19.30 Uhr, Schiffbauhalle
Nur drei Vorstellungen!

WC905T.5

www.schauspielhaus.ch

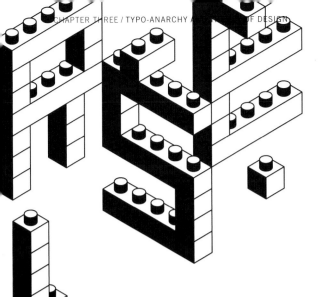

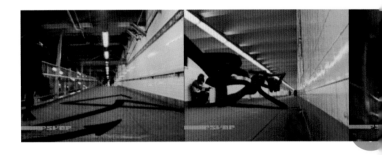

In an issue of the British punk fanzine Sideburns (December 1976), the sketchy diagram of a guitar fingerboard was captioned, 'This is a chord. This is anarchy. This is a third. Now form a band'. The 'do-it-yourself' rally cry dominated punk music, leading Mark Perry, editor of Sniffin' Glue, to tell his readership, 'Leave our music to us, if anything needs to be written, us kids will do it'. Such was the sway of this ethos that it filtered across the subculture's approach to fashion, writing and graphic design. Related music fanzines – often A4, photocopied and stapled publications – adopted the same DIY principles as the bands. Even as Mark Perry commented, 'Go out and start your own fanzines'[1], a dominant DIY graphic language emerged, relying on the immediacy and accessibility of such techniques and production strategies as 'cut-n-paste' ransom-note letterforms, lettraset rub downs, scrawled handwriting and appropriated media imagery. The photocopier was the preferred method of cheap and quick printing.

The introduction of the Macintosh computer in 1984 heralded a plethora of typefaces that reflected a new form of cultural production and slick computer aesthetics. Lewis Blackwell writes that 'by 1995 [the Macintosh] was commonplace and by 1997 it was a fundamental part of the design business practice the world over'[2]. However, it wasn't long until an anti-technology aesthetic took hold and a distressed and fragmented typography appeared. Such designers as David Carson and Graham Wood and John Warwicker of the design collective Tomato took up the design processes and techniques often affiliated with punk. mmm ... Skyscraper I Love You: A Typographic Journal of New York is a case in point and was developed as an integral process in the creation of Underworld's album dubnobasswithmyheadman. John Warwicker and Karl Hyde's creative journey through New York is printed in black and white, a reflection of the city's skyscraper landscape. A narrative unfolds through spliced letterforms and scratched out words that are set out compositionally in repetitive and nonsensical patterns[3].

This process uses similar methods to those promoted by writer William S. Burroughs (1914–97) and painter Brion Gysin (1916–86), whose 'cut-up' commentaries were the result of a scissors-and-paste assemblage of sentence fragments removed from their original printed contexts (usually newspapers) and rearranged to create totally new meanings. The narrative and its message are enhanced by the visual nature of the printed page. As Burroughs writes, 'cut-ups make explicit a psychosensory process that is going on all the time anyway'[4]. Burroughs's approach was welcomed by such designers as Neville Brody and Jonathan Barnbrook, who saw experimentation as a way of developing a new visual language. While Brody defines language as that which

'is about the fixing of boundaries and the establishment of systems'[5], his experiment began with the digital publication Fuse, which invited certain designers to explore the unconventional boundaries of language and representation. Jonathan Barnbrook took a different stance and created Burroughs (1991) in homage to the literary icon. Burroughs himself observed 'that a word is not the object it represents'[6]; and the typeface takes one set of words and, through random acts, creates a secondary level of meaning. The computer print-out retains the same designed layout, but has substituted non-related words from the computer dictionary.

While the new democratic ideals offered by Macintosh technology still reflected the early philosophy of 1970s punk, they were instead applied to the design of screen fonts and computer applications in the late 1990s. Technology prompted designers to experiment, but in new time-based and three-dimensional forms. Dutch designers Just van Rossum and Erik van Blokland formed LettError in the late 1980s as the emerging digital culture and new technologies were taking hold[7]. In 1990, they designed Beowolf, a typeface that showed their knowledge of computer programming and the coding of their own software tools. The typeface questioned the new visual aesthetic offered by digital technology and intentionally retained the appearance of having been cut from wood. Trixie (1991),

designed by Erik van Blokland, soon followed and was appreciated for its humanizing qualities and the respect it paid to the 'dirty' technology of the typewriter.

The use of objects as a basis to construct a typographic language is seen in the work of Czech designer Marek Pistora, who, for example, creates alphabets from children's plastic learning letters and building bricks. He is noted for his typographic contributions to each issue of the hip cultural magazine Zivel, and has created such typefaces as Plastik (1996) and Merkur (1995), which are unfettered reminders of how children learn to construct language through a physical engagement with letterforms. Merkur takes 1970s mechanical building blocks and transforms them into abstract silhouettes of the original metal pieces. Punctuation holds the pieces together: the comma is represented by a screw, a full stop by a square bolt and an ampersand by a flexible spanner. Plastik is based on the type of moulded plastic objects found in cereal boxes. Pistora's object-based approach to typeface design has been strongly criticized by colleague Frantisek Storm, saying that Pistora blatantly rejects the traditions of classical typography. Storm, who has created twenty-four Czech alphabets and is an ardent supporter of basic typographic principles, found the typefaces problematic in that they 'evoked in the viewer-reader an echo of

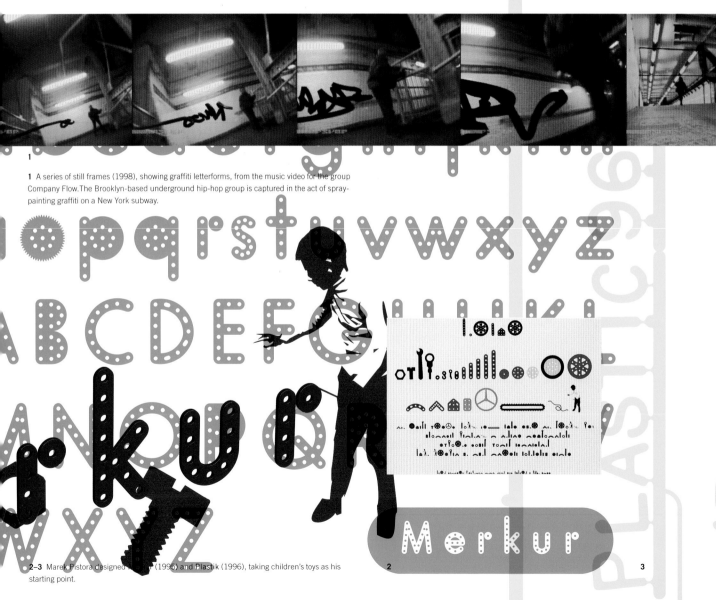

1 A series of still frames (1998), showing graffiti letterforms, from the music video for the group Company Flow. The Brooklyn-based underground hip-hop group is captured in the act of spray-painting graffiti on a New York subway.

2–3 Marek Pistora designed Merkur (1995) and Plastik (1996), taking children's toys as his starting point.

life sentiment'[8]. While Storm may consider that links to the personal and emotive aspects of typography defy the clarity of the message, Pistora's typefaces reflect contemporary Postmodernist positions.

As Postmodernism argued for the bringing together of 'ideas and forms from different times and places', it also questioned a 'sense of history as a continuous, linear "narrative"'[9]. This is evident in the work of Stephen Farrell of Slip Studios in Chicago, whose typefaces are inspired by seventeenth-century manuscripts. Volgare (1996), for example, is based around a ledger (a historical document), which recorded people's names and dates of death. By using early manuscripts, Farrell makes the viewer aware of a historical hand – that of an anonymous clerk – which is further emphasized through the personality created by his own pen strokes. The final typeface is artificially constructed yet manages to be a sign of what happens when there is a significant shift in context: what was in the past private becomes public. Farrell comments, 'As we enter into a manipulation of the private sphere of writing, we slip through voyeurism into another's hand as glove – invasive yet anonymous'[10]. The final digitized typeface is a hybrid of historical and contemporary handwriting and clearly raises questions about authenticity and authorship.

In the same way that Farrell employs the use of handwriting as a signature, other designers use the language of everyday handwriting – graffiti, shop signs, fanzines, 'lost dog' posters – as a legitimate form of mainstream typography. They bring with them sub-cultural and anti-establishment attitudes that defy conventional typographic principles and rules. Designers who adopt the aggressive and expressive handwriting and spray-painted letterforms of graffiti are seeking sub-cultural legitimacy. On one level, the reader connects with street warfare through anti-authority statements, while, on another level, the graffiti is presented to the audience as style not substance, with any aggressiveness stripped away as it is made safe for mainstream viewing.

Austrian designer Stefan Sagmeister brought the informality and immediacy of hand-scrawled letterforms to the forefront of the graphic-design avant-garde with a poster for the AIGA lecture series 'Fresh Dialogue' (1999) and with Lou Reed's album cover Set the Twilight Reeling (1996). The cover superimposes Lou Reed's face onto the handwritten lyrics of a song from the album, and, in an accompanying pamphlet, Sagmeister uses a combination of vernacular typography and everyday objects to represent each soundtrack. Here, the visual act of tattooing ultimately looses its shock value, becoming, instead, a symbol of Reed's soulful and poetic lyrics. However, when

4 5 6

4–6 Spreads and cover from mmm ... Skyscraper I Love You by John Warwicker and Karl Hyde. **7** Burroughs (1991), designed by Jonathan Barnbrook, plays with our understanding of the traditional forms of writing and reading.

Sagmeister takes this process one step further with the incision of letterforms into his own body for the AIGA poster, the shock value of Punk returns. The sheer physical process of someone cutting into Sagmeister's body using an X-acto knife reminds viewers of a primordial ritual. So the cycle begins again. This is the process whereby what may be considered experimental at one moment in time is readily absorbed into the mainstream shortly afterward.

Notes

1 Mark Perry, ed. Sniffin' Glue (issue 5, November 1976): n.p.

2 Lewis Blackwell. 20th Century Type: Remix (London: Laurence King, 1998): 148–49.

3 Karl Hyde and John Warwicker. mmm . . . Skyscraper I Love You: A Typographic Journal of New York (London: Booth-Clibborn Editions, 1994).

4 William S. Burroughs and Brion Gysin. The Third Mind (London: John Calder, 1979): 4.

5 Jon Wozencroft. The Graphic Language of Neville Brody (Thames & Hudson, 1988): 156.

6 William S. Burroughs. The Adding Machine: Selected Essays (New York: Arcade, 1993): 35.

7 Els Kuijpers, ed. LettError (Maastricht: Jan van Eyck Academie and Charles

Nypels Foundation, 2000): 13.

8 Iva Janáková. 'Druhé Strany' ('From the Other Side'). Deleatur (issue 2, 1997): 28.

9 Dominic Strinati. An Introduction to the Theories of Popular Culture (London: Routledge, 1995): 227.

10 Stephen Farrell. 'Rousting the Florentine Body' (1996). www.altx.com/ebr/ads/ebr6/farrell/roustin.htm

8

Founded by Denis Dulude and Fabrizio Gilardino, the foundry 2Rebels (1995) tries to continue the typographical revolution. Dulude suggests, 'experimentation is part of the process. How can we evolve if we don't take risks?' **8** KO Dirty (1993) by Dulude was created for the website of his first studio KO Création. **9** Stencil Braille (1997) was developed by Clotilde Olyff, who took the notion of Punk stencilling and applied it to a typeface normally associated with the sight-impaired.

9

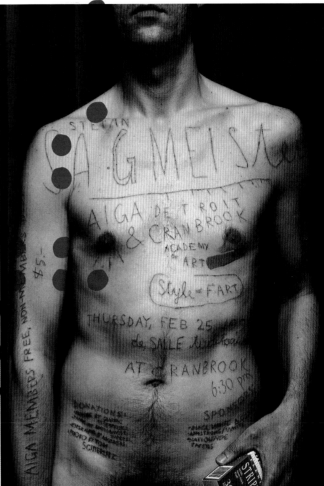

opqrstuv

KLMNOP

567890

10

10 Stefan Sagmeister takes the handwritten letterform to the extreme in this poster for the AIGA (1999).

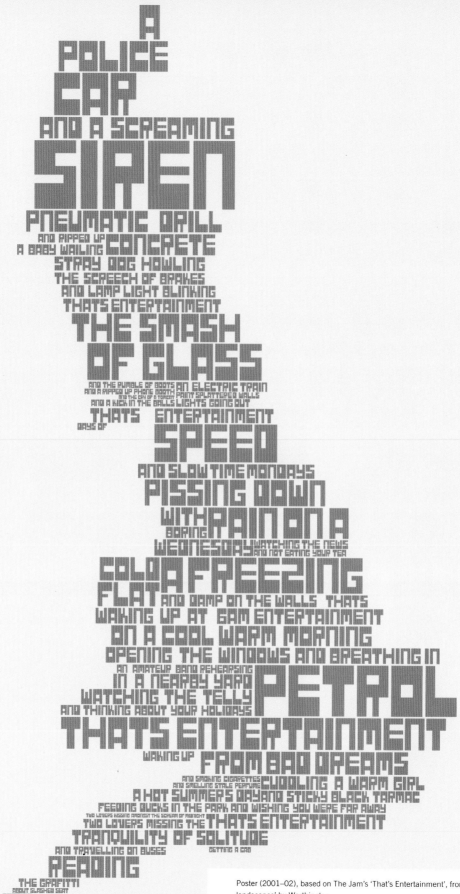

Poster (2001–02), based on The Jam's 'That's Entertainment', from a series of 'typographic landscapes' by Worthington.

MICHAEL WORTHINGTON

'True experimentation means taking risks. Not knowing the outcome but trying something that you think will be successful, but you have no proof. What happens if I mix element A with element F? Could be gold, could be sulphur. Let's find out. It means being inquisitive, believing you can make something that doesn't already exist, being willing to make mistakes and treat those failures as learning experiences that you can build into a process that allows you to move away from the familiar.

True experimental typography takes the same risks. There should be no expectations concerning what the form should be. The experimentation is in the making of the form. The form can often be as unexpected to the designer as it is to the audience (isn't that why designers aspire to create experimental work? Work that is actually creative and not mere production?). Once the experimental form is created it can be categorized, named, understood and eventually decontextualized: experimentation, with few exceptions, tends to cease to look experimental as mainstream culture adopts it, as it is surpassed by other forms of experimentation. The exceptions tend to be those pieces that are both out of time (innovative or avant-garde?) and push the minutiae of an aesthetic to such extremities that the designer can claim it as his own territory.

Experimental typography has nothing to do with style until the design is finished. Then it is all style.'

Spread from the book **Things That Quicken The Heart** (1996). The text was selected from the thirty-three short stories in the book using the find/change function on the computer; for example, this spread collected all the sentences ending in a question mark. The resulting spreads allowed the designer to create new texts and to experiment typographically with reassembling the pieces without overshadowing or interfering with the integrity of the individual stories.

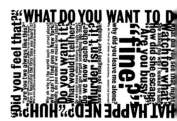

b. 1966
Studio: BOTHFORANDAND
Country: United Kingdom/United States of America

In the same year that Michael Worthington graduated in graphic design from Central Saint Martins College he co-founded Studio DM in London (1991), where his clients included the British Film Institute, Factory Records and Dorling Kindersley Publishers. He also taught part-time at Central Saint Martins and at Oxford Brookes University (UK). Worthington moved to Los Angeles in the mid-1990s to attend graduate school, completing his MFA at the California Institute of the Arts (CalArts) in 1995. Worthington worked briefly as a designer with the Los Angeles–based studio ReVerb, before setting up his own freelance business. In 1996, he became a full-time CalArts faculty member, and in 1998 was appointed programme co-director, with Louise Sandhaus, of the design department.

Worthington lectures and publishes internationally on typography and screen-based design, and his own design work has featured in such magazines as the AIGA Journal, Affiche, Emigre, Eye, Blueprint, Mute, Print and Visuelt. He has received numerous awards including the seventy-seventh annual Art Directors Club Gold Medal (1998), and has appeared in the American Center for Design '100 Show' (1996, 1999) and the American Institute of Graphic Arts (AIGA) show '50 Books/50 Covers' (2000). His work is housed in the permanent design collection of the Museum für Kunst und Gewerbe in Hamburg and the San Francisco Museum of Modern Art. Clients include the University of California at Irvine, the Greene Naftali Gallery in New York, SCI-Arc and the MAK Center for Art and Architecture.

In 1992, George P. Landow published the first of two influential books, Hypertext: The Convergence of Contemporary Critical Theory and Technology[1], which sought to explain how the experience of reading and writing was changing as new information technology emerged. Worthington's MFA thesis, entitled Hypertype, attempted to develop similar themes in screen-based design practice. Produced as a CD-Rom, the thesis re-presented Worthington's typographic treatise, exploiting the nature of hypertext interactivity, motion graphics and the 'non-linear navigable environment'. Worthington proposed that 'type should be sympathetic to the medium', but he also questioned the value of new forms of writing (in this case hypertext) in relationship to screen-based formats. Through a series of typographic teasers, the reader uncovers layer after layer of critical commentary, wordplay and narrative structures. Worthington is simultaneously author and designer, observing, 'I think the time when my work gets most interesting is when I can

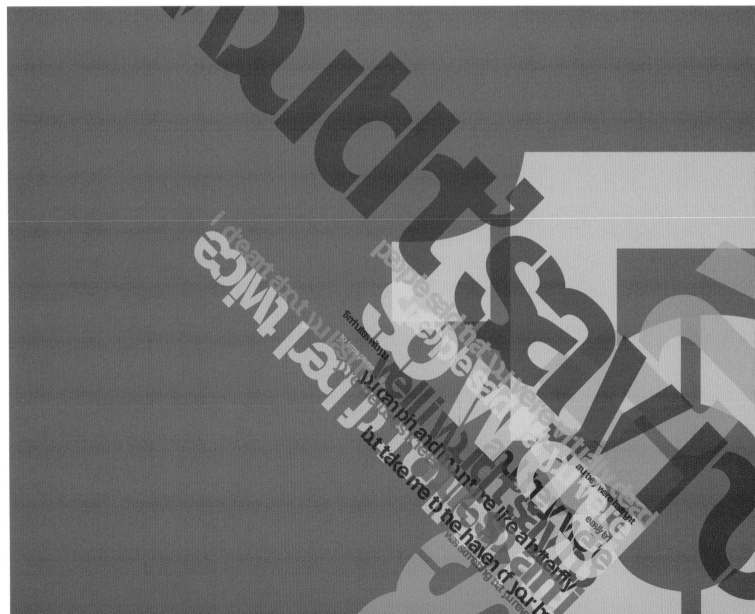

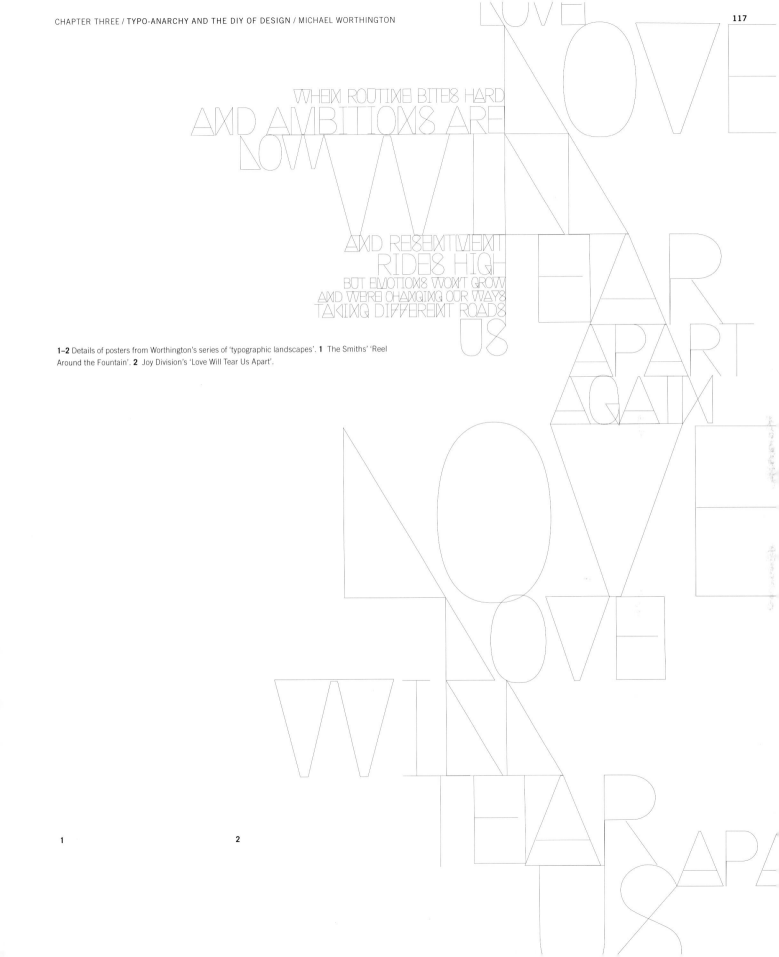

1–2 Details of posters from Worthington's series of 'typographic landscapes'. **1** The Smiths' 'Reel Around the Fountain'. **2** Joy Division's 'Love Will Tear Us Apart'.

1

2

write and design the text. It took me a while to get over my graphic-designer-as-service-provider guilt, that it was clientless and "design about design", but that shift in the function of the piece seems to make it more compact, closes the gap between design and content.'² Technology has also had an impact on the way designers like Worthington move from design concept to final product. The designer not only maintains complete control, but also finds, as Worthington suggests that 'there's a more fluid process of sketching with the computer'.

Despite advocating new technology, Worthington believes that both print and digital media deal with 'temporal design, structure, flow, and narratives'. Worthington just as easily accommodates the development of a website for the glass-wear company L.A. Eyeworks as he does the production of the print-based catalogues for the Los Angeles Museum of Contemporary Art. Defying the proclamation that 'print is dead', Worthington celebrates the opportunities for 'cross-pollination' between print and screen. He comments, 'Most of my design strategies for print come from methodologies and processes developed for working on screen.'³ In a field where most designers attempt to replicate for the screen what happens in print, it is refreshing to see that the reverse is equally valid.

The idea of 'cross-pollination' is a theme that Worthington continually revisits by exploring the potential relationships between writing, music and typography. Worthington was recipient of the City of Los Angeles' (COLA) Individual Artist Fellowship (2001–02), which provided him with the breathing space to develop work 'free from any constraints'. His starting point was non-representational typographic landscapes, and the results have offered an interesting exploration of how far we can take narrative structures. In what appears as a homage to the quintessential British bands producing hits from the 1970s to the 1990s, Worthington exploits visually the lyrics of bands and songs, including Pulp's 'Common People', Joy Division's 'Love Will Tear Us Apart' and Black Sabbath's 'Paranoid'. The Jam's 'That's Entertainment' is (re)presented as the geographic map of the United Kingdom; a hierarchical rhythm is created by the varying point sizes and blocklike letterforms, which encourage the reader's eye to move from the Orkney Islands at the top of Scotland to Land's End in Cornwall. In other posters, Worthington demonstrates his knowledge of typographic history in an apparent show of respect to the dynamic typographic compositions of the Constructivist El Lissitzky and in the typographic overprinting and production techniques stylistically reminiscent of early Wolfgang Weingart posters. Typographic history abounds in the design department corridors of CalArts, where Worthington is now programme co-director, following in the footsteps of Jeffery Keedy, Edward Fella and Lorraine

6
7
8

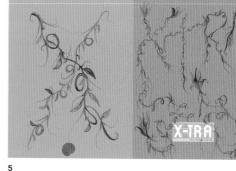

3
4
5

3 Spread from the California Institute of the Arts' admissions catalogue (2001–02).

4 X-tra (vol. II, issue 1, 1998) was designed to mutate according to the theme of each issue, while retaining a coherent identity. The first issue's theme was 'lost and found': all articles began on the opening spread and were deliberately intertwined, only differentiated by the typographic style. The plan was for the reader to literally get lost and found within the content. The cover massed layers of lost-and-found posters to suggest a wider visual vernacular than a single poster.
5 The second issue of X-tra (vol. II, issue 2, 1999) had the theme of 'gardens', with the design using historical models – from mazes and landscaped gardens to rambling overgrown weed patches – as structural models to be interpreted typographically.

Wild. In recognition of their work and others, 'Rebellion Acceptance Overdrive' (2001) was an exhibition in which Worthington and two of his graduate students, Jon Sueda and Stuart Smith, paid tribute to those who had been students or faculty members at CalArts between 1988 and 2001. The show examined the evolution of type design at CalArts 'by focusing on typefaces that designers use to convey meaning beyond the literal reading of the text', and included Barry Deck (**Template Gothic**, 1989), Jeffery Keedy (**Keedy Sans**, 1989), Conor Mangat (**Platelet**, 1993), Margo Johnson (**Giga Font**, 1993) and Sibylle Hagmann (**Cholla**, 1999, see pp. 96–99). In an opening lecture, Worthington observed that for the staff and students 'the ongoing dialogue involves aspects of both experimentation and craft: two areas that often seem diametrically opposed, but this survey is proof that the times when the two co-exist are the times when the resulting typeface is most successful.'[4] It is in this familiar CalArts tradition that Michael Worthington's approach fits only too well.

Notes
1 George P. Landow. <u>Hypertext: The Convergence of Contemporary Critical Theory and Technology</u> (Baltimore: Johns Hopkins University Press, 1992).
2 Email to author, 2001.
3 Marius Watz. 'Interview with Michael Worthington – April 99.' www.evolutionzone.com/hardwork.amoben/interview_michaelw.html
4 Michael Worthington. 'From A to Z.' CalArts, unpublished lecture, 2001.

9 10 11

6–11 Diagram and views of the CalArts exhibition 'Rebellion Acceptance Overdrive' (2001).

12

12 To help students understand the design process, Worthington created a diagram to explain the fantasy and reality of 'process' (2002).

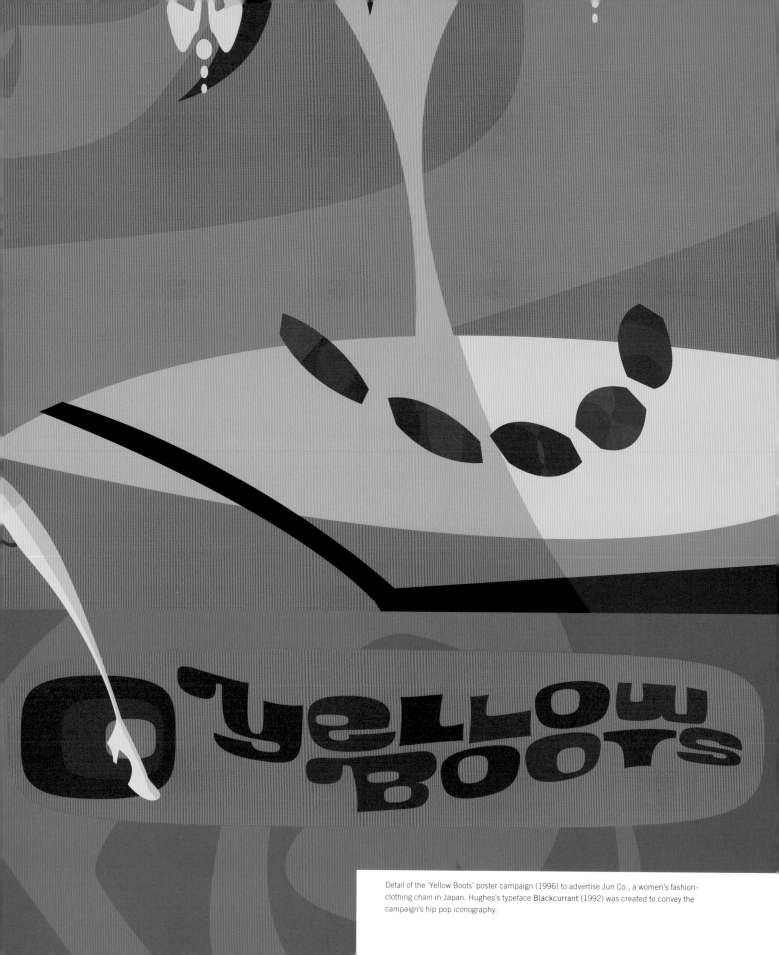

Detail of the 'Yellow Boots' poster campaign (1996) to advertise Jun Co., a women's fashion-clothing chain in Japan. Hughes's typeface Blackcurrant (1992) was created to convey the campaign's hip pop iconography.

RIAN HUGHES

'To a greater or lesser extent all type is experimental. Good typeface designs are those in which a solid graphic idea is consistently taken across the development of all the letterforms. However outré, what is essential in a well-realized design is graphic consistency and an internal logic. There is no arbitrariness involved. The best work is achieved in a synthesis of well-articulated concept and rational, technical underpinning. Experimentation may be through a playful exploration of the execution (craft skill), or it might be a conceptual investigation. Usually it is both, each to a greater or lesser degree.'

1

2

1–2 The typeface Judgement (1997) was commissioned for the 2000AD comic about Judge Dredd. A 'graphic expression' was needed that reflected the comic's larger-than-life, semi-fascist main character and the gritty urbanism of the storyline. Hughes used the stencil as a graphic device in a science-fiction environment.

b. 1963
Studio: **Device**
Country: **United Kingdom**

Since graduating from the London College of Printing (1984), Hughes has worked as a designer, illustrator and typographer in the areas of motion graphics, animation, advertising, music and publishing. Clients have included MTV Europe, Swatch, Ericsson, Warner Bros., Stock Aitken Waterman and Virgin Atlantic Airways. He has worked as designer and art director for such magazines as Deadline and as an illustrator for Q Magazine, Revolver, Maxim and MacUser. Hughes is equally experienced in the realm of comic books, having worked as a designer on The Invisibles and 2000AD. Hughes coauthored, with John Freeman, and drew the graphic novel The Science Service (1988), and collaborated with Grant Morrison on Dare (1990), an 'iconoclastic revamp of the 50s comic hero Dan Dare'.

He has contributed to numerous international exhibitions and has had a one-man show at London's Smiths Gallery (1988). His advertising typography earned him a Campaign Press Awards Silver Medal in 1996 and a Merit Award from the New York Art Directors Club in 2000.

In **Blackcurrant** (1992), Hughes rejects an underpinning grid structure, allowing a less formal exploration of these 'free-form' characters. The font evolved out of a desire to create an atmospheric, youthful and slightly 'girly' font without losing a consistent set of graphic characteristics.

English Grotesque (1998) explores the roots of the 'Englishness' evoked in older faces like Johnston Railway and Gill sans. While they may seem English, mainly due to their historical usage (Johnston is the London Underground's corporate font), the forms themselves derive from the early sans serif adaptation of traditional Trajan Roman letter proportions. So, the capital 'R' has a long tail, 'T' and 'H' are wide and 'S' is narrow in comparison to the more modern Helvetica or Univers. This is a good example of a font that is not primarily an investigation into abstract or strict graphic formalism, but it nevertheless became apparent that the shapes of Gill and Johnston and their Roman forerunners had originally been derived from a 2x2 square grid.

Paralucent (2000) is based on **Helvetica** and **Univers Sans**, but without 'the idiosyncratic holdovers from **Akzidenz** and other serif faces leading up to **Helvetica** or the emphasized optical corrections of **Univers Sans**'.

uvwxyzl234567890

OPQRSTUVWXYZ

tuvwxyzl234567890

OPQRSTUVWXYZ1234567890

stuvwxyzl234567890

NOPQRSTUVWXYZ1234567890

qrstuvwxyzl234567890

abcdefghijklmnopqrst
uvwxyzl234567890
abcdefghijklmnopqrstu
wxyzl234567890
abcdefghijklmnopqrst
uvwxyzl234567890
abcdefghijklmnopqrs
tuvwxyzl234567890
abcdefghijklmnopqr
stuvwxyz123456789
0
abcdefghijklmno
PQRSTUVWXYZ1234
567890
ABCDEFGHIJKLMNO
PQRSTUVWXYZ1234
567890

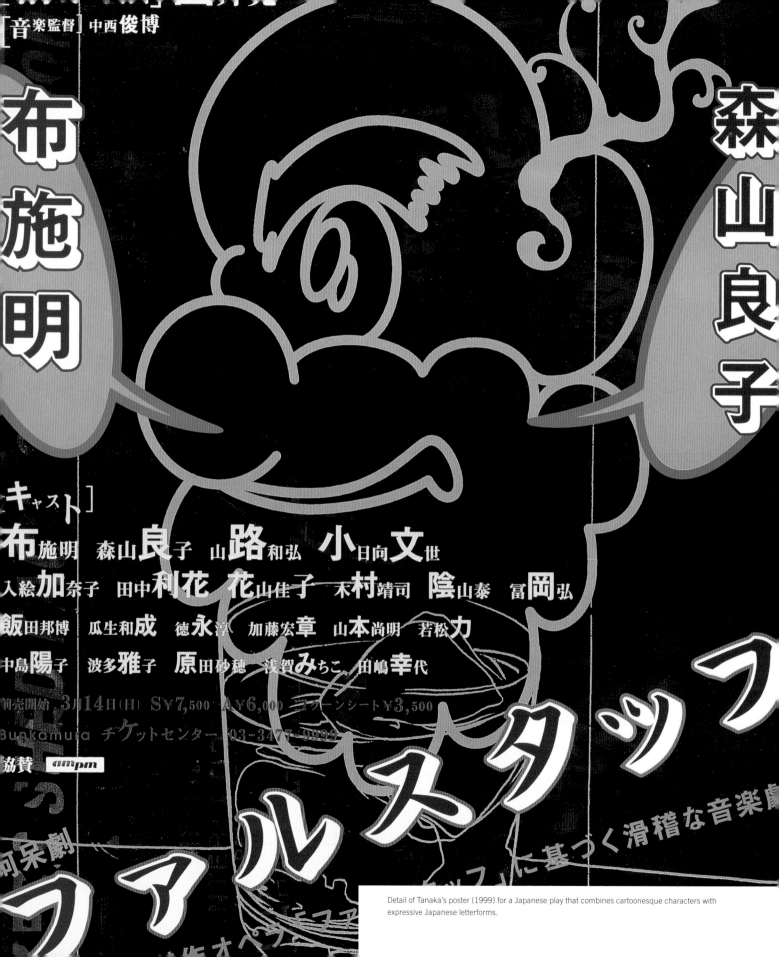

Detail of Tanaka's poster (1999) for a Japanese play that combines cartoonesque characters with expressive Japanese letterforms.

NORIYUKI TANAKA

'A step into creation. It is the most abstract state. It could be a form. Maybe it is the temperature or the sound. Searching, it is that bit before. The spirit of the time. Memory. Policy in the society. Elements created into form. Transforming into something.'

時の蘇生
柿の木プロジェクト
約半世紀前、長崎に投下された
原子爆弾。「時の蘇生」
柿の木プロジェクトは、長崎
で被爆した1本の「柿の木」から
生まれた苗木に人々が触
れ、感じ、起こした行動のすべて
をアートとして世界へ提示して
いくものです。次の
世代へ、国境を越えて生命の
エネルギーを、つなぐために。私
たちは、人々の「行動」
と「参加」を「被爆柿の木2世」
と共に、待ち続けています。

b. 1959
Studio: Noriyuki Tanaka Activity
Country: Japan

Graduating from Tokyo National University of Fine Arts and Music with a BA in visual communication design (1983), Noriyuki Tanaka went on to receive an MA in fine art (1985). He has combined two seemingly disparate approaches into a single coherent philosophy. He studied with Professor Shigeo Fukuda, known for his work in spatial design, who taught Tanaka that design is about creating a brighter future and building on dreams. Tanaka was also influenced by the German conceptual artist Joseph Beuys (1921–86). Tanaka has learned that pure design has a philosophical side, and, like Beuys, he believes that 'everybody is an artist'.

While most advertising creatives move from professional practice into the realm of fine art, Tanaka has done things the other way around. He feels this has given him a unique perspective and identifiable approach, with words becoming part of the inherent 'visualness' of the two-dimensional page. Tanaka's posters, in particular, are conducive to exploring the page as a receptacle for the dynamics of motion and the expressiveness of typographic forms. Much of his image making takes on an ethereal quality, such as his painterly flowers in mid-bloom, or his choreographed human figures whose movements are captured in mid-flight. In its extreme, Tanaka's typographic treatment has a level of kinetic energy derived from his use of fractured type, diagonally positioned texts and manga-inspired typographic explosions. For Tanaka, it is the dynamic effects of sound offered by manga and not necessarily its form that acts as a counter-cultural comment. The way we see sound and the way language is constructed forms the basis of his approach. However, Tanaka is also able to show great restraint, employing a strategy of minimalism where appropriate. In either case, the typographic form provides 'the transportation' and determines the 'speed' of his message.

Tanaka has been creative director for UNIQLO, a Japanese anti-fashion brand, since 1993. He is quick to point out that his involvement in advertising has emerged only recently and only after Nike's foray into the Asian marketplace. This enabled Tanaka to question conventional advertising by touching on subjects that are less about lifestyle and more about social and political concerns. One such advert, the 'Blind Jumper', was selected by Nike for television broadcast. It featured gold medallists from the Para Olympics and has gone on to win awards.

REVIVE TIME
KAKI TREE PROJECT
HALF A CENTURY AGO, THE ATOM BOMB WAS DROPPED IN NAGASAKI. "REVIVE TIME" KAKI TREE PROJECT PROPOSES ALL THE ACTIVITIES SUCH AS TOUCHING, FEELING WITH THE SEEDLING BORN FROM A "KAKI TREE" BOMBED IN NAGASAKI AS ART TO THE WORLD. TO THE NEXT GENERATION, TO CONNECT THE ENERGY OF LIFE ACROSS BORDERS, WE ARE WAITING FOR PEOPLES' ACTION AND PARTICIPATION WITH THE "BOMBED KAKI TREE JR.".

2

3

1–2 The poster 'Revive Time, Kaki Tree Project' (1995) appeared in French, Italian, English and Japanese to mark the anniversary of the atomic bomb dropped on Nagasaki. 3–6 These DVD covers and promotional material were produced for Tanaka's retrospective exhibition 'Out of Design' (2002). Tanaka's search for expression is represented in his traditional employment of bold calligraphic letterforms and also in his more abstract, painterly approach.

Tanaka's interest lies in the spatial environment; in particular, the changing contexts of work and how communication takes place in these different spaces. Tanaka's installations, which appear in museums, galleries and clubs, deal with the senses, the environment, the politics of design, anti-fashion and anti-design. Among his exhibitions are 'X-Department Store', shown in Tokyo, Nagoya, Osaka and Fukuoka (1991), 'Digital Art' in Tokyo (1992), 'The Art of Clear Light' in Tokyo (1995, also a CD-Rom), 'Power Room' in Osaka (1996) and 'Out of Design: Noriyuki Tanaka Exhibition' in Tokyo (2002). He has received numerous awards, among which are the members' Silver Prize from Tokyo Type Directors Club (1992), the Display Design Award's Grand Prix (1996) and the New York Art Directors Club Award (1999).

Notes
1 Interview with the author, London, 2002.

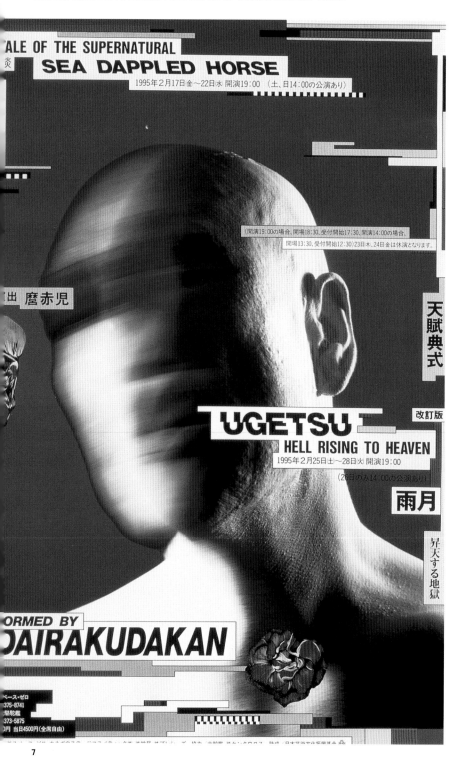

7

8

7–9 These exhibition posters for 'Scream of a New Generation – Japanese' (1995) use manga-inspired letterforms as vehicles for representing sound. Tanaka believes that these dynamic forms 'speed up the feeling of the moment' and, as a result, the speed of communication.

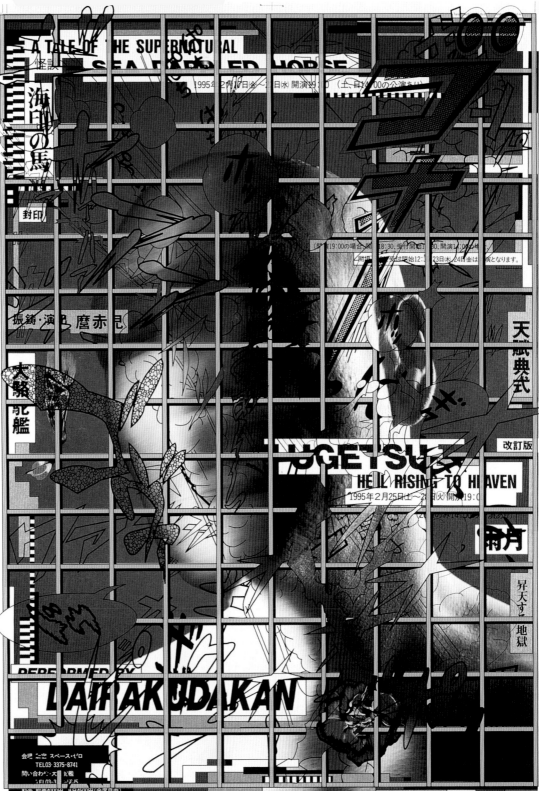

9

1 Hovados (1995) was created as part of Kvízová's final diploma work and represents a type table that is supplemented with drawing. The typeface was not of a high design quality and this is recognized in the name that translates as 'dumbface'. The font was later digitized by Czech type designer Marek Pistora and used in <u>Zivel</u> magazine (no. 6, 1997). **2** Bramb (1994) emerged out of experiments in the atelier of type designer Professor Solpera at the Academy of Arts, Architecture and Design in Prague. The typeface only appears in a single point size and each letter is cut into halved potatoes and stamped directly onto paper.

KLÁRA KVÍZOVÁ

'For me, an experimental space in typography is endless and open; it is where new ideas are replaced by another idea just that little bit different.'

b.1970
Studio: ReD [ReDesign]
Country: Czech Republic

Klára Kvízová was born in Prague and attended the Secondary Industrial School of Graphic Art (1984–88) and The Academy of Arts, Architecture and Design (1988–95), where she studied with Professor Jan Solpera. Ten years after the Czech Republic emerged from the Velvet Revolution, Petr Krejzek and Kvízová founded the design studio ReDesign to provide a range of services from annual reports to experimental typefaces. Clients include Cesky Telecom, EuroExpress, Green Planet, Zivel and Vokno. As a westernized version of corporate culture grew, designers in the Czech Republic recognized the significance of corporate identity as an integral part of an emergent economy. Kvízová, in particular, is well known for her work in this area, which includes an identity for the telecommunications company Aliatel (1998) and the annual corporate report for the power company EZ Praha (1997), which is illustrated with large-scale slogans in Helvetica. ReDesign has received numerous awards for their work in book and magazine design, including The Most Beautiful Czech Books Award (1999). They have exhibited work in the Czech Republic, France, Mexico and Finland, and their work is also in the permanent design collection of the Museum of Decorative Arts in Prague.

In an interview published in the magazine Deleateur, Kvízová proposes that the music industry allows designers to be most 'progressive'. She cites the early-1980s work of such British designers as Neville Brody (Cabaret Voltaire album covers) and Vaughan Oliver (for the independent record label 4AD) as some of the most influential in the industry. Kvízová shows her interest in contemporary pop culture in the cyber-culture magazine Zivel (1995), for which she is art director and which she co-founded with Krejzek. Created originally as a platform for typographic experiments and as a forum for a new generation of Czech typographers, Zivel has a 'street Czech style' that emerged out of techno and house music. Each issue provides a different typographic experience – using the black-and-white format of its interior pages to create a dynamic yet raw representation of the editor's 'cybernetic visions'. According to Iva Janáková, curator of the Museum of Applied Arts, Zivel has played a significant role in contemporary Czech culture; for example, it was instrumental in introducing American low-brow and non-professional vernacular style to the Czech visual landscape[1].

Kvízová's own typographic work reflects the local and has a 'do-it-yourself' approach. As a final-year student, Kvízová explored the theme of 'touch' and used materials found around her to mould a heart out of paper, thistles and rags. Her blending of artistic expression with pragmatic

functionalism led Kvízová to investigate the link between the requirements of the commercial world and the artistic, craft-inspired approach, an approach not dissimilar to that of earlier Czech designers like Karel Teige, Ladislav Sutnar, Alfons Mucha and Oldrich Hlavsa. Czech design in recent years has become a form of self-expression, as is evidenced by Petr Babák's handmade typefaces and Kvízová's use of digital avant-garde typefaces for Zivel magazine[2].

Changes in the country's global position are also reflected in Czech design. As Kvízová suggests, 'I want to share in the responsibility of making change visible'. For Kvízová, there are 'no borders'[3].

Notes
1 Iva Janáková. Foreword to TypoDesignClub Annual 1997, www.typodesignclub.cz/english/tdcjanak.en.htm
2 Ibid.
3 Email to author, 2002.

3 Kvízová's interest in design as a 'social probe' is shown in this series of covers for the magazine Zivel (1995–2001). Zivel no. 9, for example, questions the simple functionalism of black-and-white Modernist-inspired layouts, while Zivel no. 1 used Kvízová's 'quirky' typeface Excholer (1995) to represent the musical cyber world of the Shamen and author Bruce Sterling. 4 Promotional poster showing the font Excholer.

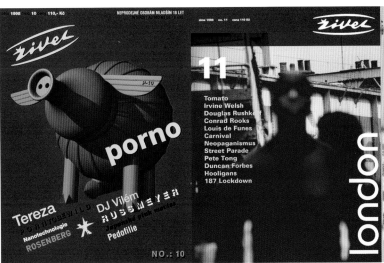

3

4

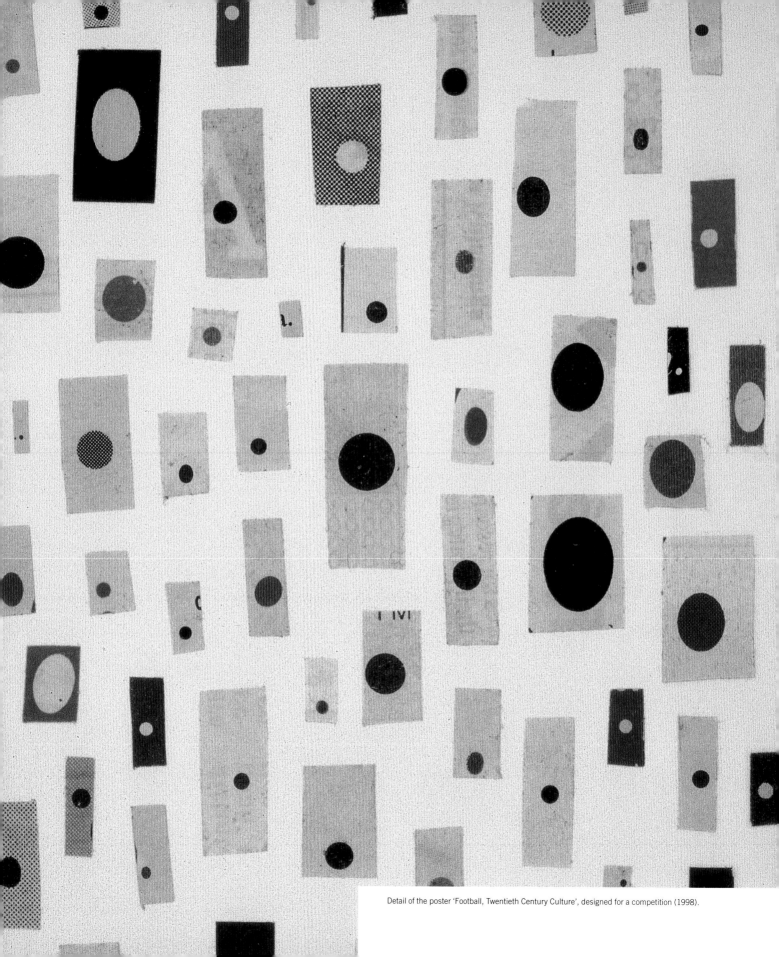

Detail of the poster 'Football, Twentieth Century Culture', designed for a competition (1998).

FUMIO TACHIBANA

'Imagine there is a sheet of white, plain paper. Nobody can say this is typography. However, I imagine what could be going on. Somebody could write letters on it with a pen. It could be printed by letterpress with the ink pressed in too deep. It could also dance and fall into the street and be trodden on by someone, leaving a shoe print.

I am aware of typography when something makes me foresee the process that can cause something to happen. I always keep watch for those happenings.'

Page from a book accompanying the exhibition 'Hen-Tai' ('Strange Body', 2001).

b. 1968
Studio: independent artist
Country: Japan

Born in Hiroshima in 1968, Fumio Tachibana graduated from the department
of visual communication design at Musashino Art University and gained an
MA in fine art research at Tokyo National University of Fine Arts and Music.
His group and personal exhibitions include 'Selections Winter '97' at the
Drawing Center in New York (1997), 'Karada' at the Nadiff Gallery in Tokyo
(2000), 'Active Wire' at the Art Sonje Center in Seoul (2001), 'Hen-Tai' at
Gallery 360 in Tokyo (2001) and 'Letterpress by Fumio Tachibana' at the
Matsuya Ginza Design Gallery in Tokyo. He has been awarded the Gold Prize
at the 17th International Biennial of Graphic Design in Brno (1996), the
members' Gold Prize from Tokyo Type Directors Club (1997) and the Gold
Prize from the New York Art Directors Club (2001). Burner Bros. is a 'creative
unit', founded by Tachibana and his brother Hidehisa Tachibana, which
publishes books by artists. Tachibana uses typography as an additional visual
element in his collages and 'sketchbook-like' pages in the books.

Tachibana's installation at the Mattress Factory Museum in Pittsburgh
(1999–2000) was based on a literal dismantling of language and reflects an
obsessive interest in the process of collecting and organizing objects. His
building blocks are books, newspapers and other 'found' graphic ephemera
containing words, letters or numbers, all evidence of the 'unfamiliar
environments' he encounters in his bike rides around Pittsburgh. These
fragments are pasted together to establish a complex interwoven linguistic
experience. Language is viewed as pattern but, at the same time, is
embedded with meaning. The 'cut-n-paste' design strategy means that text is
removed from its original context and divorced from its literal meaning. Books
are stacked, layered, even strung, sewn and glued together. This is a carefully
composed installation, which deconstructs language in the process. In much
of Tachibana's work, a tension is created between the mass-production and
communication processes of the modern industrial world and the craft
elements of handmade letterforms.

1

2

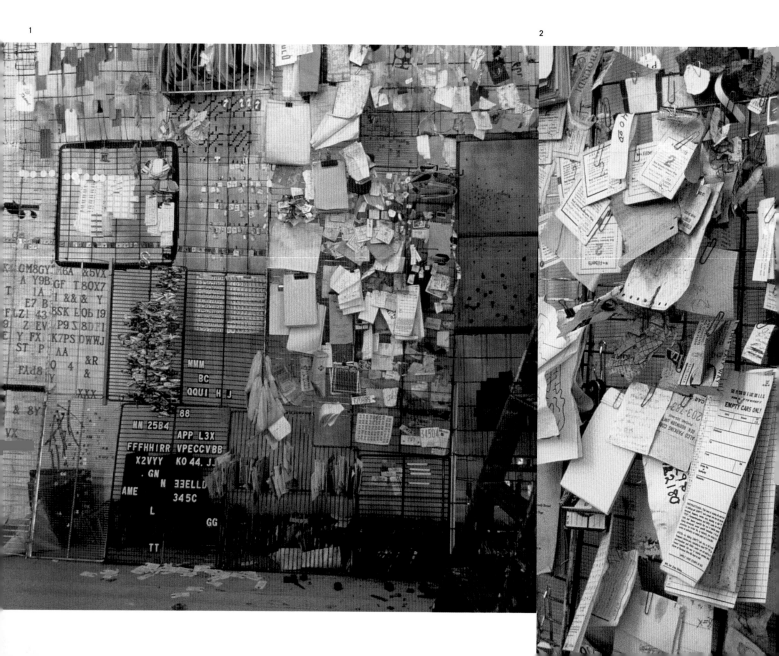

4
5

4–5 Double-page spreads from <u>Hi-Bi</u> (<u>Fire</u>, 1998), a book published by Burner Bros. in Japan. Their other books include <u>Kami-Gami</u> (1998) and <u>Clara</u> (2000).

3

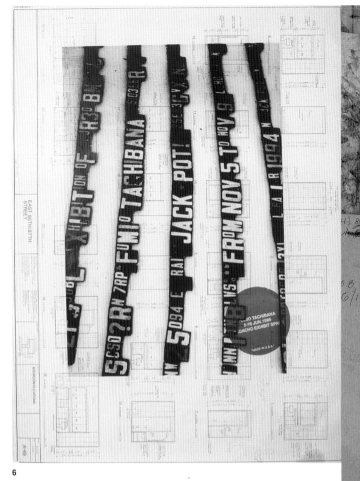

6

6 Poster for Tachibana's solo exhibition 'Made in U.S.A.', which was held at the Sagacho Exhibit Space in Tokyo (1995). The image of woodblock type has been silk-screen printed onto an old blueprint of architectural elevations for a bathroom on East 86 and 87th Streets in New York City. A third layer of information, a blue sticker, identifies the exhibition. **7** Detail of the accompanying exhibition pamphlet.

1–3 Views of Tachibana's installation in the group exhibition 'Installations of Asian Artists in Residence' at the Mattress Factory Museum, Pittsburgh (1999–2000). The museum has room-sized environments in which the artists create installations that the viewer can physically 'get into' and experience.

7

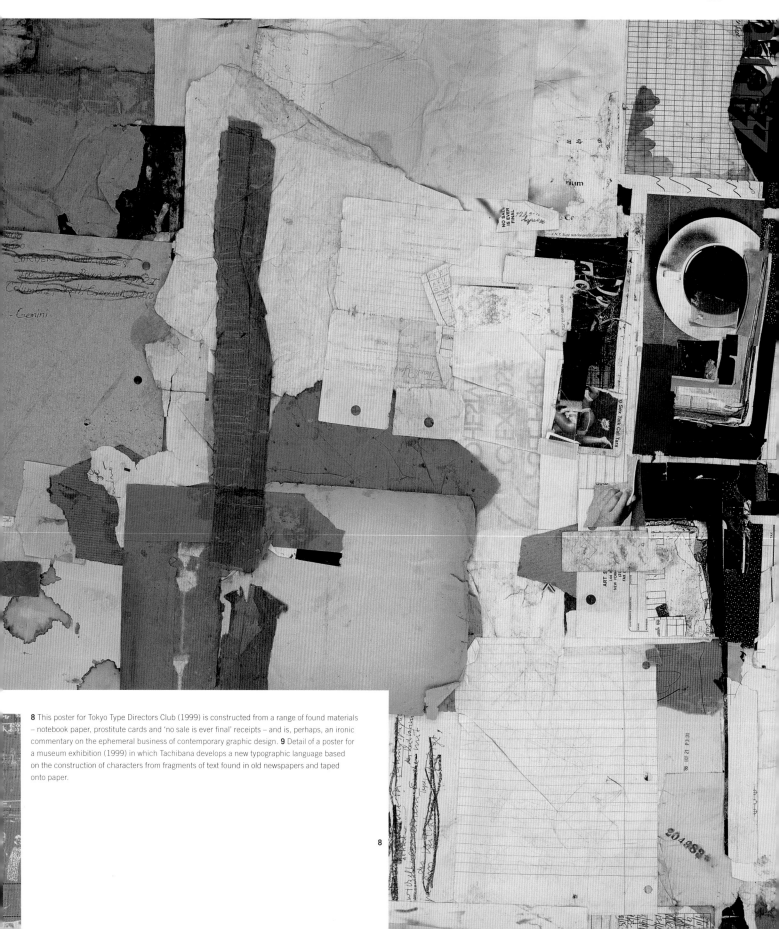

8 This poster for Tokyo Type Directors Club (1999) is constructed from a range of found materials – notebook paper, prostitute cards and 'no sale is ever final' receipts – and is, perhaps, an ironic commentary on the ephemeral business of contemporary graphic design. **9** Detail of a poster for a museum exhibition (1999) in which Tachibana develops a new typographic language based on the construction of characters from fragments of text found in old newspapers and taped onto paper.

8

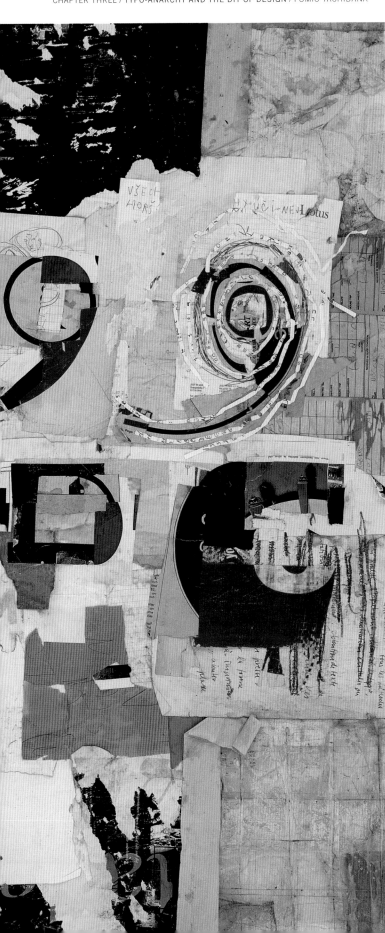

9

美術と演劇
ロシア★アヴァン●ギャルドと舞台芸術
1900-1930。

1 Detail from <u>Czech Design (1980–99)</u>, the catalogue for an exhibition held at The Museum of Decorative Arts in Prague (1999) for which Najbrt created the typeface. **2** The catalogue's cover expresses the processes of birth, formation and connection.

ALEŠ NAJBRT

2

'My attitude toward experimental typography is basically very banal. I think that an experiment means looking for something, which is a part of the development of every creative typographer. The experimental is ALWAYS a very important engine for my creativity. It is like fresh air that sweeps away stereotypes.'

b. 1962
Studio: St█████████
Country: C█████████lic

Michael H█████████ that Aleš Najbrt is an 'energ█████████of the new Czech des██████████ a time when the Czech Repu██████████ging out of a history s██████████mmunism[1]. The 1989 Velvet ██████████pened the doors to W██████████alism and Najbrt was one of a██████████ost-revolutiona██████████s attempting to unite his cou██████████ons and contempo██████████stardized' attitudes toward design██████████phy without sacrificing ██████████es of either. In 1994, Pavel Lev██████████nicka and Najbrt esta██████████ of the first graphic-design stu██████████new' Czech Republic. ██████████rs, Najbrt has played a signif██████████raising awareness██████████mporary Czech magazine des██████████h he takes as inspiration██████████British designer Neville Brody██████████adopted an approach██████████Teige and László Moholy-Nag██████████ic and spatial photograp██████████ents'[2].

Born in Pr██████████graduated from the Seconda██████████Graphic Design (1977–81) and the Academy of Applied Arts (1982–88), where he was classically trained as a painter and typographer. Following graduation, Najbrt

designed for a number of theatrical groups, including the Prazska Petka ('The Prague Five', 1984) and the art group Tvdohlaví ('The Stubborn Ones', 1984). He later became art director (1990–93), with his partner Pavel Lev, of <u>Reflex</u>, a general-interest magazine, and was also involved in the redesign of <u>Design Trend</u>, the official magazine of the Design Centrum.

Najbrt has designed a plethora of typefaces, including **Pratzské Loemé** ('Prague Black', 1990), **Hrot** ('Spike', 1991) and **Nana** ('Nana', 1994). Many are hand drawn and reflect a calligraphic angularity often associated with the design traditions of Eastern European political posters. In his own posters, Najbrt often combines traditional letterforms with his customized forms to provide a quirky agitprop sensibility. Najbrt reflects, 'with the ending of Communism in Czechoslovakia, my aggressiveness, which I was showing in my typography, was the weapon to express my attitude towards the establishment'.

Parallels may also be drawn between Najbrt's work and that of British graphic designer Neville Brody. Brody, whose own influences reside in the avant-garde of Russian Constructivism, emerged out of a period when the Left in Britain was re-establishing itself against Margaret Thatcher's Conservative government. <u>The Face</u> magazine presented a space for Brody to adopt his

5 The typeface Tuk Tuk Tuk (1989) was created for Thomas Kafka's poem 'The Visitor'. Najbrt reflects, 'I aspired to express every thought, every rhyme and every word of this poem. This is an example of over creativity ending in a blind corner.' **6** Najbrt's sketches for Prague Black (1990) are a stylistic combination of Gothic type and cubism. The final cut has been applied to a number of logos including one created for the MXM Gallery (1991).

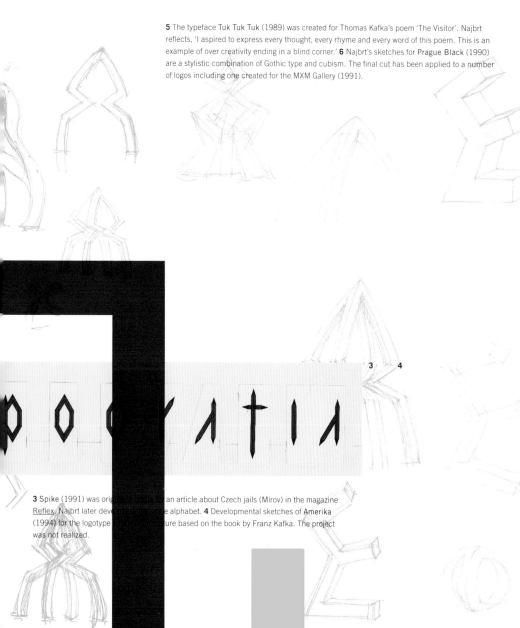

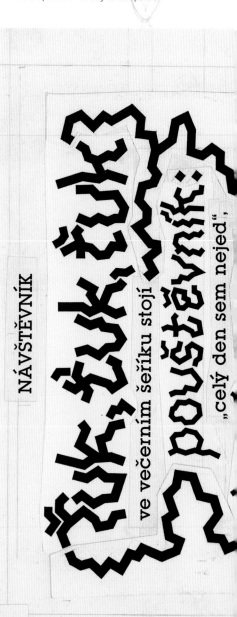

3 Spike (1991) was orig██████████ for an article about Czech jails (Mirov) in the magazine <u>Reflex</u>. Najbrt later dev██████████whole alphabet. **4** Developmental sketches of **Amerika** (1994) for the logotype██████████ture based on the book by Franz Kafka. The project was not realized.

social stance and to offer readers a visual identity reflecting cultural change. Raut provided Najbrt with a similar forum: as co-founder, chief editor and art director, Najbrt produced this large-format Czech art-and-culture magazine that features well-known and up-and-coming artists, poets and musicians. The magazine has been described as a place for 'free expression and choice' and inspires Najbrt to further his work.

Najbrt has been involved in such exhibitions as the Czech Republic exhibit at the Expo in the Republic of Korea (1993) and the 16th International Biennale of Graphic Design in Brno (1994). He has designed identities for arts organizations, such as the Czech Philharmonic Orchestra (1995), and has worked in the corporate world for Synergy (1995) and the Central and Eastern European Location Expo (1995). Najbrt's design work has been shown internationally and he has received a number of awards, including The Most Beautiful Czech Books Award (1996), the Grand Prix at the 17th International Biennale of Graphic Design in Brno (1996) and the Bronze Prize from the Tokyo Type Directors Club (1996–97).

Notes
1 Michael Horsham. 'Soirée in the Ruins.' Eye (no. 17, 1995): 38.
2 Iva Janáková. 'The Search for Continuity: Young Czech Designers.' Baseline (issue 25, 1998): 11.

6

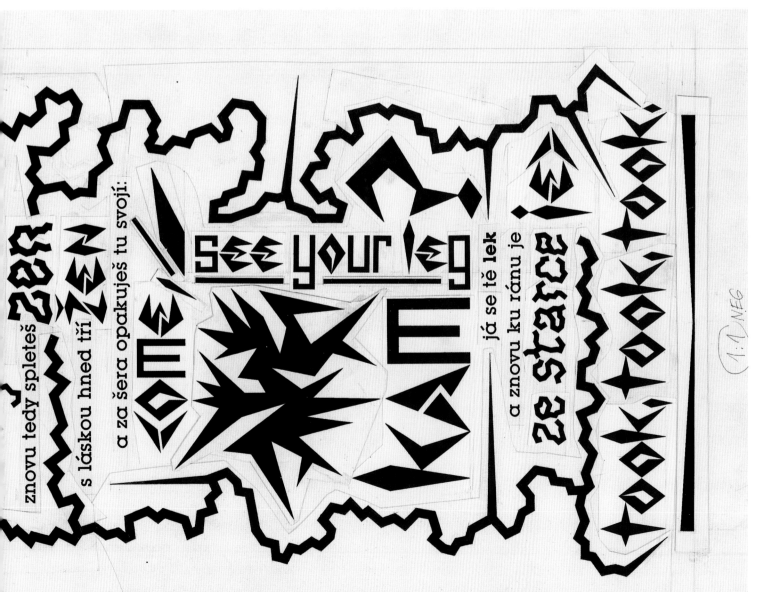

VISUAL
POETRY

Italian Futurism, Dadaism and other twentieth-century avant-garde movements explored the 'liberation of words' and, thereby, fostered the liberation of the two-dimensional page. This approach initiated a move from the traditional grammatical syntax of a formal page to a spatial syntax that embraces the acoustic and image qualities of text. Words, sentences and paragraphs were cut apart, re-ordered and re-presented typographically, fitting 'into expressive and often semantic, pictorial configurations', as seen in the work of Guillaume Apollinaire and Filippo Marinetti[1]. Those who sought to break free from the formal constraints of syntax, grammar, punctuation and orthography were responding to advances in new technologies and grappling with their inherent cultural and social forces. At the same time, poets and writers established links with major artistic movements, sparking off 'radical' and integrative typographic and poetic experiments. The sound poems of Hugo Ball (1916) and the letter poems of Raoul Hausmann (1918) visualized the 'loudness and the pronunciation' of letters using capital letters or bold type. This was a period in which standard literary modes of expression were subverted, giving rise to new and innovative visual and verbal lexicons.

The collaborations between artist El Lissitzky and poet Vladimir Mayakovsky in For the Voice (1923) made effective use of the elements of a standard metal typecase by 'visually programming' the formal arrangements of letterforms and geometric and iconic devices. Equally, Ilia Zdanevich's books, such as Ledentu as Beacon (1923), created a series of autobiographical plays that distinguished between individual voices either spatially or typographically in the construction of a 'theatrical environment'[2]. At the same time, Italian Futurist poets were creating new words out of the essence of sound and letter symbols. As theorist Gérard Mermoz argued, the typographies of the Futurists 'were not formal experiments, but radical (and utopian) interventions on the structure of language and the conventions of discourse'[3].

Innovative use of language heralded innovative visual vocabularies in which meaning was often attached to 'words according to their graphic and phonic characteristics'[4]: vowels were used to represent space and time; consonants signified colour, sound and smell. Commercial artist Fortunato Depero (1892–1960), for example, produced Dinamo-Azari Depero Futurista (1927), a bound collection of his typographic work, posters and advertising design. Depero was interested in developing new approaches to structuring language and images that were radical rejections of classical text traditions. He

1 Dinamo-Azari Depero Futurista (1927) is a compilation of the Italian Futurist Fortunato Depero's advertising work and experimental typography.

2–3 Details of <u>Enhance 57:19</u> (1998), a fashion broadsheet that has its roots in Dublin-based <u>Code</u> magazine. Peter Maybury draws parallels between the content and its presentation, visually establishing a typographic weave. **4** <u>White Book</u> (1997) was self-published by Peter Maybury in a limited edition of five. He writes, 'the text and type contain many levels of pattern and rhythm. Using text pages from a paperback, I made alternative typographic compositions by stripping out all elements of the original text (with the exception of the word spaces) except one, for example, a vowel or punctuation mark. I then scanned the resulting pages and compiled them as another book.' [email to author, 2002]

considered his letterforms as physical constructions, mirroring the principles laid out in his and Giacomo Balla's manifesto <u>The Futurist Reconstruction of the Universe</u> (11 March 1915). Their ideal was to 'find abstract equivalents for every form and element in the universe'.

Such explorations continued well into the 1950s with the arrival of concrete poetry, championed by Eugen Gomringer, then secretary to artist Max Bill. Centres of activity were in Saõ Paulo, Vienna and Italy. It was the visual, as well as the phonetic and the kinetic, that played a key role in communicating the poem's message, and concrete poets recognized that conventional syntactical structures were no longer adequate to 'advance the processes of thought and communication' of their time. Here, the typographic experiment re-examined how language functioned on the page. Where poets traditionally concentrated on 'the sound of verse, rhymes, rhythms and cadences', concrete poets explored the visual and physical material from which the poem or text was made.

Claire Hoertz Badaracco has noted wider resonances in her book <u>Trading Words</u>. She argues that not only the layout and arrangement of image and text counted, but also 'the quality of paper; its weave, color, and weight; the opacity of inks; the thickness of ascenders and descenders in type fonts; and the space or elaborate use of printer's devices such as flowers, bars, lines and dots.'[5] For many concrete poets 'typography became part of the autonomy of words' and 'semantics became the defining principle of typographic decisions'[6].

The book became the ideal format for experimenting visually and textually, 'a major feature of experimental artistic vision, and a unique vehicle for its realization'[7]. Contemporary designers and typographers continue to develop the book as a forum for typographic experimentation. Dublin-based designer Peter Maybury, for example, focuses on ideas and visual interpretations. In the design of the book <u>Patmos</u> (2001) by John Hutchinson, the text in the first section describes a physical and spiritual journey in search of a 'home', beginning in darkness and moving toward light and hope. In keeping with the book's subject, the inks become progressively lighter through the text sections; and, simultaneously, the paper's colour changes from a cream to a white and the weight becomes lighter, from a bulky 150gsm through varying surfaces and textures to a semi-transparent 60gsm. The typographic treatment at first appears conventional, yet the 'otherworldly title typeface' – **Citizen Caps** – and awkward bitmap graphics soon dispel this notion. The boundaries of the justified type are gradually broken to exceed the measure of the grid: the type starts to disappear as the author quotes from the notes of

5

6

Con Amore

Ode to you
The boulevard-stroller
Bluebeard of the sea
Strutting along
Spotless sands
From tea-room
To tea-room
From Dame Blanche
To Grand Parfait

(Dutch) (English)

Con Amore

Ode aan jou
De boulevardier
Blauwbaard van de zee
Flanerend langs
Smetteloze stranden
Van theehuis naar theehuis
Van Dame Blanche
Naar Bombe Glacée

7

8

5 Text in the first section of the book <u>Patmos</u> (2001), designed by Peter Maybury.
6 Throughout his career, designer and educator Jan van Toorn has been committed to promoting the relationship between art and design and society, as opposed to the notion of artistic autonomy. <u>Pamphlet</u> (1970) was a project by Jan van Toorn for the Sikkens Foundation. In this example of a fanzine-like approach, van Toorn subverts conventional linear reading by turning the text on its side. The combination of diagonally placed blocks of type, handwritten letterforms and negatives promotes a sense of immediacy of information. 7 Spread from <u>Emigre</u> (no. 1, 1984) designed by Rudy VanderLans and showing bilingual poems by Marc Susan. The first few issues of the magazine relied on existing materials: Susan's typewritten poems were enlarged from the originals and juxtaposed with imagery that he provided. The layouts were 'forcedly expressive' and the production process was inexpensive, immediate and accessible to a growing community of like-minded artists, designers and typographers. 8 During the late 1990s, Petr Babák designed many book covers. Influenced by early-1970s experimental approaches, Babák often uses minimal colour and typographic elements, as in the catalogue cover for <u>Pelcl-Design, Cotto-Furniture</u> (1999). Many of his books rely on the tactility of materials and the addition of such elements as string, plastic, tape and ribbon, as in the catalogue <u>The Most Beautiful Czech Books Award</u> (1998). Babák adopts the use of 'dirty' aesthetics – inspired by David Carson – in the book <u>Much Pop and More Art</u> (1995) by using letterpress printing and carefully placing apparently accidental ink smudges.

an uncompleted text. As the paper becomes lighter, text begins to show through from other pages, creating shadows.

Such an integration of form, production and text-based narrative suggests that the page is no longer static; rather it actively engages the reader's participation through the open-ended nature of the text. Gérard Memoz draws this to our attention in his investigation into the relationship between typography and Deconstruction. He cites the work of the philosopher Jacques Derrida and book designer Richard Eckersley on Glas as demonstrating the way in which the multiplicity of reading paths is depicted visually and textually. This proves that for Derrida 'it is not from gazing at the page, but from reading the text that typography reveals its functionalities'[8].

Richard Eckersley's design of Avital Ronell's The Telephone Book (1989) establishes 'structural and functional correlations between form and content', with typography addressing both the text and the reading process. The Telephone Book is a treatise on communication and presents an 'endless network of telephone connections'. The author suggests that typography is used to 'break up its logic', and, as with the interventions of the Futurists, 'you will become sensitive to the switching on and off of interjected voices'[9].

The book also presents the ultimate 'collaboration between author, designer and compositor; with the designer participating in the process of authorship'[10].

While Eckersley uses spatial constructs within the book itself, Lucinda Hitchcock (see pp. 150–53) takes the book from the two-dimensional page to a three-dimensional spatial environment. She explains that 'by transferring text from the two-dimensional surface to multi-dimensional space, a new context can be created allowing readers or viewers to read, see and experience word: environment: material: meaning simultaneously.' Her experiments using a deconstructed copy of the book Tristram Shandy (1759) look at the conventions of the typographic and literary genres. The pages are recontextualized to question the authority of the book form and result in the production of a 'space divider, a mobile piece of furniture and a performance'. Hitchcock continues, 'the words hang in space ready and willing to be approached from any position'[11].

These and other three-dimensional typographic experiments have implications for the development of the book form in virtual space and, ultimately, inform our expectations of the reading experience. The book, whether viewed as an object, installation or receptacle, provides a foundation for the exploration of visual poetry.

9 Perhaps Richard Eckersley's best-known scholarly book design is for Avital Ronell's The Telephone Book (1989). While the author explores the philosophy of Jacques Derrida and Martin Heidegger through telephonic communication, Eckersley uses Deconstructivist strategies in the treatment of the typographic page. Graphic marks, gaps (such as the deliberate creation of 'rivers') and ways of framing the text all question the conventional page layout. Typography becomes the vehicle to express different voices and modes of writing. **10** In the design of Stupidity (University of Illinois Press, 2001), Eckersley continues to develop his skilful typographic approach.

9

10

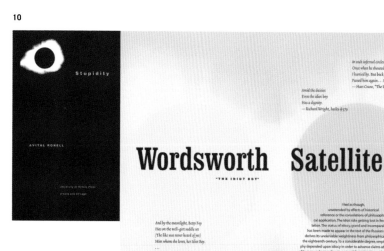

Notes

1 Christian Scholz. 'The Path from the Optophonetic Poem to the Multimedia Text.' Visible Language (35.1, 2001): 94.

2 Johanna Drucker. The Century of Artists' Books (New York: Granary Books, 1995): 54.

3 Gérard Mermoz. 'Deconstruction and the Typography of Books.' Baseline (issue 25, 1998): 42.

4 Patricia Railing. From Science to Systems of Art (Forest Row, UK: Artists Bookworks, 1989): 74.

5 Claire Hoertz Badaracco. Trading Words: Poetry Typography and Illustrated Books in the Modern Literary Economy (Baltimore: Johns Hopkins University Press, 1995): 14.

6 Mary Ellen Solt, ed. Concrete Poetry: A World View (1968, shown at: www.ubu.com/papers/solt/index.html).

7 Johanna Drucker. The Century of Artists' Books (New York: Granary Books, 1995): 45.

8 Gérard Mermoz. 'Deconstruction and the Typography of Books.' Baseline (issue 25, 1998): 43, 44.

9 Avital Ronell. The Telephone Book: Technology, Schizophrenia, Electric Speech (Lincoln: University of Nebraska Press, 1989): xv.

10 Gérard Mermoz. 'Deconstruction and the Typography of Books.' Baseline (issue 25, 1998): 44.

11 Lucinda Hitchcock. 'Word Space/Book Space/Poetic Space: Experiments in Transformation.' Visible Language (34.2, 2000): 174.

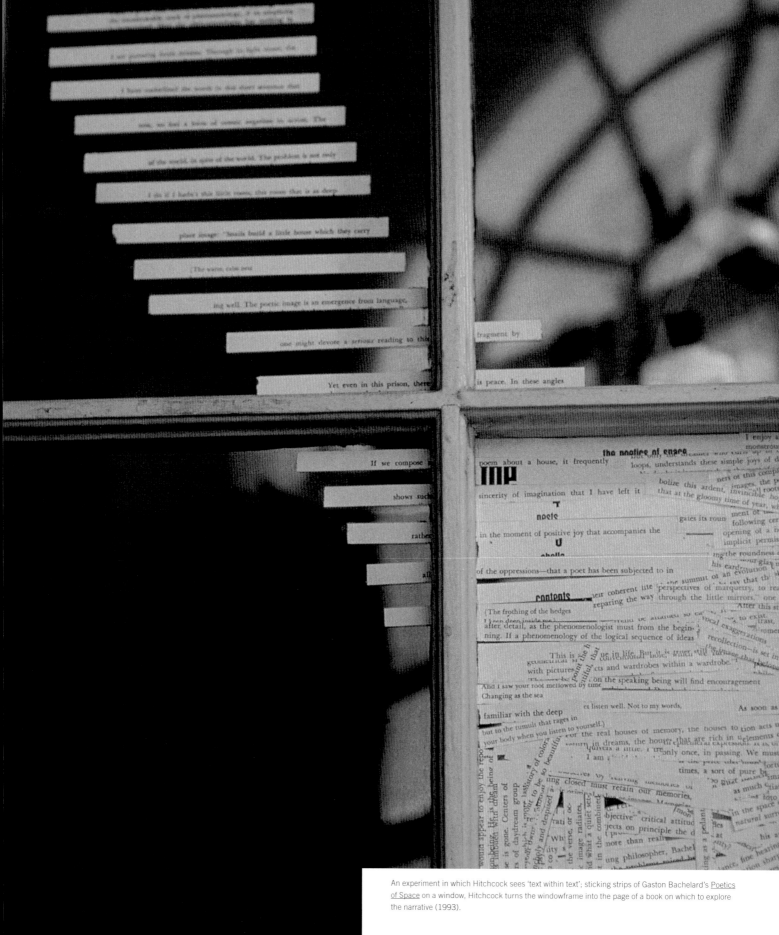

An experiment in which Hitchcock sees 'text within text'; sticking strips of Gaston Bachelard's <u>Poetics of Space</u> on a window, Hitchcock turns the windowframe into the page of a book on which to explore the narrative (1993).

LUCINDA HITCHCOCK & STUDENTS

'Typography is the design, choice and arrangement of typeset matter, and is shaped by conventions that aim to create legible and accessible reading material. Experimental typography challenges the notion that legibility and message are primary, rather asking that the maker/user/viewer consider other characteristics that are inherent to type. Like many conventions, typography is old and revered. Like paint, it can be used to show something akin to the truth, or it can be asked merely to suggest. It can be dressed up or down. Typography is nothing without meaning, and meaning is nothing without questioning. And to experiment is not to seek an answer but to serve the question.'

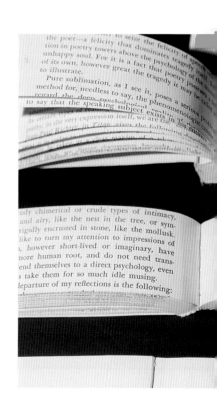

b. 1961
Institution: Rhode Island School of Design
Country: United States of America

In 1983, Hitchcock graduated in English Literature from Kenyon College, Ohio and received her masters in the same subject from Columbia University (1986). Hitchcock was awarded an MFA in graphic design from Yale University (1994), where she completed her thesis titled <u>Visual Poetics: Toward an Understanding of Words in Space</u>. Since 1998, she has been assistant professor at Rhode Island School of Design, teaching typography and graphic design. She has been a faculty member of the Art Institute of Boston (1995–98) and Yale University, where she was also a senior project advisor (1994) and a teaching assistant (1993–94). She has taught at the Letterpress Guild of New England (1990).

Hitchcock has designed books and jackets for such publishers as Beacon Press and David Godine, Boston. She has received the Bookbuilders of Boston, New England Award for book design and the Association of American University Presses Award for book and jacket design (1998 and 2000). Her work has been exhibited in the American Institute of Graphic Arts (AIGA) prestigious '50 Books/50 Covers' (2001) and published in <u>Print</u> magazine,

Communication Arts, <u>AAUP Best Books Annual</u>, <u>Esquire</u> and <u>The Nation</u>. Hitchcock's essay 'Word Space/Book Space/Poetic Space: Experiments in Transformation' was published in <u>Visible Language</u> (34.2, 2000) and explores 'poetic spatiality', not only in terms of words on the two-dimensional page but also words in actual space. Her experiments encourage readers to engage in new ways of seeing and interpreting typography.

1

1 In <u>Tristram Shandy</u> (1994), Hitchcock challenges the conventions of form, considering how it pertains to meaning. The book <u>Tristram Shandy</u> – once a 647-page English novel – is deconstructed and transformed into an entirely different experience as a 10-x-12-foot screen. 2–3 A sliced copy of Gaston Bachelard's <u>Poetics of Space</u> symbolically does away with the assumptions that a book is 'precious, true and finite' (1993). 4–5 Student work from Hitchcock's course on environmental graphic design at Rhode Island School of Design. Michelle Moyal and Nancy Birkholt explored large 3-D letterforms and the process of their construction using any material. The results were then photographed in a variety of settings.

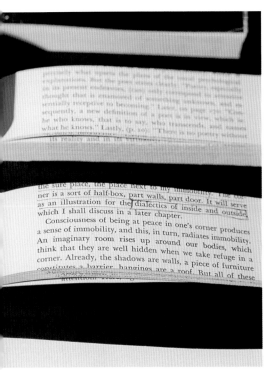

2

3

4

5

6

9

10

7

8

11

6 An experiment in meaning takes Rainer Maria Rilke's poem 'Sybil' and redesigns it in a number of different ways and formats. Here, Hitchcock challenges the typically formal and organized appearance of publishing by enlarging the page to an an oversized poster (1993). **7–8** The course on visual narrative gave students the single word 'compulsion' to work with. In this case, Jay Salvas produced a concrete book (2000), essentially a catalogue of obsession using luggage tags and type.

9–11 Hitchcock used the annual snowfall as a blank page on which to experiment with type, text and meaning (1993–94). She spray-painted Martin Heidegger's words onto layer after layer of snow, which melted, froze and was snowed upon again. The project was evidence of the passage of time and the will of the weather.

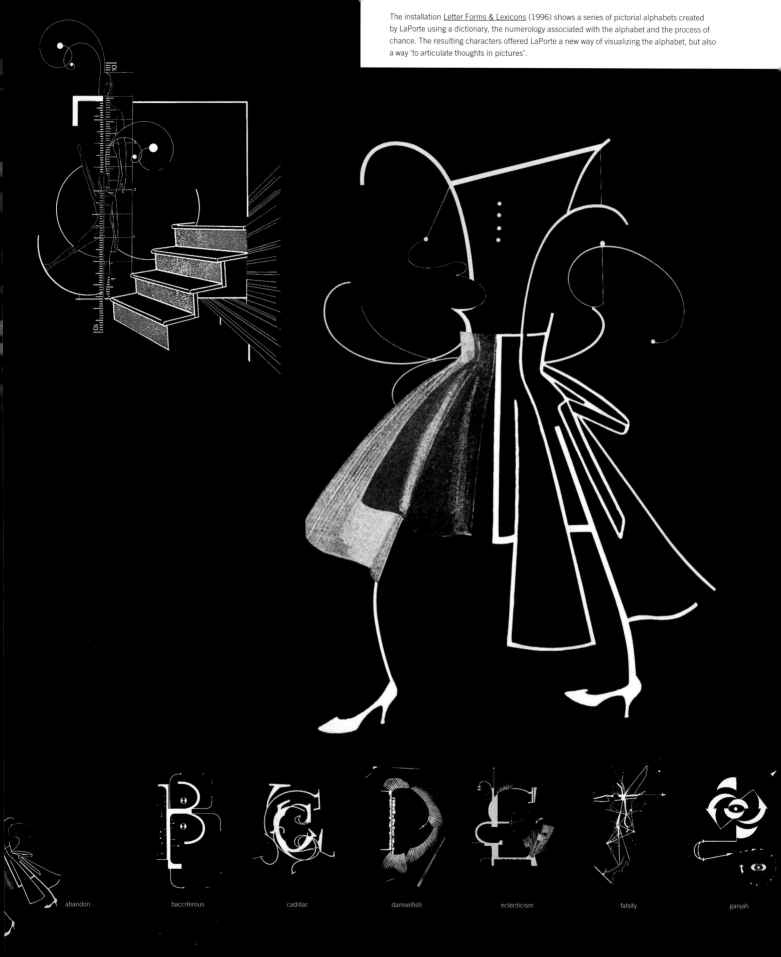

The installation <u>Letter Forms & Lexicons</u> (1996) shows a series of pictorial alphabets created by LaPorte using a dictionary, the numerology associated with the alphabet and the process of chance. The resulting characters offered LaPorte a new way of visualizing the alphabet, but also a way 'to articulate thoughts in pictures'.

abandon bacciferous cadillac damselfish eclecticism falsity ganjah

SUSAN LAPORTE

'Experiment (n):

1 A test, trial, or tentative procedure; an act or operation for the purpose of discovering something unknown or for testing a principle, supposition, etc.

2 The conducting of such operations, experimentation.

3 Experience; empirical; provable.

Like a scientist, I have always enjoyed investigating systems. Systems or processes that allow the known and unknown to intermingle to create the unique and the unusual. While in the process of such experiments, I often discover things that lead me to new or more interesting questions and, if I am lucky, to the ridiculous.

However, whether I am thinking like a designer or a mad scientist, using both left and right brain activities, typographic communication continues to engage me and certainly helps to provide a focus/purpose for my play.'

handily immane jollity kirschwaser latin manageable neville

b. 1965
Institution: **College for Creative Studies, Detroit, Michigan**
Country: **United States of America**

Before joining the communication design department at the College for Creative Studies as an associate professor (1999), Susan LaPorte taught at Eastern Michigan University (1993–97). She is a graduate of the University of Illinois at Chicago (BFA, 1988) and she received her MFA in graphic design from the California Institute of the Arts (CalArts, 1991). LaPorte has worked for the Walker Arts Center (1992–93) and CalArts (1991–92). Her work has been published in various editions of Emigre: 'The Authentic Issue' (no. 38, 1996–97), 'Rebirth of Design' (no. 34, 1995) and 'Broadcast' (no. 28, 1993).

LaPorte's interest in typographic and design processes and experimentation is evident in her installation Letter Forms & Lexicons (1996), originally created for Eastern Michigan University's Ford Gallery and later published in Emigre ('The Authentic Issue', no. 38, 1996–97). She keenly challenges design practice, initially by keeping within the parameters offered by typographic practice itself; that is, the need to establish a consistent system across the design of the actual letterforms. However, the twenty-six letters that make up

LaPorte's exploration are not visually consistent. The installation is reminiscent of Schwitters's type characters but also the Dadaists' 'process of chance and wilful choice'[1] and the collage techniques of such artists as John Heartfield and Hannah Höch. LaPorte's letterforms combine elements of hand drawings, photographs and informational diagrams. Each character is individually realized as pictorial play, confronting our understanding of typographic convention and presenting an end product that is essentially 'theoretically based' but which has developed out of a systematic approach. The alphabet is created by taking the definition of words from the dictionary and 'finding the word comes from a corresponding numbering system assigned to the letters in the alphabet'[2]. Her method relies not only on control but also on chance pairings.

Drawing on her own cultural frames of reference including her knowledge of typographic history, perceptions about gender and the vernacular, LaPorte offers even more to the viewer. Letter Forms & Lexicons establishes that the design process (form, process and meaning) is continually redefined in relationship to its context. This is also evident in LaPorte's MFA thesis project Extended Families (1991), which explores typographic hybrids. Borrowing from the process of genealogy, specific type family members were inserted into a 'family tree' to produce a family of hybrids. The fonts were created

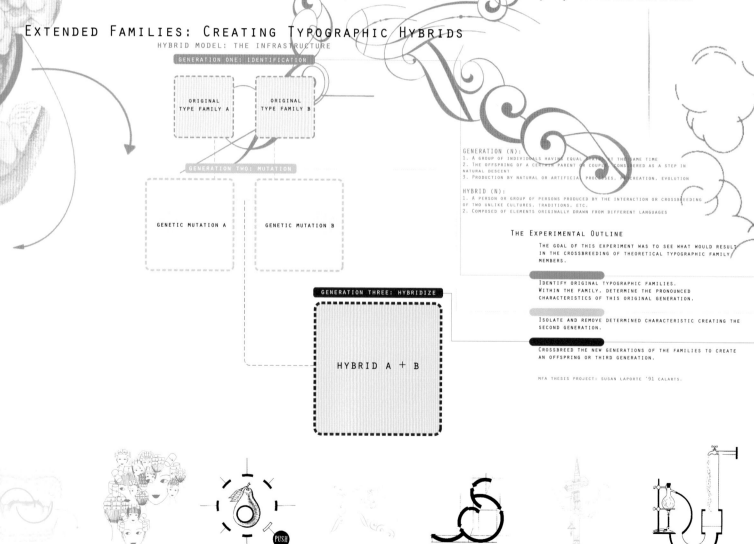

EXTENDED FAMILIES: CREATING TYPOGRAPHIC HYBRIDS

HYBRID MODEL: THE INFRASTRUCTURE

GENERATION ONE: IDENTIFICATION

ORIGINAL TYPE FAMILY A

ORIGINAL TYPE FAMILY B

GENERATION TWO: MUTATION

GENETIC MUTATION A

GENETIC MUTATION B

GENERATION (N):
1. A GROUP OF INDIVIDUALS HAVING EQUAL STATUS AT THE SAME TIME
2. THE OFFSPRING OF A CERTAIN PARENT OR COUPLE CONSIDERED AS A STEP IN NATURAL DESCENT
3. PRODUCTION BY NATURAL OR ARTIFICIAL PROCESSES, PROCREATION, EVOLUTION

HYBRID (N):
1. A PERSON OR GROUP OF PERSONS PRODUCED BY THE INTERACTION OR CROSSBREEDING OF TWO UNLIKE CULTURES, TRADITIONS, ETC.
2. COMPOSED OF ELEMENTS ORIGINALLY DRAWN FROM DIFFERENT LANGUAGES

THE EXPERIMENTAL OUTLINE
THE GOAL OF THIS EXPERIMENT WAS TO SEE WHAT WOULD RESULT IN THE CROSSBREEDING OF THEORETICAL TYPOGRAPHIC FAMILY MEMBERS.

IDENTIFY ORIGINAL TYPOGRAPHIC FAMILIES.
WITHIN THE FAMILY, DETERMINE THE PRONOUNCED CHARACTERISTICS OF THIS ORIGINAL GENERATION.

ISOLATE AND REMOVE DETERMINED CHARACTERISTIC CREATING THE SECOND GENERATION.

CROSSBREED THE NEW GENERATIONS OF THE FAMILIES TO CREATE AN OFFSPRING OR THIRD GENERATION.

MFA THESIS PROJECT: SUSAN LAPORTE '91 CALARTS.

GENERATION THREE: HYBRIDIZE

HYBRID A + B

onrush parlor maids qy-(query) record player scaffolding tenon ureotelic

by hand and only later placed in Fontographer. LaPorte has developed a systematic process for typographic analysis and form giving.

Notes
1 Philip B. Meggs. A History of Graphic Design (New York: John Wiley & Sons, 1998, 3rd ed.): 239.
2 Susan LaPorte. 'Letterforms & Lexicons.' Emigre (no. 38, 'The Authentic Issue', 1996–97): 36.

LaPorte's MFA thesis project Extended Families (1991). The experiment crossbreeds theoretical typographic family members. There were three steps to the process: the identification of original typographic families and the recognition of their characteristics; the isolation and removal of specific characteristics to create the second generation; and crossbreeding to form a third generation.

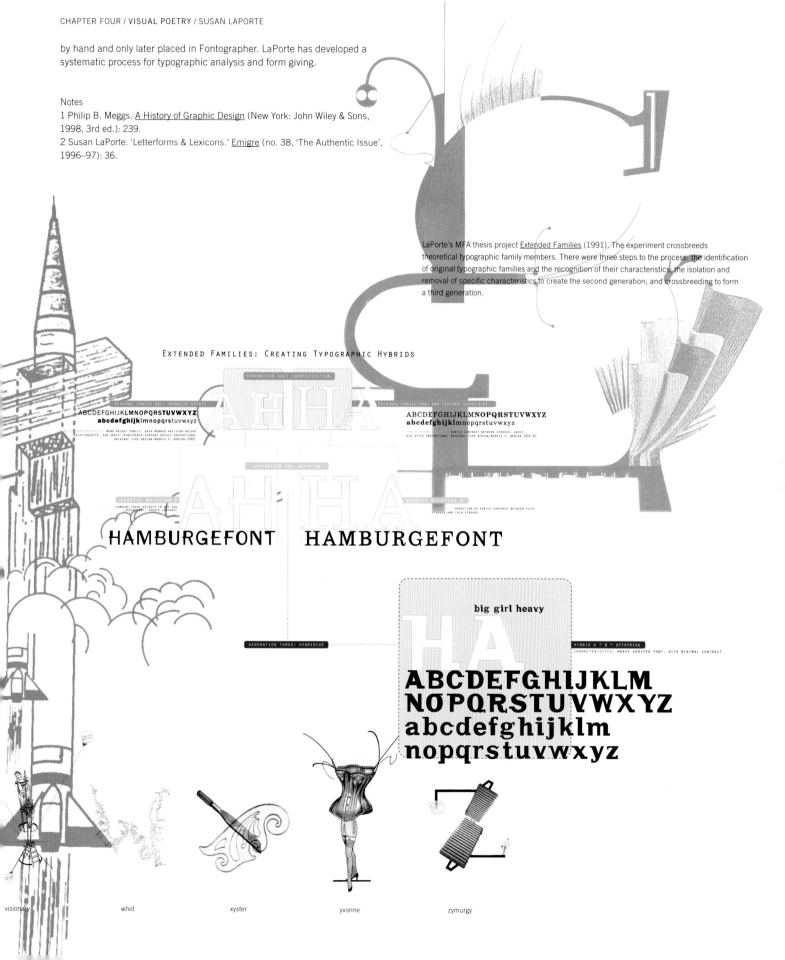

EXTENDED FAMILIES: CREATING TYPOGRAPHIC HYBRIDS

GENERATION ONE: IDENTIFICATION

ORIGINAL FAMILY ONE: FRANKLIN GOTHIC
ABCDEFGHIJKLMNOPQRSTUVWXYZ
abcdefghijklmnopqrstuvwxyz

ORIGINAL FAMILY TWO: NEW CENTURY SCHOOLBOOK
ABCDEFGHIJKLMNOPQRSTUVWXYZ
abcdefghijklmnopqrstuvwxyz

GENERATION TWO: MUTATION

HAMBURGEFONT HAMBURGEFONT

big girl heavy

GENERATION THREE: HYBRIDIZE

HYBRID A + B = OFFSPRING

ABCDEFGHIJKLM
NOPQRSTUVWXYZ
abcdefghijklm
nopqrstuvwxyz

visionary whid xyster yvonne zymurgy

Spreads from <u>aaa ooo eee, Confetti 25</u> (1991), published by Melle Hammer in a limited-edition of five hundred. He employs such variations in size and weight of the letterforms to replicate the sounds of a theatrical performance. Here, the word 'klap' is repeated as if reflecting the applause during a performance.

MELLE HAMMER

'gooi nooit zomaar wat stokken in de lucht
voor je het weet werp je een vijfkant
of vallen er woorden in het gras.'

– Melle Hammer

'do not carelessly throw sticks in the air
you may just cast a diamond
or words might fall upon the grass.'

– translation by Hans Kloos

'Experimental typography does not exist, nor ever has.

Typography exists within a social context. It's growing up in public. It's a living language with many dialects, which develops in a split between convention and imagination. Even when it is "disturbing", "accompanying" or "provoking" the text, decisions are made for the sake of the presentation* not to establish the presence of the design. In the reader's view, typography and content are isomorphic, but the typographer will never know if particular graphic choices are visible to the reader. Even an "unmarked" text seems to situate the reader in relation to the various levels of articulation of meaning. In that sense typography is always "experimental". As a typographer, it is impossible to escape being a translator. This forces him/her to be a very effective one, remaining consistent to the interpretation.

* The presentation is a complex grouping of significant elements. Although the typographer can explore new directions s/he will never want to cause confusion. An "experiment" may go against expectations of what a particular document will look like, but it will not (should not) be in contradiction to that which is cognisable. Given the constraints of a design brief, there is only "good" and "bad" typography.'

1 Hammer designed a puppet theatre for René Kool and The Seventh Museum (The Hague) that was easy to set up and used no screws or nails. The parts fit together like a Chinese puzzle and the depth and size of the opening are flexible. **2** Hammer did this self-portrait to accompany an interview in <u>Items 2</u> (1995).

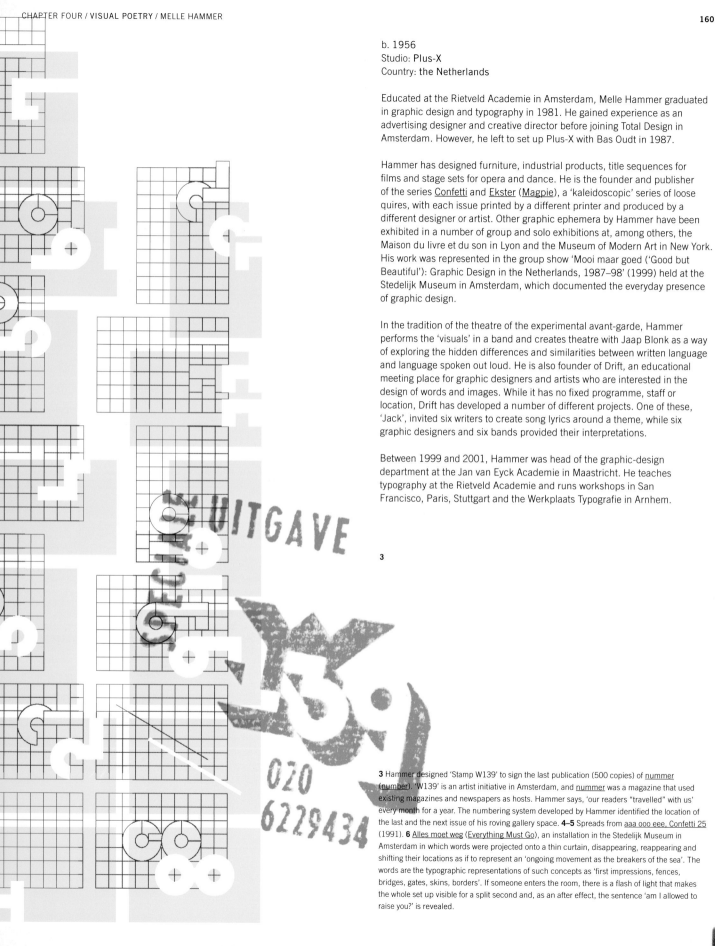

b. 1956
Studio: Plus-X
Country: the Netherlands

Educated at the Rietveld Academie in Amsterdam, Melle Hammer graduated in graphic design and typography in 1981. He gained experience as an advertising designer and creative director before joining Total Design in Amsterdam. However, he left to set up Plus-X with Bas Oudt in 1987.

Hammer has designed furniture, industrial products, title sequences for films and stage sets for opera and dance. He is the founder and publisher of the series Confetti and Ekster (Magpie), a 'kaleidoscopic' series of loose quires, with each issue printed by a different printer and produced by a different designer or artist. Other graphic ephemera by Hammer have been exhibited in a number of group and solo exhibitions at, among others, the Maison du livre et du son in Lyon and the Museum of Modern Art in New York. His work was represented in the group show 'Mooi maar goed ('Good but Beautiful'): Graphic Design in the Netherlands, 1987–98' (1999) held at the Stedelijk Museum in Amsterdam, which documented the everyday presence of graphic design.

In the tradition of the theatre of the experimental avant-garde, Hammer performs the 'visuals' in a band and creates theatre with Jaap Blonk as a way of exploring the hidden differences and similarities between written language and language spoken out loud. He is also founder of Drift, an educational meeting place for graphic designers and artists who are interested in the design of words and images. While it has no fixed programme, staff or location, Drift has developed a number of different projects. One of these, 'Jack', invited six writers to create song lyrics around a theme, while six graphic designers and six bands provided their interpretations.

Between 1999 and 2001, Hammer was head of the graphic-design department at the Jan van Eyck Academie in Maastricht. He teaches typography at the Rietveld Academie and runs workshops in San Francisco, Paris, Stuttgart and the Werkplaats Typografie in Arnhem.

3

3 Hammer designed 'Stamp W139' to sign the last publication (500 copies) of nummer (number). 'W139' is an artist initiative in Amsterdam, and nummer was a magazine that used existing magazines and newspapers as hosts. Hammer says, 'our readers "travelled" with us' every month for a year. The numbering system developed by Hammer identified the location of the last and the next issue of his roving gallery space. **4–5** Spreads from aaa ooo eee, Confetti 25 (1991). **6** Alles moet weg (Everything Must Go), an installation in the Stedelijk Museum in Amsterdam in which words were projected onto a thin curtain, disappearing, reappearing and shifting their locations as if to represent an 'ongoing movement as the breakers of the sea'. The words are the typographic representations of such concepts as 'first impressions, fences, bridges, gates, skins, borders'. If someone enters the room, there is a flash of light that makes the whole set up visible for a split second and, as an after effect, the sentence 'am I allowed to raise you?' is revealed.

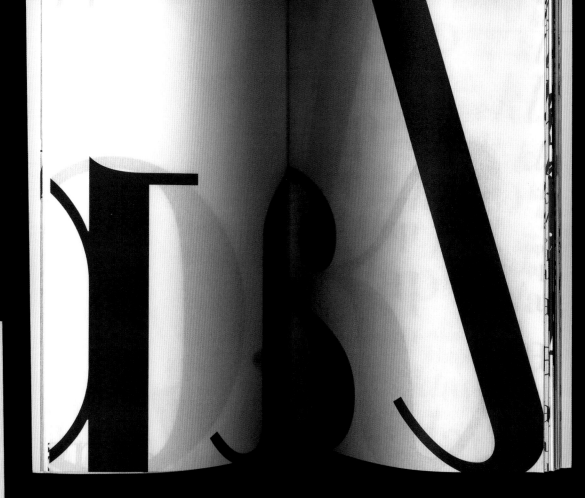

AANSTELLERIG

AARZELEND

BEHAAGZIEK

BRAAF

BRUTAAL

DEEMOEDIG

EIGENWIJS

HELDER

KLOTEN

OODZAKELIJKHEID

STEVIG

STRENG

HO

COQUETTISH

DECENT, OBEDIENT

PERT, INSOLENT
BAREFACED

HUMBLE, MEEK

CONCEITED
SMART-ASS

BRIGHT

BALLS, STRONG

NECESSITY

IN ALPHABETICAL ORDER
File under:
GRAPHIC DESIGN,
SCHOOLS or
WERKPLAATS
TYPOGRAFIE

ed. Stuart Bailey
NAi Publishers
Printed and bound in
the Netherlands
ISBN 90-5662-272-2

9 789056 622725

In Alphabetical Order (2002) is a retrospective of the Werkplaats Typografie, which tied in with an exhibition of their work at Amsterdam's Stedelijk Museum. As the book was about the five-year-old design school, Bailey was afraid that it might be in danger of 'premature self-mythologizing'. As a result, the book 'became as much, if not more, about graphic design (and the problems of presenting it) and schools (both design and general education) as the Werkplaats itself'.

STUART
BAILEY

'The closest I can get to answering this is to recommend listening to the back catalogue of The Fall: always the same, always different, as John Peel put it. To clarify:

Kurt Schwitters said
"Innumerable laws may be written about typography.
The most important is: never make it as someone before you did."

Anthony Froshaug said
"Schwitters is, here, quite wrong. Make it as they did unless the constraints are changed.

'Modern typography' is not a mode; it consists in a reasoned assessment of what is needed, and of what somehow is done, under certain constraints. When typographic and social constraints change, the important thing is not to spray a random pattern on the page but to assess the new, with the old, requirements of the text."

and Mark E. Smith said
"Whenever I say anything, I often think that the opposite is true as well. Sometimes I think the truth is too fucking obvious for people to take. The possibilities are endless and people don't like that. They go for the average every time. Well, that doesn't interest me in the slightest."'

b. 1973
Studio: independent designer
Country: United Kingdom

Stuart Bailey is a graduate of the University of Reading (1991–95), where he received a BA (Hons) in graphic design. He was among the first group of participants at the Werkplaats Typografie, an experimental postgraduate programme in Arnhem, the Netherlands (1998–2000). Since graduation Bailey has divided his time between London and Amsterdam, doing freelance work and teaching at the Rietveld Academie and in the department of typography and graphic communication at the University of Reading.

Bailey is co-founder (2000), with Peter Bil'ak, of the graphic-design magazine Dot dot dot to which he contributes as an editor, writer and designer. He is also an occasional contributor to such magazines as Eye and Emigre. His clients include everything Publications, Werkplaats Typografie, Unknown Public and the publishers 21, Thames & Hudson, Artimo, NAi and SUN. Bailey also records music on his own Northern Line label under the names Molecules and The Dow Jones.

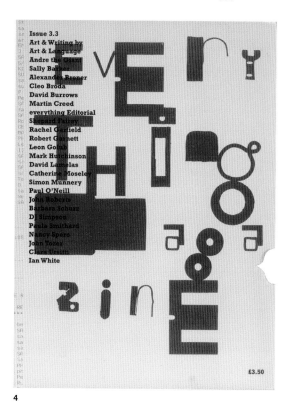

4

Stories written by Stuart Bailey

1

2

3

1–3 'CHANCE pamphlet. A few years ago I had an itch to write something about the use of chance in design. The only work that seemed worth paying attention to at that time seemed to share some sort of chance methodology. It was actually more to do with systems, though I didn't realise that until much later. 1997 was an odd year involving a lot of travelling. I spent a lot of time mailing, faxing and phoning a list of people in cities across Europe and America whose work I wanted to discuss. Over the course of these meetings, my ideas were becoming more clouded than clear; they wouldn't settle. Writing about the subject seemed to suck all the life out of it. On the other hand, the journeys and meetings themselves had been full of coincidence and lucky breaks. I ended up writing a sort of travelogue instead, and the design aspect crept in almost unconsciously. Then, just before Christmas, I was on my way to meet John with my year's worth of stories to tell. Walking past the bookshops on Charing Cross Road on the way to meet him in Covent Garden, I passed a small yellow card on the pavement. Picking up odd scraps of print is habitual, but I resisted for a few seconds. Then stopped, deliberating whether to go back and have a look. Carried on. Stopped again. Went back and picked it up. In small Helvetica capitals it said: CHANCE. I pocketed it and fled. The flipside of the mini Monopoly card said GO TO JAIL, which felt about as close to a conclusion as I was going to get. A few months later I made a small laser-printed pamphlet, designed by the Monopoly card, and sent a copy to everyone involved in the story. When the text was later published in Emigre magazine, I was asked for accompanying visual material – photographs, film, whatever – but I only had the card, which they didn't seem too keen on. When the issue eventually came out, the text was accompanied by Emigre editor Rudy VanderLans's own chance photography – pictures gone wrong, cut off at the end of the film or bleached by light, like flashbacks to the places I'd visited that year.'

4–7 '<u>everything Magazine</u> (the lowercase is a deliberate editorial affectation) is a long-running London-based independent art publication produced irregularly on a minimal budget. Asked to redesign it, we offered a limited grid system, simple enough for the editorial team to use themselves. Circumstances changed, of course, and we ended up producing each new layout ourselves. For the first four-issue volume we worked within our own self-imposed limits (whole-, half- or quarter-page images; three weights and sizes of Rockwell), but grew increasingly bored with it. After two issues we incorporated Paul Elliman's Bits font on the cover – an alphabet made from found objects, with the idea to change the objects each time. After issue 3.4, the editorial team were told they wouldn't receive any more funding unless they produced two issues very quickly, so we proposed making two issues at half the normal format. 4.1 and 4.2 were then shrink-wrapped together, with the covers facing outwards, and a number of the contributors made use of the possibility to work across the two issues. The magazine is founded on chaos and disorganization; in this sense at least it remains close to its fanzine roots, though we always had the feeling our tight redesign was too clean. For 4.1 and 4.2, then, we tried returning to a process now outdated by at least a decade: paste-up. We composed pages by sticking blocks of text, uncropped images and page numbers onto template spreads with magic tape. These spreads were then scanned and repositioned in Quark for printing: a perfectly stupid, fake and unnecessary system, very impractical for proofing and correcting, but actually resulting in the right sort of roughness. Never again, but the shrunken format will remain for future issues: everybody that holds it says it feels right.' (volumes 4.1 and 4.2 of <u>everything Magazine</u> were designed with Ruth Blacksell and Paul Elliman.)

8

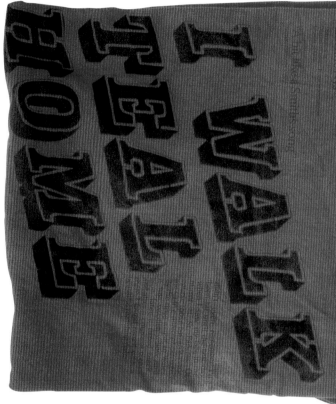
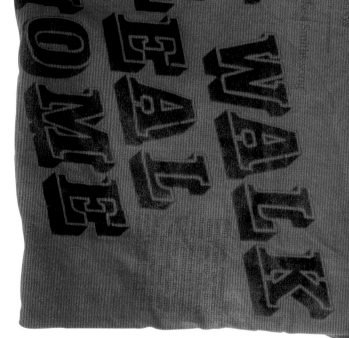

5

6

7

9

8–9 'I Walk Teal Home' T-shirt. 'This was an afterthought following a project made in conjunction with the artist Ryan Gander. It was part of a bigger work of his that involved asking nine friends to design and make posters for fictitious products and events, including a computer game, a CD, a lecture and a club night. For each project, Gander supplied a written brief containing a concise description of the product/event and an inventory of the material to appear on the poster. One subtext of the project was the inclusion of a colour in every title. I was assigned "Walking Teal Home", which I changed to "I Walk Teal Home" as it fitted better (this was within the rules) – an art film set in Wales. The project was an interesting failure, because all the designers knew the posters were going to end up in a gallery; if strangers had been commissioned, the result would have been very different. The nine works exist in an odd twilight-zone between personal project and commission, between art and design, with a number of personal twists. For example, I used a photograph from my own seaside childhood, and incorporated a spoken-word text, also about colours. The obligatory personnel list at the foot of the poster is drawn from Italo Calvino's <u>If on a Winter's Night a Traveller</u>, itself about the fake and incomplete. The T-shirt was one of a few additional objects worn at the opening of the poster exhibition, intended to look like a cheap promo from the film company.'

Dot dot dot is published twice a year. In the first issue, the editors stated, 'We are not interested in re-promoting established material or creating another "portfolio" magazine. Instead, we hope to offer inventive critical journalism on a variety of topics related both directly and indirectly to graphic-design culture.' [www.dot-dot-dot.org] **10** A spread from the magazine. **11** The cover of Dot dot dot (no. 4) was designed with goodwill (Will Holder).

n.b. Not exactly a graphic design magazine, more an attempt
Pay no more than 10 Euros

ellipsis (i'lipsis) n., pl. **-ses** (-sɪz). 1. Also called: **eclipsis**, **ellipsis**. omission of parts of a word or sentence. 2. *Printing* a sequence of three dots (...) indicating an omission in text. [C16: from Latin, from Greek *elleipsis* omission, from *elleipein* to leave out, from *leipein* to leave]

elliptical (i'lɪptɪk'l) *adj.* 1. relating to or having the shape of an ellipse. 2. relating to or resulting from ellipsis. 3. (of speech, literary style, etc.) **a.** very condensed or concise, often so as to be obscure or ambiguous. **b.** circumlocutory or long-winded. —Also (for senses 1 and 2): **elliptic**. —el'liptically *adv.* —el'lipticalness *n.* ▷ *Usage.* The use of *elliptical* to mean *circumlocutory* is avoided by many careful speakers and writers.

elliptic geometry *n.* another name for *Riemannian geometry*.

Dot dot dot Nº4 (ISSN 1615-1968)

a. Archæological æsthetics **b.** Based on true stories **c.** Stroppy/Revelatory

[This page consists of a dense collage of fragmentary text from web search result listings, yellow-pages category indexes, and online bookstore catalog entries, overlaid with ASCII-art lettering. Only the most clearly legible anchor elements are reproduced below.]

Yellow Pages International search on "e"

Jump to: Reviewed Web Site Topics

ENGINES GASOLINE REPAIRING
ENGINES GASOLINE WHOLESALE
ENGINES MARINE REPAIRING
ENGINES REBUILDING & EXCHANGING
ENGINES SUPPLIES & PARTS (MFRS)
ENGRAVERS
ENGRAVERS GENERAL (MANUFACTURERS)
ENGRAVERS METAL
ENGRAVERS PHOTO
ENGRAVERS RUBBER
...

E-Cards
Every E-Card you send contributes to the
World Wildlife Fund. E-Cards are free to
send. E-Cards (video postcards) are also avail-
able.

RESULTS 1 - 10 of 30,509,202 total results

RESULTS 11 - 20 of 30,509,202 total results

RESULTS 21 - 30 of 30,509,202 total results

Excite search for "e"

LookSmart — Government of Canada

From LookSmart category — North America - Canada

Search Again search for: E

Yellow Pages Netscape Search results on "e"

AltaVista search result on "e" — AltaVista: No answer! 000

Book Search results — Powell's Book Search Results : Books on "e"

17 november 1998, 20:00
"defining research"

1

PETER BIL'AK

2

FFEûřékåMoňo FF FFËûřèkạŠáñ

'I was just thinking how am I going to respond to defining experimental typography. I was always very suspicious of the word, it sounds like a disclaimer, indicating that people shouldn't take it seriously. It just confirms the schizophrenia found in current design: people creating work to make a living and a completely different design that is seen as experimental in order to score at the design competitions. I guess the point would be to have "experimental" work function in a real environment so it can prove itself. Well, I guess this will be my response.'

Đ

/

>

X

r

Ç

ß

¡

1 The poster 'Paul Elliman On "E"' (1998) was designed for a lecture given by Paul Elliman at the Jan van Eyck Academie in Maastricht. The letter 'E' was the only information offered to Bil'ak about the subject of Elliman's lecture. So, to document the ambiguity and vastness of the talk, Bil'ak entered the letter 'E' into various search engines on the web, and a sample portion of the 35,000,000 results was used to produce the poster. **2** These postcards featuring the typeface Eureka (1995–2000) were what Bil'ak considered a 'useful experiment' in the design of his large type family. He also created a central European version containing all the accents and diacritical marks needed for such languages as Polish, Hungarian, Czech, French and Slovak. The font is available in three styles – serif, sans serif, monospaced – and consists of more than 15,000 characters.

b. 1973
Studio: Typotheque and Peter Bil'ak, Graphic & Interactive Design
Country: Slovakia/the Netherlands

Peter Bil'ak has studied in England, the United States, France, the Netherlands and Slovakia. While in the United States, he published his research in Illegibility (self-published, 1995), and while in France, he undertook a postgraduate course in typography at the Atelier National de Création Typographique, Paris. His second book Transparency (self-published, 1997) was launched in Slovakia. He attended The Academy of Fine Arts and Design in Bratislava, Slovakia (1991–97) and the Jan van Eyck Academie (1997–99) in Maastricht. Bil'ak currently teaches part-time at the Art Academy in Arnhem and on the postgraduate course 'Type & Media' at the Royal Academy in The Hague.

He has gone from being an art director for BBDO Bratislava in Slovakia to being a graphic and multimedia designer for Studio Dumbar in The Hague and, finally, to starting his own studio in 2001. The studio works in the field of editorial, graphic, type and web design, on cultural and commercial projects, with a focus on the creation of custom-made fonts. Clients include, STROOM (The Hague Art Center), Frame magazine (Amsterdam), the Ministry of

Agriculture, Nature Management and Fisheries, the Institut Curie (Paris) and the Slovak Design Centre (Bratislava). He has designed several fonts for FontShop, including Eureka (1995–2000), and is also the creator of Fedra Sans (2001), which is distributed through his independent foundry, Typotheque.

Bil'ak has lectured on his work internationally and it has been exhibited in 'Video Lisboa 2001' in Portugal, the 17th International Biennale of Graphic Design in Brno (Czech Republic), 'New Typo' in Pécs (Hungary), 'The Next Generation' in Nagoya (Japan) and the Conduit 3 Digital Film Festival in Austin, Texas. Bil'ak is contributing editor to Deleatur and DeSignUm magazines, and co-founded the magazine Dot dot dot (2000) with Stuart Bailey. Bil'ak was winner of Adobe's Imagine '96 International Design Competition (1996), the Neografia Design Award in Slovakia (1998), the National Design Award from the Slovak Design Centre (1998), the 19th International Biennale of Graphic Design (Brno, 2002) and the Deutscher Preis für Kommunikationdesign (2000).

3

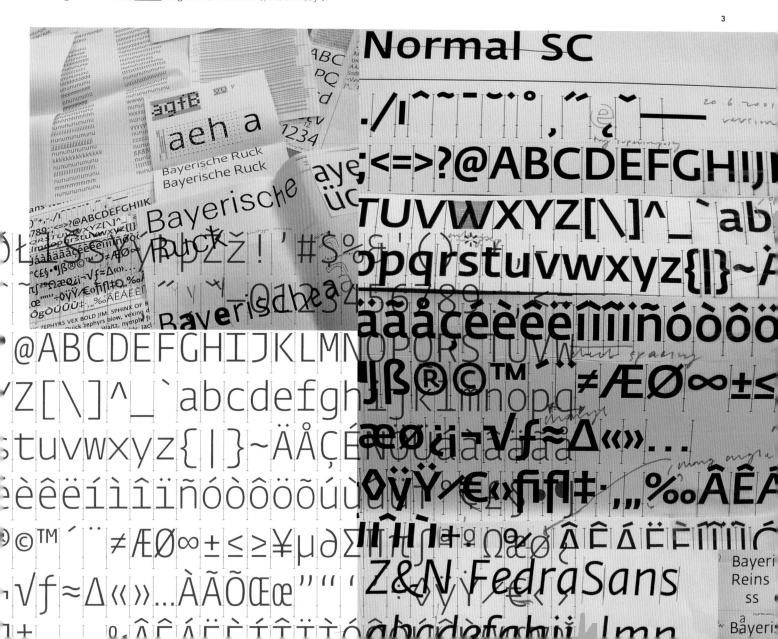

3 Sketch and test work for the typeface **Fedra Mono** (2002), developed for an annual report that required a fixed-width counterpart to **Fedra Sans** and a central European and Turkish character set. **Fedra Sans** (2001) was commissioned by Ruedi Baur Integral Design as a corporate font for Bayerische Rück, a German insurance company. Although the font was never used by the corporation, Bil'ak continued to develop the typeface by adding extra weights and expert fonts. **Fedra** balances humanistic roots (handwriting) with rational drawings on a coarse computer-screen grid (which, together with an enlarged x-height, makes the font particularly suitable for screen use). **4** 'Interactive Font Tester' (2002) was created as a typographic toy, an informal online chat box for those interested in seeing how particular typefaces are rendered. Users can create their own text sample, selecting the font, weight and point size. The text is then stored as the background of the viewing area.

4

hi Teal! good morning , péter thanks. time to go t Enter text... let\'s use this as well? the tester? fine

5 Sample stills from <u>Typo Ballet</u> (1998–99), a video set in five acts that explores the typeface **Eureka** in all its variations (italics, bold, small caps and regular, among others).

5

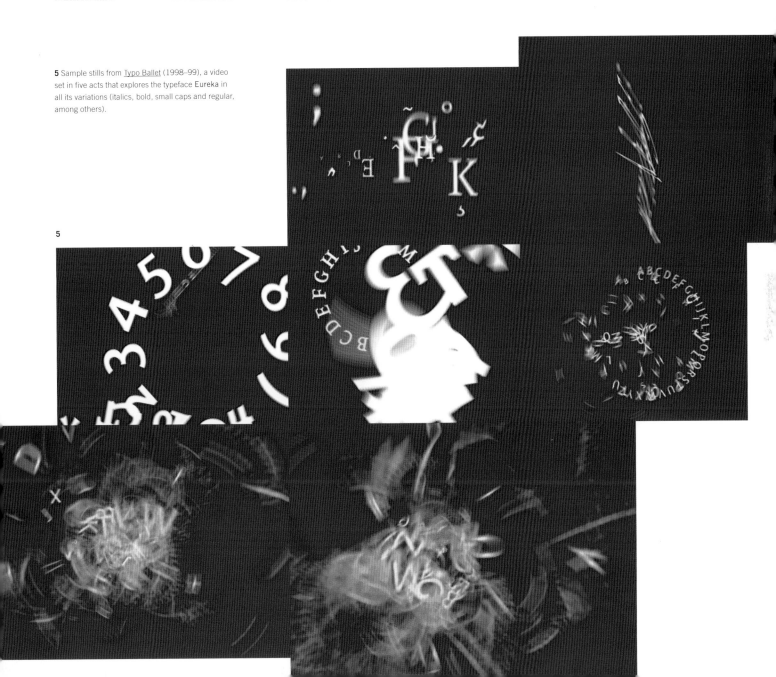

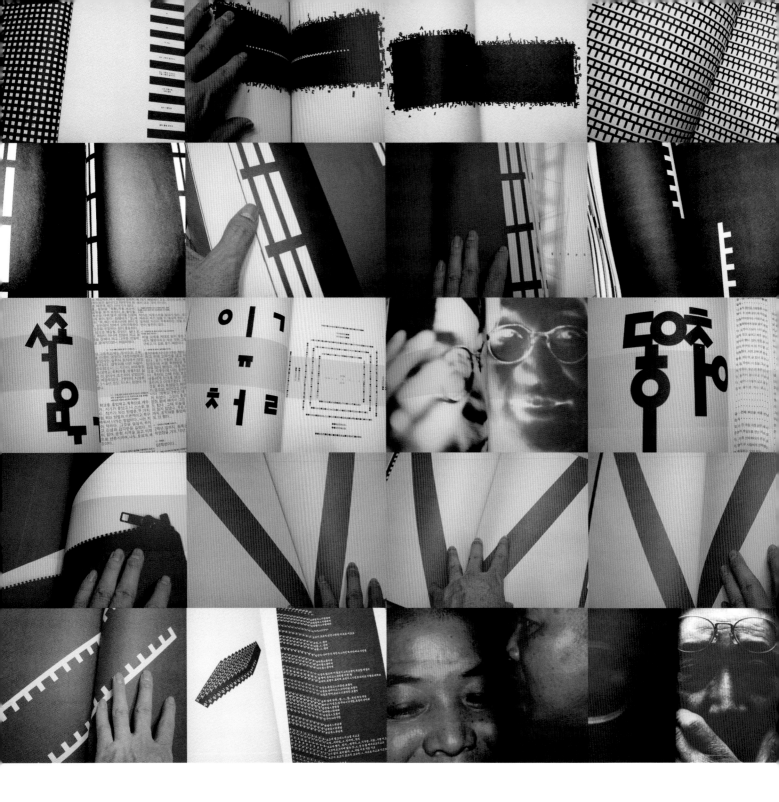

Spreads from the underground art-culture magazine <u>Bogoseo/Bogoseo</u> ('Report/Report'), for which
Ahn Sang-Soo is editor and art director. The layouts demonstrate a playful, yet visually structured
approach to typographic organization. Ahn uses the magazine to combine his interest in art and life
with typographic experimentation.

AHN SANG-SOO

'typographic.experiment.is.f(p)un.
(e.)x)perimental.

it.is.gaining.freedom.from.meaning.
with.axe-like.visual.language.cleaving.the.mystery.of.empty.space.
private.imagination.energetically.invading.public.space.

it.takes.place.where.
the.visual.sense.meets.the.other.senses.
and.we.force.it.out.to.beyond.the.perceptible.senses.

transformed by.external.forces.
"do.we.have.nothing.left?"
questions.to.ourselves.guide.us.to.experimental.works.

i.am.who.i.am.

if.we.say.
that.tradition.is.the.root.or.trunk.of.a.tree.
then.experimenting.is.fresh.new.leaves.
thus.complementary.
experiment.and.tradition.belong.to.
the.same.tree.

big.trunk.
by.the.leaves.fiercely.active.photosynthesis.
give.blossom.to.beautiful.flowers.
for.a.bigger.more.beautiful.tree.'

b. 1952
Studio: Ahn Graphics
Country: South Korea

Long one of the most influential designers and educators in East Asia, Ahn Sang-Soo has won the respect of students and designers internationally with his typographic development work. A graduate of Seoul's Hongik University, he was made a professor in the university's College of Fine Arts in 1991. By 1995 he had completed his doctorate thesis in the department of applied arts at Seoul's Hanyang University, and, in 2001, he received an honorary doctorate from Kingston University, UK for his contribution to graphic design and typography. He served as vice-president on the International Council of Graphic Design Associations from 1997 to 2001. In October 2000, he chaired ICOGRADA's prestigious Millennium Congress Oullim (meaning 'great harmony') in Seoul, and directed the ICOGRADA Design Education Manifesto project. He also organized the first TypoJanchi, an international typography biennale, in Seoul (2001), which attracted designers from all over the world.

Ahn's thesis focused on the work of the Korean poet Isang Yun, who, in the 1930s, explored type as a visual element often 'relegating literal meaning to a separate, sometimes subordinate role'[1]. Ahn is interested in the 'cultural position of language', however, his graphic-design work often emphasizes the more formal aspects of typographic composition. He is perhaps best known for having 'master-minded and supervised a revolutionary transition' of the Korean alphabet, Hangul, transforming the traditional letterform into a functional medium for contemporary usage 'with all its digital demands and interpretations'. This earned him a commendation from the Hangul Academy for his contribution to the advancement of Hangul (1988). Ahn's fonts are based primarily upon systems of regularized modules – he has completed four typefaces to date – and symbolically break away from the traditional Korean writing system inspired by the Chinese arrangement of characters in a square.

Having received a number of awards and prizes, Ahn was selected as designer of the year by Design magazine in 1983. He won the Korean Journalism Award for research into the readability of newspaper typography (1983) and has designed many major international exhibitions and contributed to over forty shows. Ahn has authored fifteen books and numerous essays and papers, including translations of seminal works on typography by Jan Tschichold and Emil Ruder.

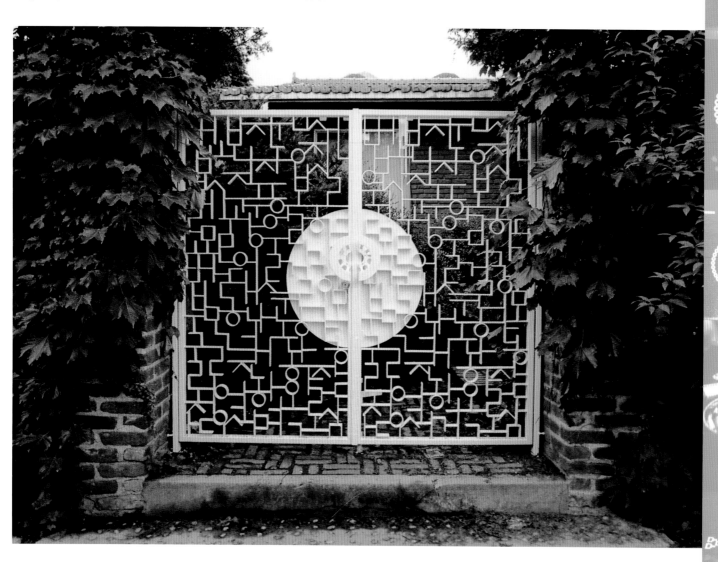

Ahn created a mosaic-like pattern of letterforms for the Hangul Gate (2001), the entrance to his home in Korea. The poem used to create the pattern is by Kwang Duk, a leader in contemporary Korean Buddhism. One critic described the letterforms as creating a form of 'geometric aestheticism'.

Note
1 Maggie Kinser Saiki. 'Ahn Sang-Soo: Going Home.' <u>Graphis</u> (no. 327): 33.

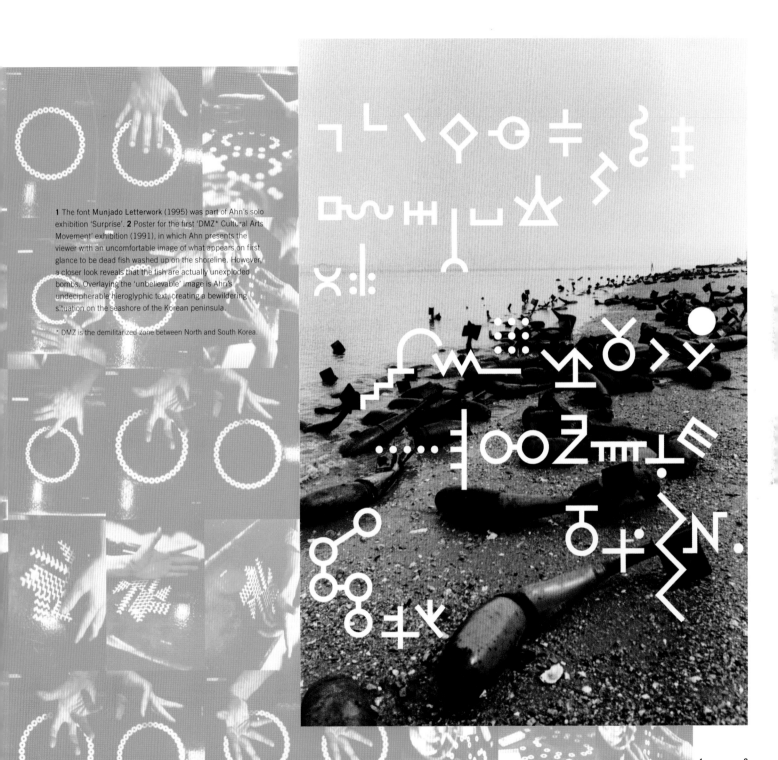

1 The font Munjado Letterwork (1995) was part of Ahn's solo exhibition 'Surprise'. 2 Poster for the first 'DMZ* Cultural Arts Movement' exhibition (1991), in which Ahn presents the viewer with an uncomfortable image of what appears on first glance to be dead fish washed up on the shoreline. However, a closer look reveals that the fish are actually unexploded bombs. Overlaying the 'unbelievable' image is Ahn's undecipherable hieroglyphic text, creating a bewildering situation on the seashore of the Korean peninsula.

* DMZ is the demilitarized zone between North and South Korea.

1 2

SPACE/
SIGHT

Essays by Laura Letinsky and
Elizabeth Bloom

Contributions from

Catherine Cooper
(Jürgen Mayer Hermann)

Jasmine Davila
(Brett Bloom)

Liv Gjestvang
(Dawoud Bey, Nina Levitt)

Tony Neuhoff
(Holly Rittenhouse,
Inez van Lamsweerde)

Anna Pomykala
(Alice Hargrave,
Byron Kim, Ana Mendieta)

Liza Siegler
(Francesca Woodman)

The David and Alfred Smart
Museum of Art

The University of Chicago

/SELF

STUDIO BLUE

Weese: 'On experimental typography, I suppose the place to start is by defining what isn't experimental.

What isn't:

typefaces based on Renaissance, nineteenth-century grotesque, or twentieth-century Modernist models – all of which may have been considered experimental initially, but have become canonical with widespread use (though unexpected permutations or juxtapositions of these types can be experimental)

typefaces or typesetting whose primary aim is the transmission of information and easy legibility

typography that seems understood, expected, known

The typography I make that I consider experimental is:

creating typefaces or groups of symbols from found objects and found, three-dimensional lettering

reworking existing typefaces in a way that gives them attributes that are personal, individual and project-specific

creating type that somehow feels made, rather than typeset; working it over until the integrity of the hand dominates and the influence of the machine is submerged; so that the type takes on a specific, self-referential geist and spirit

typography that is used in a way that surprises, that provokes wonder and curiosity, that questions readers and asks them to look further, and that is a sort of intellectual sport.'

Cheryl Towler Weese
b. 1964
Kathy Fredrickson
b. 1960
Studio: Studio Blue
Country: United States of America

Cheryl Towler Weese and Kathy Fredrickson are Studio Blue. Weese formed the studio in 1993 to 'push buttons and connect dots, incorporate viewpoints and most of all to facilitate understanding'. The majority of their projects are rooted in the liberal arts and they skilfully develop solutions to briefs that incorporate culture and context. Projects are approached collaboratively – as a design team and as a close collaboration between client and designer – and include book design, environmental design, identities and a range of web and printed matter. Among their clients are the American Institute of Graphic Arts (AIGA), Guggenheim Museum Publications and Harry N. Abrams. They have created identity systems, environmental design and exhibitions for The Art Institute of Chicago, Chicago Music and Dance Theater and Winnetka Congregational Church, Illinois. An interest in typographic interaction, colour, play and 'meaningful associations' have resulted in numerous awards, including the Carl Hertzog Award for Excellence in Book Design,

and recognition from the Association of American University Presses, the American Center for Design and the AIGA.

Cheryl Towler Weese received a BFA in art and art history from Wesleyan University, Illinois (1987) and an MFA in graphic design from Yale University (1991). Before setting up Studio Blue, Weese worked in newspaper design and production and in graphic-design firms in Connecticut and Chicago. She was an adjunct assistant professor (1993) and a visiting critic (1998–2001) at the University of Illinois in Chicago. She has also been a visiting critic at Washington University School of Art (1997–2000).

Kathy Fredrickson received a BA in English literature and studio art (1982) and an MA in arts administration (1997). She became a partner in Studio Blue in 1995, before which she had been an associate director for the publications department at The Art Institute of Chicago (1993–95) and production manager at The Metropolitan Museum of Art (1986–87) and at Aperture, Inc. in New York (1985–86).

The "flat in back" is a type of head shape used in making detailed verbal and written descriptions of the human body.

Hermann Rorschach was the first to use ink blots as a visual stimulus for free association in tests to identify particular characteristics of an individual's personality.

FLAT IN BACK

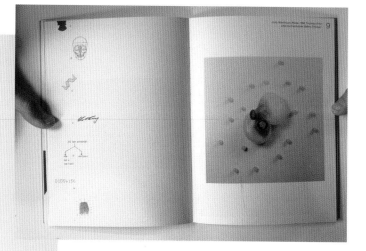

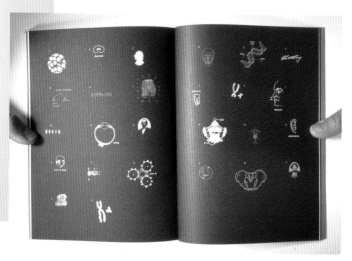

The book Space/Sight/Self (1998) documents an exhibition examining the role of portraiture and identity in contemporary art. The book's design was as generic as possible, playing off the notion of identity. All the title type was scanned from the ubiquitous plastic letters on signs from funeral parlours to discount carpet stores. Essays are typeset large in Akzidenz Grotesk. Twenty-six concrete images of identity – fingerprints, passports and DNA – act as foils to the more fluid representations of identity proposed by the artwork in the show.

The Chicago Park District and The Art Institute of Chicago commissioned artist Louise Bourgeois to create a set of six small sculptures to commemorate Jane Addams. Working with a curator, artist, architect, editor, historian and local museum, Studio Blue created four bronze signs placed in a circle around the sculptures. The signs, which over time will weather and turn green, are like open books and are based upon Jane Addams's life as a pacifist, visionary and Hull-House (a social settlement) founder. The typography is restrained but reflects the park's location as a quiet refuge.

The catalogue <u>Literary Objects: Flaubert</u> (1998) was for an exhibition that compared object descriptions by Gustave Flaubert to decorative arts owned by The Smart Museum of Art in Chicago. The designers tried to replicate Flaubert's writing style – 'sumptuous, sometimes almost erotic' – by creating a typographic environment that felt like a boudoir from the 1860s. The catalogue is organized like Diderot's encyclopedia, with each text and image numbered or lettered.

SMALL SCREEN (BIGGER PICTURE)

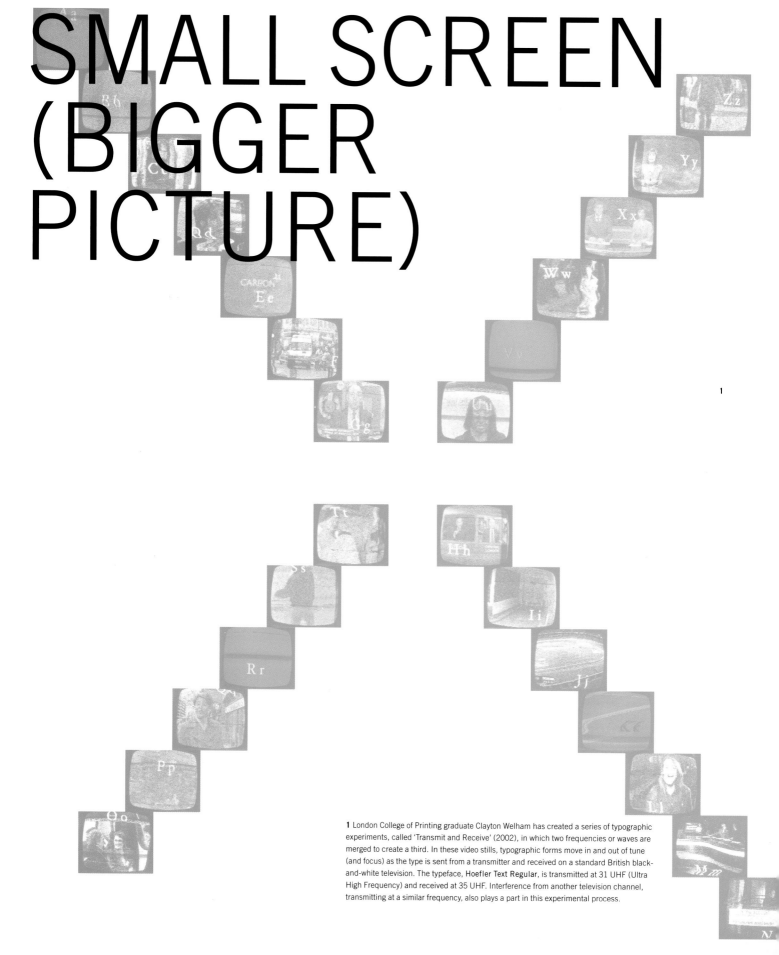

1 London College of Printing graduate Clayton Welham has created a series of typographic experiments, called 'Transmit and Receive' (2002), in which two frequencies or waves are merged to create a third. In these video stills, typographic forms move in and out of tune (and focus) as the type is sent from a transmitter and received on a standard British black-and-white television. The typeface, Hoefler Text Regular, is transmitted at 31 UHF (Ultra High Frequency) and received at 35 UHF. Interference from another television channel, transmitting at a similar frequency, also plays a part in this experimental process.

With the development of new digital technologies, alternative ways of communicating using screen-based environments have become increasingly commonplace. Whether through computers, interactive television, or, more publicly, our architectural environment, the transition from print to screen has prompted a review of the ways in which movement, time, visual and audible sensations might be employed. An integral part of the process includes re-examining how space can be defined and experienced, and it is here that typography has a role to play. The typographic form is embedded on the page (or screen), thereby describing the area spatially. As a system of representation, the word 'freezes the flow of experience', and when considered typographically through the use of scale, weight or hierarchical structures, it creates a physical space. David Harvey explains in The Condition of Postmodernity, 'even the written word abstracts properties from the flux of experience and fixes them in spatial form'[1]. Precedents are found in such art movements as Futurism, which sought to 'shape space in ways that could represent speed and motion', and in Dadaism, whose proponents viewed art as ephemeral, and, at best, its space temporal. In either case, the typographic marks made by these artists, poets, writers and sculptors on two-dimensional surfaces visually formed a spatial construct that evaluated the political, economic and cultural processes of their times.

Bauhaus artist László Moholy-Nagy experimented with the expressive qualities offered by film, foreshadowing some of the basic principles in producing cinematic spaces. For example, the way in which the medium creates a dynamic tension between the 'actor and set, light and dark, film movement and audience reaction'[2]. Non-representational cinematography led Moholy-Nagy to explore kinetic compositions, and, in 1947, he promoted a 'vision in motion' based upon the creation of a dialogue between image and text. Images, he proposed were there to 'illustrate the discourse' but as importantly to 'complete the discourse' to attain a 'better visual communication'. He also recognized that 'visual-typographical design' was a 'simultaneous experience of vision and communication', arguing that it was 'a form of communication and not just the practical vehicle to put across an "external" message'[3]. Equally, he accepted that each generation has its own visual forms and corresponding typography, which not only relate to cultural or social contexts but also to new production and printing methods.

More recently, new-media scholar Jay David Bolter comments that typography and writing has changed specifically in relationship to the shift from the papyrus roll, to codex, to the printed book and to screen-based work. He questions the way in which typography is treated visually and also the relationships between image, text, sound and time. Screen-based

2

3

2 This Smirnoff Vodka advertising poster (1990), created by Why Not Associates, appeared in the London underground and predates the recent popularity of computer-generated, three-dimensional typographic constructions. Here, models were created in the studio and then photographed. **3** The Virgin project was a series of four annual conference videos that Why Not Associates completed, each with a different visual theme and style. Each video consisted of introductory and concluding sequences and thirty minutes of footage of various artists' work. Why Not experimented with all forms of the moving image – typography, 3-D animation, film. For the 1999 video, for example, they selected quotes from each artist and animated their words in relation to their speech patterns.

experiments have focused on organizational and narrative relationships and, in particular, on the use of hypertext. Bolter observes, in his article 'Topographic Writing: Hypertext and the Electronic Writing Space', 'hypertext forces us to redefine text as a structure of visible elements on the screen and as a structure of signs in the minds of writers and their readers'. He suggests, 'hypertext is the typography of the electronic medium', where the 'electronic writing space' is comprised of signs. Hypertext holds meaning but now connects the 'set of symbolic elements', once meant to be read in a linear fashion, as an experiment in 'a new form of [interactive] dialogue'[4]. In this way, interactivity may be defined as the viewer or reader taking an active role in producing what they are seeing or reading.

SMALL SCREEN

The interactive experiments of graphic designer David Small take this idea one step further. While a doctorate student at the MIT Media Lab, Small produced the Talmud Project (1998–99), an interactive book that explores the way layers of complex information might be conveyed within the digital landscape. The Talmud is the primary source of Jewish religious law. Small represented the polemic fuelled by the Talmud by linking passages taken from the sacred writings with philosopher Emmanuel Levinas's critical commentary (in English and French) on the Talmud. Small facilitated the

reader's control over 'conceptual chunks of information' by using hyperlinked texts. At the same time he considered how type is read and used on screen: its perspective and distortion, its size, its spatial depth and its expressive potential. Experimental software tools aided Small's enquiry into 'three-dimensional graphics as a medium for typographic communication'[5].

Similarly, designer and educator Michael Worthington (see pp. 114–19) argues that using new technology is not enough and that beneath the surface 'there are possibilities to widen the expressive range of typography, and find new directions for the discipline that can provide a greater cultural longevity'[6]. Worthington believes that interactive type should emphasize structure and navigation and make the reader an active participant. This is exemplified in his CD-Rom Hypertype (1995), in which the reader moves through multiple layers of information. Typefaces are used to identify a range of contemporary debates from graphic authorship to the vernacular in design. In more recent musings on typography, Worthington suggests that in the 1990s motion was implied within the static page by creating three-dimensional letterforms, which gave the illusion of navigation, and where appropriate filmic references to sequential imagery. In the move from stasis to kinetics and from print to screen-based design, interactivity has become increasingly important in the consideration of 'cinematic space'.

4 The Talmud Project (1998–99) by David Small explores the way in which communication may be helped by using three-dimensional graphics.

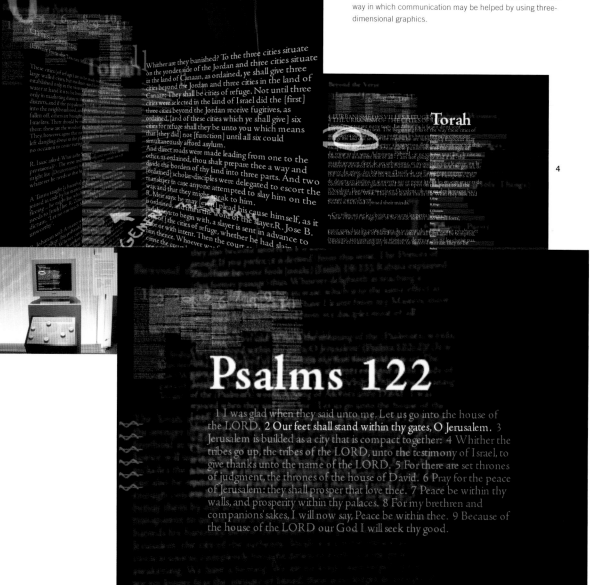

4

BIGGER PICTURE

Jessica Helfand writes in Six (+2) Essays on Design and New Media that interactivity with the movie screen was 'primarily a consequence of seeing and responding internally – viscerally, even – to a moment observed', whereas now 'filmic storytelling offers a more compelling way to think about the power of visual narrative'[7]. Film title sequences, for example, are short introductory statements, but are also charged with selling the content of the film. They must convey information and create a recognizable brand identity, as is evident in such title sequences by Saul Bass as those for Carmen Jones (1954), The Man with the Golden Arm (1955) and Vertigo (1958), and in those created for the James Bond films by Robert Brownjohn, including From Russia With Love (1963). The 1960s also produced noted work from designer Pablo Ferro with his sequences for Dr Strangelove (1963) and The Thomas Crown Affair (1968). The critic Peter Hall wrote that it was this 'first title wave' of films that 'established the opening credits sequence as a significant ingredient of a movie'[8]. These are also good examples of typography as an integral part of the image-making process while maintaining its position as a carrier of information.

By 1977, and with the founding of the New York–based R/Greenberg Associates, the next wave of film sequences initiated a trend for special effects. Perhaps the best-known example is The World According to Garp (1982), where 'a baby floats effortlessly in the sky – gurgling, smiling, clutching its feet in delight'[9]. In a bid to create an image sequence that would appear smoothly simulated, the designers experimented with new forms of computer technology, combining shots of animation and live action on an optical printer. Also in 1982, Martin Lambie-Nairn animated a new brand identity for the British television station Channel Four using a 'high-powered' flight-simulation computer to bring together differently coloured bars to form the logotype '4'. By making the process in which the numeral is constructed part of the logotype itself, Lambie-Nairn marries the constituent parts of sign and symbol.

A decade later, designers stood back from the visual homogeneity created by the 'slickness' of computer technology, focusing instead on the cultural and narrative-inspired contexts of their typographic forms. Kyle Cooper, a designer at R/Greenberg Associates before forming Imaginary Forces (1996), created the title sequences for the feature film Seven (1995), which has become one of the most widely imitated typographic motion sequences of all time. Cooper represents the dark side of this psychological thriller in scratchy lines that jump across the screen, degraded type and a process of carelessly scrawled handwritten texts that are juxtaposed with rough-cut footage of the serial

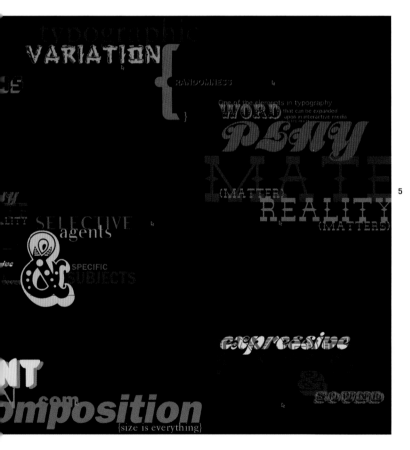

5 6 7

5 The CD-Rom Hypertype (1995) was written and designed by Michael Worthington as part of his thesis project, which questioned the role typography plays in interactivity on screen.

6 Spreads from the article 'Sex and Typography' by Robert Brownjohn in Typographica (no. 10, December 1964). Watching the effect of still type projected onto moving bodies as people arrived late for a slide presentation notably influenced Brownjohn, and he went on to do the title sequences for From Russia with Love (1963), Goldfinger (1964) and a series of cinema commercials for Midland Bank, UK. [Katy Homans, 'BJ', Eye (vol. 4, no. 1, 1991): 60]

murderer's tools of mutilation. The sequence reflected the grunge music scene of the 1990s, and Cooper brought the use of distressed lettering and shaky camera movements often used in experimental film and music videos to the big screen.

Visual strategies developed by Marlene McCarty of Bureau, for such typographic sequences as those in I Shot Andy Warhol (1996), capitalized on the use of low-tech technology, often in low-budget productions. However, McCarty was able to use effectively the films' budgetary constraints as aesthetic strengths appropriate to the tenor of the stories[10]. Trainspotting (1996), on the other hand, reflects British collective Tomato's early typographic experimentation with fast-cut frames of abstract shapes, flickering lights and typographic brevity. Mimicking the pace of trains and the surreal drug-induced moments experienced by the main characters, designer Jason Kedgley provides a typographic rendition of the gritty underworld theme of the controversial Irvine Welsh novel (1993) from which the film was adapted. A year earlier, in 1995, Jonathan Barnbrook created the highly successful television commercial 'Foggie Bummer' (Scottish dialect for 'bee') to promote BBC Radio Scotland. Barnbrook used type to replicate visually the dialect and verbal pace of the Scottish voice-over. Roland Barthes argued 'the meaning of images … is always related to, and, in a sense, dependent

on verbal text' and, in much of the work produced over the last decade, this has been the case. However, Gunther Kress and Theo van Leeuwen propose that equally 'communication starts from a social base' and that we must consider the 'different media through which texts are constructed and show these social differences in contrasting encodings'. They continue, 'in a multimodal text using images and writing, the writing may carry one set of meanings and the images another'[11]. Typography has been used historically to portray the dynamic changes that are occurring in a society, but it is equally crucial to consider the differences of interpretation visual language represents and creates.

As technology progresses, so does the opportunity for communication through user interaction. Readers are no longer confined to the two-dimensional typographic spaces offered by the print medium, rather they play an active role in controlling their narrative journey. The typographic experience will continue to extend from the virtual into physical public spaces, advancing from billboards and posters to include projections onto buildings, installations and theatrical performances. Spatial perceptions will be enhanced, thereby offering a more unified communication experience.

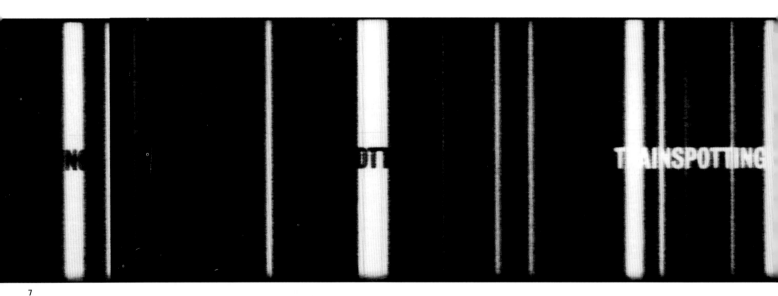

7

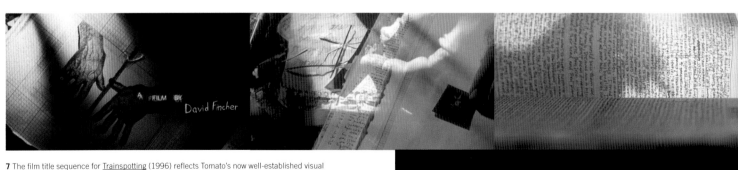

7 The film title sequence for Trainspotting (1996) reflects Tomato's now well-established visual vocabulary. **8** Title sequences from the feature film Seven (1995).

8

Notes
1 David Harvey. The Condition of Postmodernity: An Enquiry into the Origins of
Cultural Change (Oxford: Blackwell, 1989): 206.
2 Richard Kostelanetz, ed. Visions of Totality: László Moholy-Nagy, Theo van
Doesburg and El Lissitzky (Ann Arbor: UMI Research Press, 1980): 58.
3 Ibid., 97.
4 Jay David Bolter. 'Topographic Writing: Hypertext and the Electronic Writing
Space.' In Paul Delany and George P. Landow, eds. The Hypermedia and Literary
Studies (Cambridge: The MIT Press, 1994): 105–18.
5 David Small, Suguru Ishizaki and Muriel Cooper. 'Typographic Space.' Visible
Language Workshop at MIT Media Lab.
6 Michael Worthington. 'Entranced by Motion, Seduced by Stillness.' Eye (no. 33,
1999): 31.
7 Jessica Helfand. Six (+2) Essays on Design and New Media (New York: William
Drentell, 1997): 56.
8 Peter Hall. 'Title Waves.' I.D. (vol. 46, no. 2, 1999): 61.
9 Victoria Geibel. Foreword for Design Quarterly 144 (Cambridge: The MIT Press,
1989): 5.
10 Peter Hall. 'Title Waves.' I.D. (vol. 46, no. 2, 1999): 62.
11 Gunther Kress and Theo van Leeuwen. Reading Images: The Grammar of
Visual Design (London: Routledge, 1996): 16.

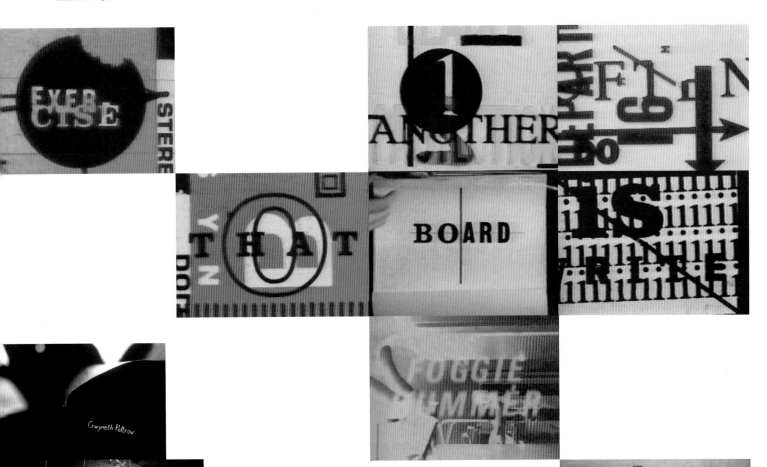

9 This highly successful BBC Radio Scotland advertisement, 'Foggie Bummer' (1995), was one of three commissioned TV commercials. Designer Jonathan Barnbrook has drawn the typographic forms directly onto pieces of found film.

9

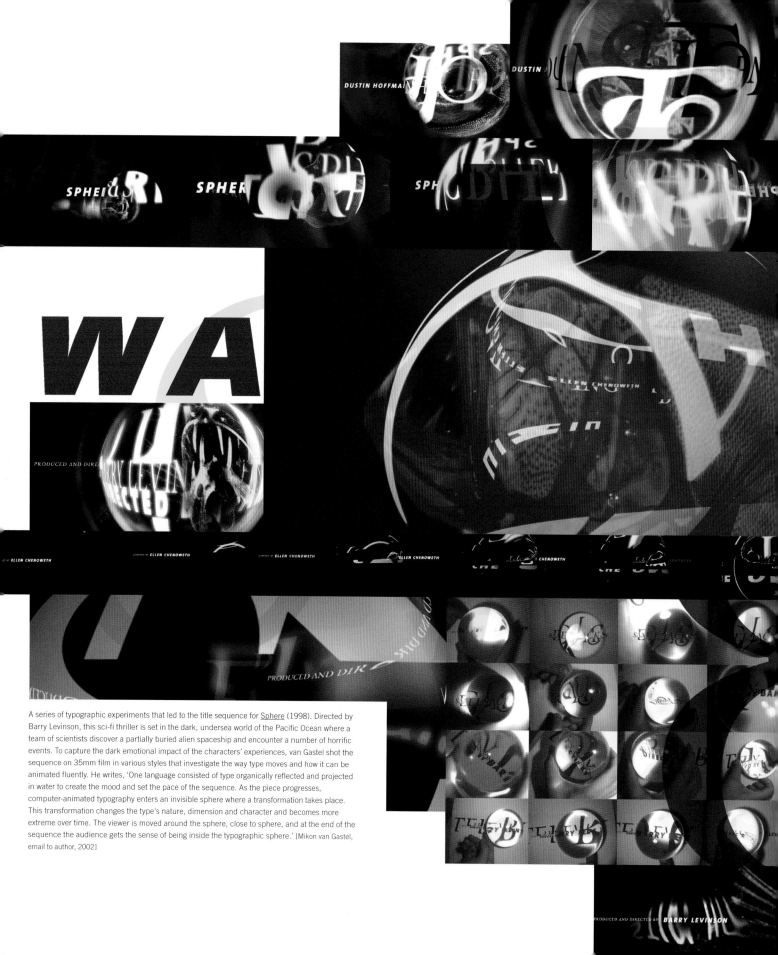

A series of typographic experiments that led to the title sequence for Sphere (1998). Directed by Barry Levinson, this sci-fi thriller is set in the dark, undersea world of the Pacific Ocean where a team of scientists discover a partially buried alien spaceship and encounter a number of horrific events. To capture the dark emotional impact of the characters' experiences, van Gastel shot the sequence on 35mm film in various styles that investigate the way type moves and how it can be animated fluently. He writes, 'One language consisted of type organically reflected and projected in water to create the mood and set the pace of the sequence. As the piece progresses, computer-animated typography enters an invisible sphere where a transformation takes place. This transformation changes the type's nature, dimension and character and becomes more extreme over time. The viewer is moved around the sphere, close to sphere, and at the end of the sequence the audience gets the sense of being inside the typographic sphere.' [Mikon van Gastel, email to author, 2002]

MIKON
VAN GASTEL

"Imaginary Forces has allowed me to be constantly influenced by creative minds from such diverse backgrounds and perspectives as design, film, architecture, programming, creative writing, industrial design, sculpture and music. In the studio, I promote experimentation within film-making, design, architecture and culture through creative collaborative projects.

My interest in the changing media landscape lies in the new spaces designers can occupy. Not just cinematic spaces or the television screen, but digital space and physical environments. Typography plays a crucial role in the definition of these spaces. I am also interested in exploring new directions in the application of digital technology in the context of typographic design. Digital media and programming variables allow typography and messaging to be dynamic. My focus is to think of solutions that are not only form-based but also content-based, moving dynamic behaviour beyond stylistic transformations and insertions, and using these dynamic capabilities to modify content, meaning and language.'

b. 1971
Studio: Imaginary Forces
Country: the Netherlands/United States of America

Imaginary Forces, in which Mikon van Gastel is partner and creative director, is an internationally recognized film and design studio in Hollywood and New York. The studio is perhaps best known for its title sequences for <u>Spiderman</u> (2002), <u>Harry Potter</u> (2001), and <u>The Mummy</u> (1999). Prior to joining Imaginary Forces (2000), van Gastel received a degree in design from the Utrecht School of the Arts and an MFA degree from Cranbrook Academy of Art. While at Cranbrook, he was also a designer at Laurie Haycock Makela and the late P. Scott Makela's studio Words + Pictures.

Van Gastel works on a range of projects, including film titles, television commercials and branding. He believes that typography created for film title design 'communicates the transformations the main characters go through in an abstract way'; in <u>Sphere</u> (1998), for example, he uses sequential typography to express emotions, changes in tone, character and personality. He asserts that 'typography is not the top layer; it is the leading actor. It takes centre stage as it sets the mood for the film, creates a metaphor or tells a part of the story.' After working primarily in film and television, van Gastel became more

interested in engaging with physical spaces and exploring the area of 'environmental media'. Some of his more recent work attempts to break from the conventional, including a multi-screen video installation for the Wexner Center in Columbus, Ohio, developed in collaboration with Greg Lynn and Jeffrey Kipnis.

Investigating the use of (responsive) three-dimensional elements as a form of typographic communication, van Gastel worked on the Centers for IBM e-business Innovation in Chicago (2000). For van Gastel, the most interesting aspect of the project stems from the collaborative nature of the design process. It is here where the space, designed by Imaginary Forces and architects from Design Office, is 'an experience that articulates content as environment'. The space reflects and reinforces the e-business values of openness, collaboration and flexibility, and, where the space is responsive, it is activated by the people in it. In this way, interactive screens allow immediate personalization and 'smart' technology guides a soundscape that changes with the movement of the inhabitants. The architecture gracefully reconfigures to allow for individual or group experiences. 'The idea of shifting the audience's point of view and allowing them to see the complexities of today's changing e-business culture became both the embodiment of IBM's e-business philosophy as well as the concept behind the typographic experimentation', explains van Gastel.

At the Centers for IBM e-business Innovation (2000), companies can access all the information needed to develop, implement and manage e-business solutions. Van Gastel and the multidisciplinary team (architects and sound designers) integrated media, architecture, interactivity, lighting and sound to form a unified whole that resonates throughout the centres' design. **1–3** The branding perspective that set the mood and tone for the centres' design, and the branding animation that greets people on entering the centres. **4** An architectural fly-through used in the design process to give the client a sense of the experience.

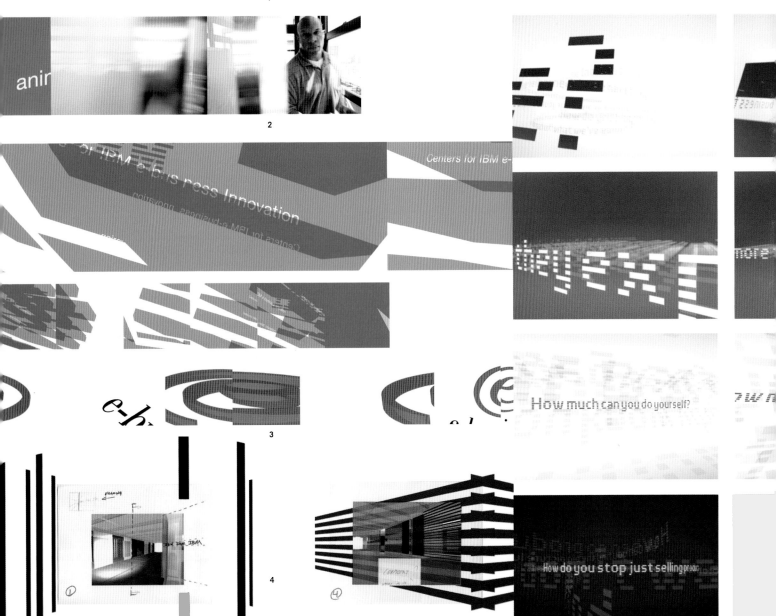

1

2

3

4

Perhaps he sums it up best when he states, 'Where in my earlier work I treat the screen as a stage for the typography, the way the typography acts, performs and communicates within the architectural projects addresses the sculptural and architectural aspects of the site.'

In 2002, van Gastel joined United Architects, a team of international architects who submitted new designs for the World Trade Center site. United Architects was selected as one of the six finalists from a group of more than four hundred international entrants and was awarded a grant to explore the site further. He has also lectured internationally at, among others, the International Film Festival in Rotterdam, the 4th ADG Symposium on Design and Technology in São Paulo (Brazil), the Walker Art Center in Minneapolis, the AIGA National Design Conference, CalArts and Yale University. His work has been recognized by the American Center for Design, the Type Directors Club of New York, the AIGA and the New York Art Directors Club. His work has appeared in such magazines as I.D., Metropolis, Frame and IDEA.

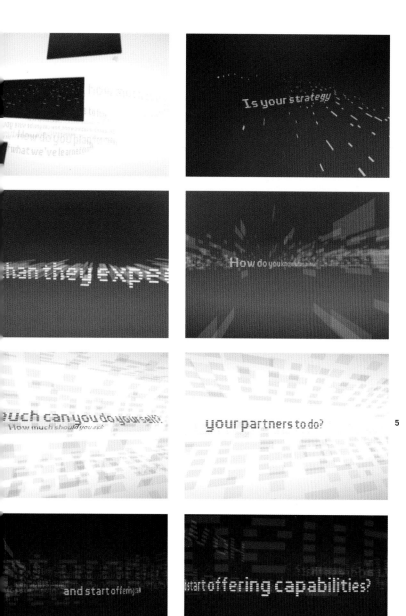

5

6

5 The 'Questions-Video' for the IBM project uses the original typeface and creates a typographic landscape. Both the logo and the original typeface allowed the designer to orient and disorient the audience in an environment composed of typography, shifting architectural structures and ever-changing points of view.

6 The '745 7th Avenue Signage' (2001) focuses on 'the creation of non-linear (non-commercial) content displayed 7 days a week, 365 days a year', and is wrapped around the façade of a skyscraper in New York's Times Square area. The project forced van Gastel to think about the difference between a linear, scripted typographic story (as told in a main title sequence) and a freeform, non-linear environment with many variables and multiple entry and exit points. Van Gastel explains, 'typographic messaging becomes an essential element in communication to a non-captivated audience. In this project typographic messages are treated as "bits" of information to be programmed, processed, and rendered live.' Content changes over time depending on global and local market fluctuations, the time of day and events in the world. This is 'an experience where information is staged and performed dynamically and in real-time'.

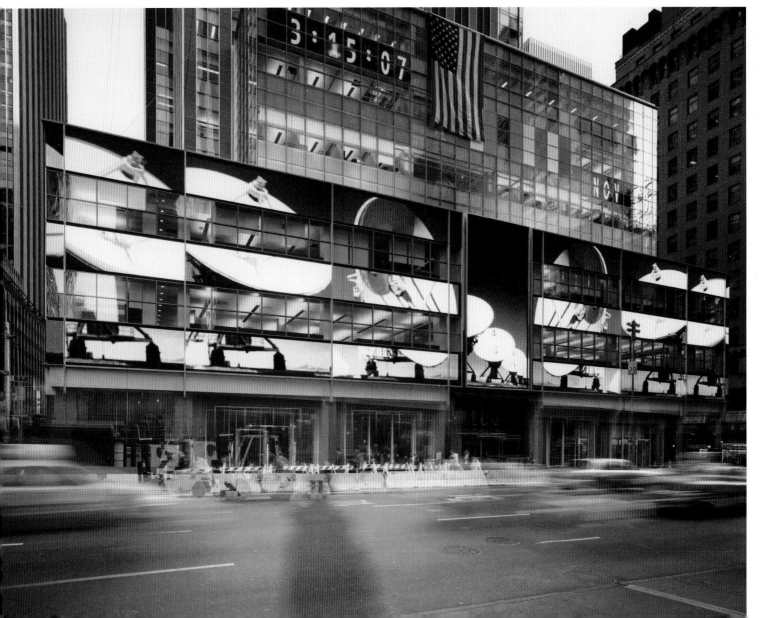

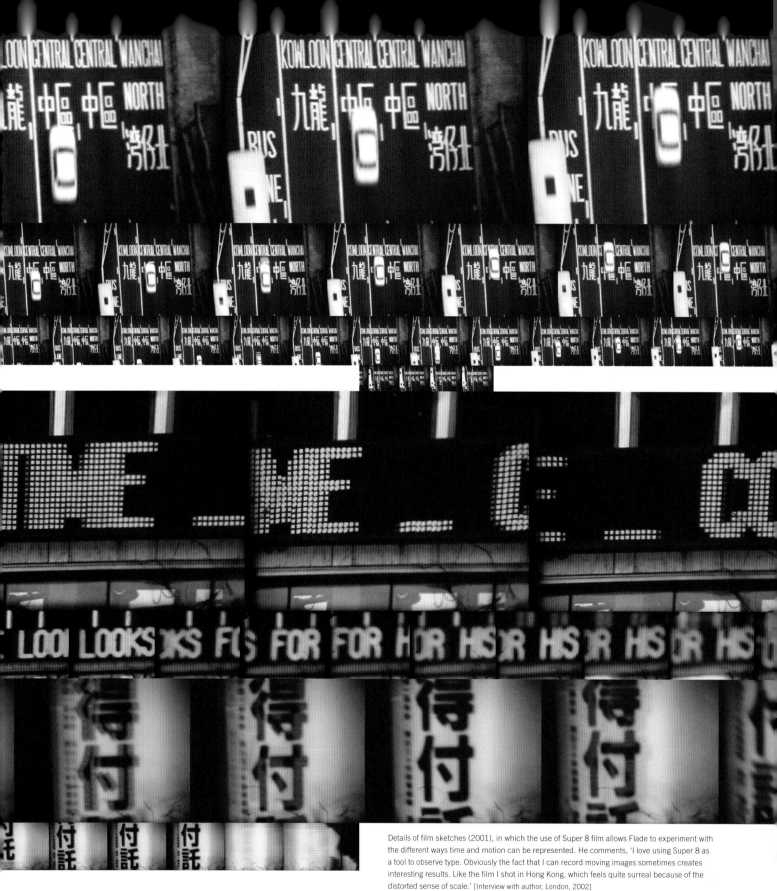

Details of film sketches (2001), in which the use of Super 8 film allows Flade to experiment with the different ways time and motion can be represented. He comments, 'I love using Super 8 as a tool to observe type. Obviously the fact that I can record moving images sometimes creates interesting results. Like the film I shot in Hong Kong, which feels quite surreal because of the distorted sense of scale.' [Interview with author, London, 2002]

FRED FLADE

'Experimental typography is a "doodle", an investigation into something. It is nonsense communication.'

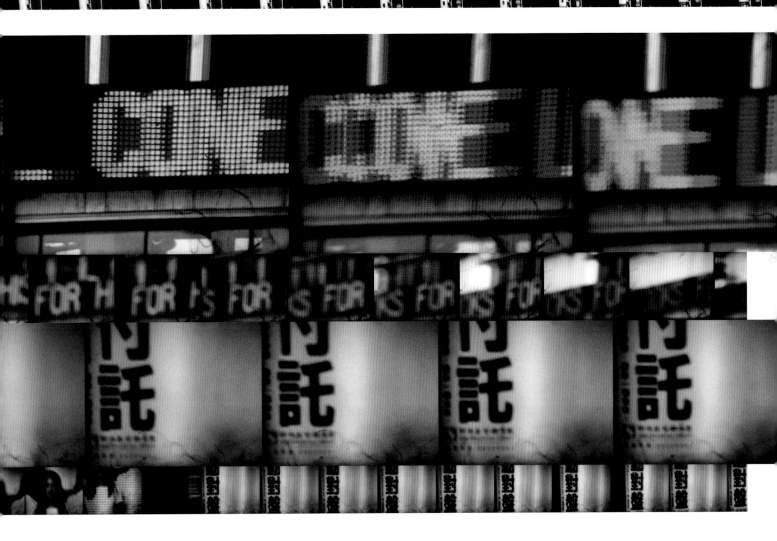

b. 1969
Studio: de-construct
Country: Germany/United Kingdom

After working at the FP Werbung Advertising Agency in Munich (1990–92) and attending one-year study programmes at the Bavarian Academy of Advertising (1992) and Kingston University (1993), Fred Flade went on to graduate from Ravensbourne College of Design and Communication in London (1997). While at Ravensbourne, he won a British Design and Art Direction (D&AD) Student Award (1996) for his website work and a Royal Society of Arts Student Design Award (1997) for his design of interactive services for television viewers. Following a three-month placement at Philips Design in Eindhoven, the Netherlands, Flade joined the internationally recognized interactive design company Deepend in London (1997) as a graphic designer, soon becoming design director (1999–2001). He has won numerous awards for his website design including the coveted British Design and Art Direction Silver Pencil (1999), two British Interactive Multimedia Association Awards and the 2000 Creative Circle Award. The website for London's Design Museum is perhaps Flade's best-known website and epitomizes his strong graphic style and seamless interactive design. A cube represents the museum, the perfect

symbol for the modern, minimalist and functional building and exhibition space. Flade's approach won him the Art Directors Club of New York Gold Medal (2001).

Flade has lectured internationally about his work at various D&AD events and at the digital design magazine IdN's 'Fresh Conference' (2001). He has been a judge for the D&AD Awards, the International Society of Typographic Designers Awards (2001) and the Mando Student Website Design Awards (2002). He has also published his experimental interactive design work 'Technophobia' in issue 11 of the interactive forum 'The Remedi Project' (www.theremediproject.com). In 2001, Flade and six others from Deepend formed a new 'digital creative' company called de-construct in London. The company's strength in strategic thinking coupled with their unique brand of creative and technical approaches has meant that they effectively maximize digital media as an integral part of marketing solutions. de-construct's clients include Technics, Virgin Trains, Working Title Films, Orange and First Direct.

Flade designed the website for Frost Design (2002, www.frostdesign.co.uk). Established in 1994 by Vince Frost, Frost Design works on editorial design, magazine production, video titles, album covers and annual reports. Frost is known for his innovative use of photographic images and his bold typographic style, as exemplified by his catalogue work for the publishers 4th Estate (1997–98), which depicts Frost's interest in the tactility of traditional letterpress printing methods and the bold forms created by the use of wood type. Flade takes this visual approach as his starting point for the website, basing the site on maps and a landscape made up of typography alone, from big typographic landmarks to small detailed typographic areas. Only one typeface (Akzidenz Grotesk Super) one colour and one format achieves maximum effect, allowing the playful treatment of typography to become the main focus. The lack of any specific brief from the client led Flade to comment that this was 'a rare example of a "commercial" project so open and free it becomes an experimental project'.

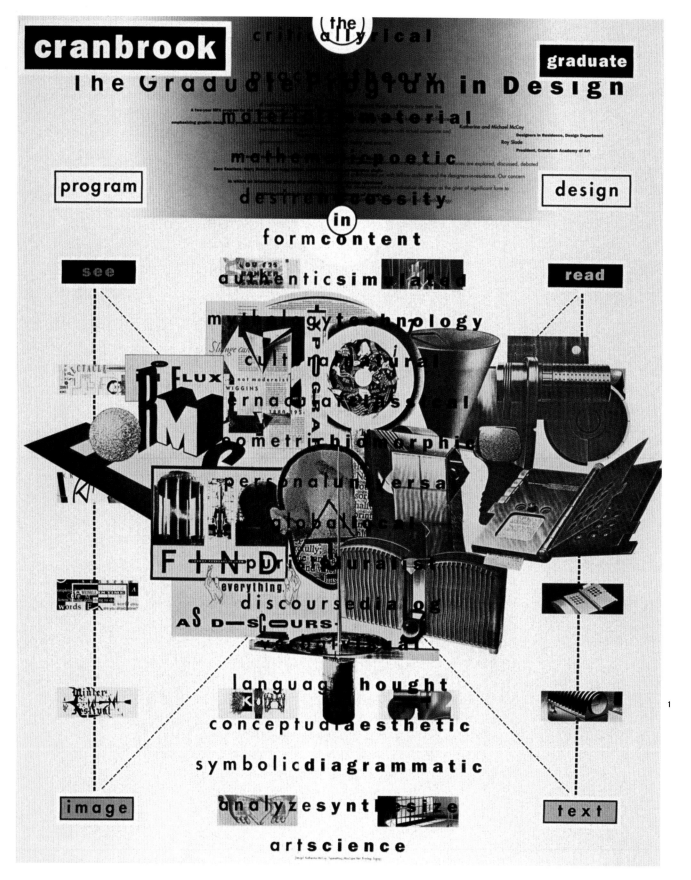

1 McCoy designed this poster (1989) for Cranbrook design department to promote graduate study and to communicate the programme's philosophy. A photographic collage of student work (2-D on the left in red and 3-D on the right in blue) is overlaid by a communications-theory diagram and a list of possibly opposing values referred to frequently in the department. The poster is bisected by the red-blue axis and is perforated so recipients can remove sections of the image area to use as reply postcards. 2 McCoy's poster for Cranbrook Academy of Art (1972).

KATHERINE McCOY & STUDENTS

'I cannot imagine practising as a communications designer without engaging with experimentation … I feel compelled to continuously search for new ways to express a written message. Each message is unique, and has embedded in it a new way to structure it typographically. I like to listen to each message and let it suggest new ways to organize itself and express itself in space, proportion itself and render itself in type fonts. This has led me through a number of investigations.'

2

b. 1945
Institution: Institute of Design, Illinois Institute of Technology
Country: United States of America

Katherine McCoy is recognized internationally as an educator and graphic designer. She received a BA degree from Michigan State University and began her career as a graphic designer at Unimark International in the late 1960s. At Unimark, working with Massimo Vignelli and Herbert Bayer, she was exposed to the Swiss School method, a rational approach that used just one sans serif font in a few sizes, which she remarks 'was very radical on the US scene'. She continues, 'Our modernist graphic spaces were packed with narrow columns, tight leading, and minimal margins'[1].

As co-chair of the department of design at Cranbrook Academy of Art (1971–95), with her partner and husband, McCoy began to break the Modernist typographic paradigms through a 'long succession of typographic formal explorations'. She also began to engage with ideas of literary theory and Post-structuralism and credits Cranbrook student Ed Fella for introducing notions of the vernacular and 'low-design' typography into the academy's programme. This, when coupled with a sense of anti-formalism, helped to shape the department's foray into 'audience interpretation of symbolic codes'.

Shown here is student work developed for the 'Interactive Typography Project Sequence' at the Institute of Design, Illinois Institute of Technology, Chicago (2001). The students range from industrial designers and design planners to communications designers, and from those with a minimal typographic experience to those with a more sophisticated understanding.

The project brief was to explore 'strategies for message analysis, spatial organisation and structure as they interact with typography and graphic composition in digital space'. This step-by-step process begins with the analysis of websites on public health issues to create typographic

While at Cranbrook, she encouraged students to engage with typographic experimentation and the potential of 'typography as discourse' to 'discover their own individual understanding of design and its role and importance in society, and in the process help them discover their own means of formal expression'. Her success in this matter is evident in the number of well-known graduates who were products of those Cranbrook years, such as Lorraine Wild, Nancy Skolos, Lucille Tenazas (see pp. 84–87), Martin Venezky (see pp. 26–31), Elliott Peter Earls (see pp. 214–19), Robert Nakata and Jeffery Keedy[2].

After twenty-four years at Cranbrook, McCoy left to become senior lecturer at the Chicago Institute of Design (1995–), where she runs courses and workshops in communication design and interdisciplinary design theory and criticism. This move has presented McCoy with the opportunity to investigate the areas of interactive electronic communications design and interactive dynamic typography. Although McCoy's role is mainly as an educator and critic, she continues to develop a framework from which students may better understand the 'new dimensions of sound, motion and interactivity'. Intrigued by what traditional graphic-design grammars, methods and media can contribute, McCoy writes, 'My biggest interest here lies in an exploration of how interactivity can affect the reading process'[3].

compositions on posters. Then, readers are observed as they navigate through the student's information spaces and their reading paths and eye movements are recorded to produce a graphic representation of the space's structure, hierarchy and content areas. Next, typographic forms are replaced with abstract forms, challenging students to invent original graphic languages. The final stage of the process deals with interactivity, exploring how the reader can trigger transformations through interaction with dynamic textual and numerical material.

3

4

McCoy is the recipient of numerous design awards, including the prestigious American Institute of Graphic Arts Medal in recognition of her teaching and practice (1999), and is joint recipient, with Michael McCoy, of the Daimler Chrysler Award for Innovation in Design (1994). She is also an honorary member of the Alliance Graphique Internationale. She was president of the American Center for Design, vice-president of the American Institute of Graphic Arts and has served on the Design Arts Policy Panel of the National Endowment for the Arts. McCoy was a distinguished visiting professor at the Royal College of Art in London (1992–96).

Notes
1 Katherine McCoy. 'Experimental Typography', unpublished paper, 2001.
2 Bruce N. Wright. 'The McCoy Generation.' Print (Nov/Dec 1996): 32.
3 Katherine McCoy. 'Experimental Typography', unpublished paper, 2001.

3–4 For the first step of the project, Robert Zolna produced a poster incorporating the website text of the peace and justice organization Peace Action; while Emily Ulrich used the website text from the organization Recording for the Blind and Dyslexic. **5** The second step combined a text from each website, resulting in interwoven text phrases and the invention of a hypothetical organization called Dyslexic Action. The students then mapped the eye movements of their readers. **6** The final step is an animation of the reader's experience, focusing on what content they retained and their visual experience.

Dyslexic

Dyslexic Action believes that all people should have ready access to an action plan for creating a new century free of the scourge of war — regardless of their disability.

Action

disability.

5

6

peace action
www.peaceaction.org

recording for the blind and dyslexic
www.rfbd.org

Tools **For** *Project*
Self *Gutenberg*
Reliance

Could you work without?

7 Step two of Margaret Alrutz and Gitte Waldman's project combines the two websites 'Tools for Self-Reliance' and 'Project Gutenberg'. **8** They went on to note and animate the reader's eye movement. A tutor explained, 'this team deals with the idea of peripheral vision and how the various chunks of text content intermix in the reader's mind and attention span'.

Patients' Rights.

How many more people have to die before we accept that quality is everyone's problem?

Physicians for a National Health Program

Physicians for a National Health Program is a single-issue organization advocating a universal, comprehensive single-payer national health care program. PNHP has over 8,000 members and chapters across the United States. Please join us in marking that health care is a right, not a privilege.

PNHP educates members with widely differing political views, united by our dismay at our nation's widening gaps in income and access to medical care. We believe that only public health infrastructure, and the corporate takeover of the health sector. We are convinced that most Americans, and most physicians, support health care reform based on principles of social justice and medical need, not the current reforms driven by Wall Street.

PNHP has already played a critical role in building public awareness of the single-payer alternative. We published the first major single-payer proposal in the New England Journal of Medicine in 1989. Its 2-year

Aetna U.S. Healthcare

Aetna is the nation's leading health care and related benefits organization, providing a full spectrum of products and services, including health care, dental, vision, pharmacy, group life, disability and long-term care coverage. Aetna provides products and services to more than 18.3 million health care and 13.2 million dental members, plus 11.4 million group insurance customers nationwide.

Recently, class-action lawsuits have been filed against various health maintenance organizations (HMOs), including Aetna. These suits, all making the same broad claims, have been brought to court all around the country.

The following are a collection of articles and opinions addressing managed care plans.

What's at Stake?

9 10

9 The websites for two organizations with antagonistic viewpoints – Physicians for a National Health Program and Aetna U.S. Healthcare – were combined in Taehwan Kim and Jun Lee's project. **10** The typography was abstracted into simple architectural forms. A tutor commented, 'the reader is visualized as an embattled patient that literally must navigate his way through the three-dimensional adversarial healthcare process.'

11 12

11–12 King Das and Doug Stewart's project uses a visual language of dots, DNA structures and a child's hand to represent eye movement over texts for first aid and CPR (cardiopulmonary resuscitation). The DNA structure could be interpreted as a metaphor for an interactive set of information relationships: typography as a visual structure is transformed into an information structure.

The British Council's brief for the 'Lost and Found' exhibition (1999) was to 'find a way to "spill" content out of the main exhibition area into other buildings scattered on the venue site'. Nick Bell's solution was to produce screen-printed paper tablecloths on which he listed English, Welsh, French, Celtic, Norse, Roman, Flemish and Dutch rivers. The tablecloths became a 'metaphor for ideas that originate in one place and get carried, like flotsam, somewhere else – turning up in unexpected places and forms'. The names are positioned on the tablecloth to spill over the side of the table, and it is interesting to note that one critic attributes Bell's use of

landscape imagery and metaphors to growing up in the flat Fens of Norfolk, England [Nick Barley]. Lost and Found: Critical Voices in New British Design. London: The British Council/Birkhäuser, 1999, p.32]. The tablecloths were placed on tables set up between the main exhibition area and the gallery refectory. A pot of wax crayons was put on each table, inviting people to respond to the show on the tablecloths, which were then displayed on a washing line.

NICK
BELL

'To experiment means to risk taking actions knowing they might result in unpredictable outcomes. True experimentation can happen if you are lucky enough to be working in a medium that allows for outcomes that are not what were ordered. Graphic design is an applied art and most designers find themselves honouring requests for particular outcomes where results are fixed. This does not stop designers from messing with their method but isn't this a kind of safe, false experimentation if it is never likely to change the outcome? Or, if the outcome does change, won't this result in effects so inconsequential as not to be registered beyond the confines of typography itself? To truly experiment, what you do has to really matter. Do we as graphic designers have anything at stake? Are we ever risking anything?

What is "experimental typography"? It can be said that it is possible to truly experiment in the field of typography. This is made possible by the specific expectations we all have when reading: right to left, (or left to right) and top to bottom in parallel rows of text. Confounding these expectations is effective since so much we read we take in blindly without thinking. Every so often it takes a glitch in the transmission for us to notice something.

But what is it we notice? Do we notice what is being said or do we become distracted by the way something is said? It is increasingly the latter. We can't help but be interested in signatures – how the way you do it says something about you. Attention shifts from getting a message across to an obsession with the creation of its form and the cultivation of the individual who created it.

I am not looking for excuses to "do" typography. I am all too aware, when undertaking assignments for clients, that what I am trying to communicate for them on their behalf can occasionally be a message that could reach its destination more effectively through some medium other than graphic design. However, graphic design is what I do and when I have tasks to perform, of course I make use of it.

Currently, the most interesting experimentation seems less about the manipulation of form than about risking departure from the canon. There is a thorough yet humorous engagement with context. When considering issues local to the assignment, cherished notions about what makes good design can be questioned, as they might not be relevant.'

b. 1965
Studio: UNA (London)
Country: United Kingdom

Soon after graduating from the London College of Printing with a BA (Hons) in graphic design (1987), Nick Bell set up his own studio, Nick Bell Design, in London. He established a strong reputation with his design of classical record albums and CD covers for the labels Virgin Classics and Ultraviolet. By 1998, Nick Bell Design became informally associated with the design company UNA, based in Amsterdam, which works in both the cultural and business sectors.

His career as an educator began in 1990 as a part-time tutor at LCP. Two years later, his innovative project briefs and the students' solutions were the sole feature of Emigre (no. 22, 1992). His typeface Psycho (1992), an investigation into a 'vocabulary of marks', was also published in the issue, highlighting Bell's interest in experimentation. Bell's approach to typographic semiotics became a main feature of the MA Typo/graphic Studies programme at LCP, which he co-wrote and taught with Teal Triggs (1997–99). He also designed the college's prospectus (1998–99).

In December 1997, Bell was appointed art director of Eye and, in 1999, became editorially involved as the magazine's creative director. Eye has won numerous editorial design awards and was recognized for 'High Design Quality' by the Design Centre Germany in Essen (1999). Bell won a gold award from the Typographers International Association (1992) for his typographic installation at the BBC Schools TV offices in London. In addition, UNA (London) won the print category in the Design Week Awards (2000) for its innovative disposable tablecloth designed for the British Council exhibition 'Lost and Found'.

Bell was guest designer of issue 52 of Typographic magazine (1998) published by the International Society of Typographic Designers. Other clients include Tate Publishing, Tate Britain, Taschen, Phaidon Press, The Science Museum in London, the Barbican Centre in London, Royal Mail, the Hayward Gallery in London, John Lyall Architects and Casson Mann Designers.

In 1996, Bell explained, 'For me by keeping things minimal you somehow enhance the value of that which is there'[1]. This is Bell's mantra and has resulted in an aesthetic that is both content-led and understated in its formality. He has developed an acute awareness of meaning through the

There is no country in the world that has found an acceptable solution for its radioactive waste

juxtaposition of language and image. From his early work to more recent projects, such as the animations for the British Nuclear Fuel visitor centre at Sellafield, UK, Bell has arranged the elements on the graphic page with semiotic perfection. He often creates wordplay to highlight the ambiguity of language, much in the same way that Roland Barthes asks us to question the linguistic message: 'Does the image duplicate certain items of information in the text, by a phenomenon of redundancy, or does the text add a brand-new item of information to the image?'[2]. Bell selects words, already embedded with meaning, and positions them in an image plane to provide the reader with a second tier of information. For example, his typographic screen-based animations for a large-scale installation at the visitor centre at Sellafield (2002) merged typography into image, and ultimately created a single thought-provoking narrative. The text reveals factual information from established sources about the nuclear industry: 'There is no safe dose of radiation', 'There is no country in the world that has found an acceptable solution for its radioactive waste'. The typography mutates and distorts symbolically, leading Bell to write, 'The use of flat graphic techniques will give all the text sequences a formal discipline that despite being spectacular will retain the degree of gravitas this serious subject deserves'[3].

Notes

1 Nick Bell and Teal Triggs. 'Wednesday Evenings: Conversations between Nick Bell and Teal Triggs.' Speak, 1996.
2 Roland Barthes. The Responsibility of Forms (Berkeley: University of California Press, 1985): 27.
3 Nick Bell in his proposal to Roger Mann, design director on the Sellafield project, 2002.

1

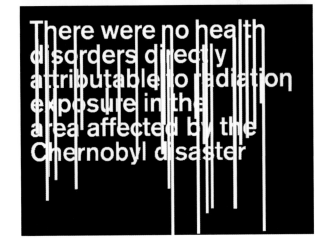

1 A sequence of screen-based animations from an installation at the British Nuclear Fuel visitor centre at Sellafield, curated by the Science Museum (2002). 2 The cover of issue 22 of Emigre (1992), devoted to Bell's teaching approach.

2

Nowacek designed an identity system for GameLab (2000), a 'new kind of game developer'.

NANCY NOWACEK

'Initially, I was interested in reading.

I was interested in experiments that abstract letterforms to their most basic components, testing limits of recognition and readability. Those ideas led to investigations into letterforms in words, words in a line of type, typesetting and grid systems. How to subvert the reading process, how to extend it, how to use reading to express some intrinsic characteristic of the subject matter at hand? Over the past few years, my relationship with "experimental typography" has evolved into an exploration of language systems. Is it possible to derive a rich system of communication – one that is expressive, clear and functional – from a set of base elements? More specifically, I seek to establish a collection of components or elements drawn from the typographic, diagrammatic and representational, and to provide a grammar by which to structure their usage and meaning to create a language that speaks of issues posed by the content. Whether it is for a game, identity system or magazine spread, I intend to create languages that take a life of their own, organic systems flexible enough to adapt and respond to the ongoing dialogue they have with their content and context.'

1 A two-page spread designed by Nowacek for Rojo Magazine (2001), using the character Curi created by artist Marina Zurkow of O-Matic.

b. 1972
Studio: independent designer
Country: United States of America

Nancy Nowacek received a BFA in graphic design and photography from the University of Michigan (1994) and an MFA in communication arts and design from Virginia Commonwealth University (1996). She then worked as a designer and consultant for Old Navy Clothing, Gap Inc. and Life Magazine and as an interaction designer for Plumb Design (1999–2001) and R/GA Interactive (1998–99). Nowacek also worked for Bruce Mau Design (1997–98), where she was the system designer for Mau's book Lifestyle, developing the grid system and typographic hierarchy for the publication. Nowacek has published essays about interaction design and culture and is a guest critic at Columbia School of Architecture and Rhode Island School of Design. Her work was represented in the Art Directors Club 'Young Guns Exhibition' (2000) and in the Cooper-Hewitt National Design Triennial (2000).

In 2001, she founded NOWACEKDESIGN/PROJECTS, where her clients include NetAid Foundation, IBM/Philip Glass, the University of Minnesota Design Institute and Rosemary McMonigal Architects. Nowacek believes that designers should be 'able to function across a continuum of applications and operate in every capacity to creatively solve their clients' problems and address their clients' needs'[1]. Such multimodal activity places Nowacek in a key position. For example, in association with Ralph Appelbaum Associates, Nowacek was lead graphic designer for the UNICEF Visitor's Center in New York, a permanent exhibition space on UN Plaza to educate visitors about UNICEF's history and the continuing challenges to young people around the world. She designed an interactive video booth, in which visitors are recorded sharing their ideas about current issues, which are reviewed by UNICEF officials and then placed on the website for the Global Movement for Children.

An interest in popular culture led Nowacek to collaborate with artist Marina Zurkow (O-Matic) in the design of a double-page spread for Rojo Magazine (2001). Zurkow created five illustrations of a character called Curi, to which Nowacek assigned a word or idea so the images read like a 'textless comic book or soundless cinema'. The spread became an exploration into sequential reading, and in the first five sequences, the narrative could be read vertically as well as horizontally. Certain creators in the comic world, like Chris Ware, have experimented with nonlinear scripts; in an online context, Scott McCloud has written about 'the ever-expanding page'[2]; yet this manga-influenced work has an atmosphere of its own.

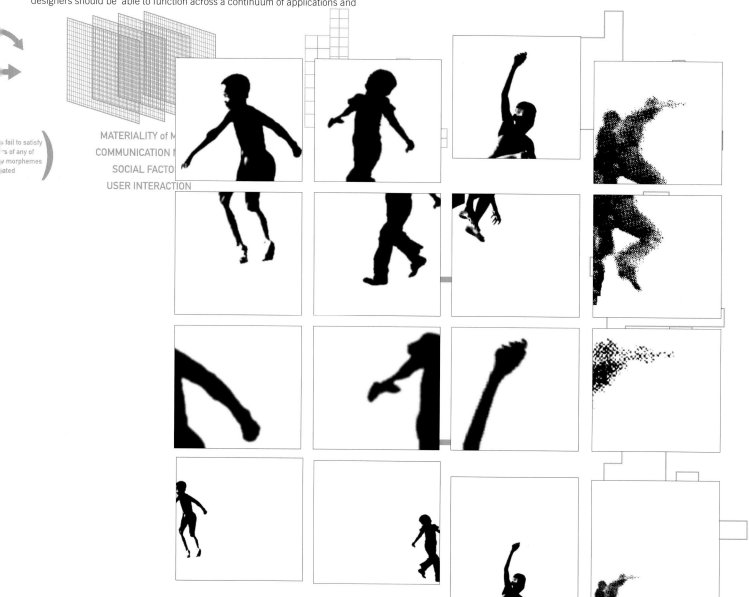

With an interest in gaming language, Nowacek has developed an evolutionary identity system for GameLab (2000). As Erik Zimmerman observes in the GameLab promotional material, 'Cinema has its independent filmmakers. The music industry has alternative and underground bands and DJs. And the gaming industry needs its independent voices.' Taking the square as a designated unit of space and the diagonal line as a representation of the relationship between a player's move and the board, Nowacek intended to create a language that 'was playful and game-like'. She designed a vocabulary of squares using the grid as a framework (or gameboard); the resulting diagrams replicated the basic principles of the gaming experiences. The identity was applied to stationery, the website and T-shirts, with each diagram expressing a theoretical move, such as 'mediated uncertainty', 'emergent play or narrative terrain'.

Notes
1 Nancy Nowacek. 'Us versus Them.' Steven Heller, ed. <u>The Education of the E-Designer</u> (New York: Allworth Press, 2001): 187.
2 www.scottmccloud.com

idea'

idea''

youth

growth

community

empowerment

idea''' 'The Learning Web' (1996) is a non-profit youth outreach programme in Ithaca, New York. Supported by Cornell University, Nowacek became involved with the project while she was at Virginia Commonwealth University. The aim of the website was to empower the local youth by providing information on career internships, community revitalization and other volunteer activities. The site matched children with community members who shared similar career interests, offered discussion groups, traditional counselling and intervention programmes.

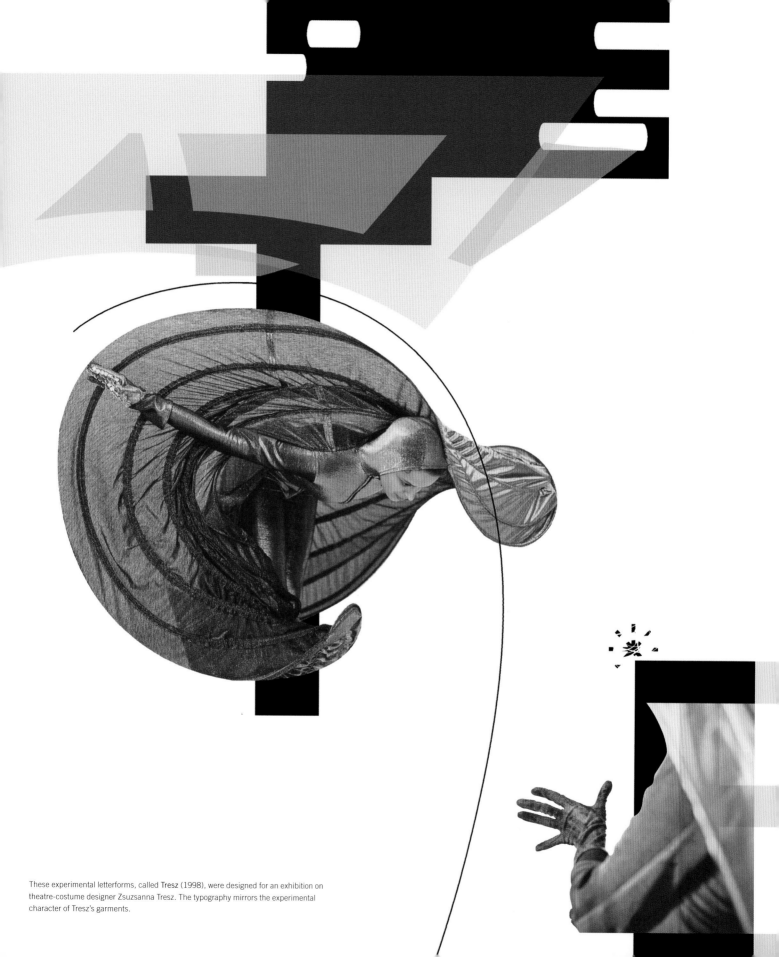

These experimental letterforms, called Tresz (1998), were designed for an exhibition on theatre-costume designer Zsuzsanna Tresz. The typography mirrors the experimental character of Tresz's garments.

ZSOLT CZAKÓ

'I think that good typography presents an authentic image of meaning. In many cases we have to create a new visual language to fit the meaning if it is to be clearly conveyed. Experimental typography is an attempt to reflect individual oral expression and communicative features.

For me, this is about a process of continuous research to find the most adequate image for a given message. I also think that we have to redefine the values of typography to achieve efficacy. Reading abilities and habits are changing rapidly: experimental typography should precede that phenomenon.'

b. 1965
Studio: ART ï csók
Country: Hungary

Graduating from the Hungarian Academy of Applied Arts in Budapest with a diploma in typography (1993–94), Zsolt Czakó had previously studied experimental typography at the Academy of Applied Arts in Vienna (1990). A member of the Association of Hungarian Visual Artists, Czakó also holds a certificate of mastership in photography from the Association of Photographers (1985). In 1993, he co-founded ART ï csók, a creative workshop and multidisciplinary studio, whose core team consists of a designer, architect and writer. Clients include the Office of the President of Hungary, MOL (the Hungarian National Petrol Company) and the art-book publisher Kijárat Kiadó.

Czakó works in the tradition of the Modernists, his approach being informed by functional and aesthetic considerations. The Bauhaus has also had a strong influence on him, and László Moholy-Nagy's work with photograms led Czakó to experiment with photography and typography. Czakó's experience as a photographer and his interest in image making informs much of his client-based work. He remarks, 'The seen images are not empty pictures for me. . . . Associations, symbolic interpretations or just untypical meanings are paired with the most common things in my mind. I have a collection of these images in my brain. When I face a problem, these visual meanings come to the forefront of my mind.'[1]

Hungarian television has commissioned Czakó to work on a number of high-profile projects, including a short film presenting Duna Television at the World Fair in Hanover (2000). For Hungarian National Television, he has produced advertisements for their film department (1998) and their on-screen and off-screen corporate design (1997), while for ARTE (French-German Cultural Television), he created the television spots for their fifth birthday. His work was celebrated in the exhibition 'The film world of Zsolt Czakó' (2002) at the French Institute in Hungary, which was organized by Duna Television. In the same year, his work was shown in 'Dublin 3 Graphic Art' at the Gallery of Szombathely, 'Könyv-Mvész' ('Book Artists') in Budapest and in an exhibition of graphic designers at Vigado Gallery in Budapest. In addition, his work has featured in the group exhibitions 'New Typo 2' in Pécs (1996) and 'Post Script' at Tölgyfa Gallery in Budapest – a selection of the best Hungarian graphic design (1999).

His work also extends into the print medium, where Czakó is recognized for his poster and book design. He has been employed by the publisher Szabad Föld

2

3

(2001–02), has designed a poster and catalogue for <u>The Tempest</u> (2001) and was editor and designer of the book <u>Rövidülni Kezdet</u> (1994). Czakó produced the exhibition design for Film Unio (which promotes Hungarian film makers) at the film festivals in Cannes and Montreal and developed the visual surface design and catalogues for the customer-service department of Éléctricité de France /DÉMÁSZ Rt (2002). Of his work, Czakó reflects, 'I take time to find my position and role in the situation, to eliminate all those features that are not important and to focus on what is really at the heart of the message. By the time the thinking process is over the visual answers usually rise in a rather intuitive way.'[2]

Notes
1 Email to author, 2002.
2 Ibid.

1 The film sequence 'Art Kino' (1998) for Hungarian National Television was designed to announce late-evening art films, aimed at the 'intellectual' public. The sequence has a rhythmical movement of vertical lines and creates tension in its use of opposing images. There are two typographic layers: on one, the lines open up to provide space for letters; on the other, the letters of 'Art Kino' are dropped from the upper part of the screen. Czakó wanted 'to create a contemporary context that is as intellectually provoking as the films within the series'. **2** As part of the work for Hungarian National Television's film department, Czakó designed the title sequence for a series of films made in Europe or thought to be typically European (1998). The letters, used as negative forms, were filled up with moving images from Giuseppe Tornatore's <u>Cinema Paradiso</u>. **3** The television title sequence 'HIRADÓ' ('News') created for Hungarian National Television (1999). Czako comments, 'the basic idea behind the image was to create a visual language that was distinct from commercial television and to use important basic values and make them understood in a simple but sophisticated way.'

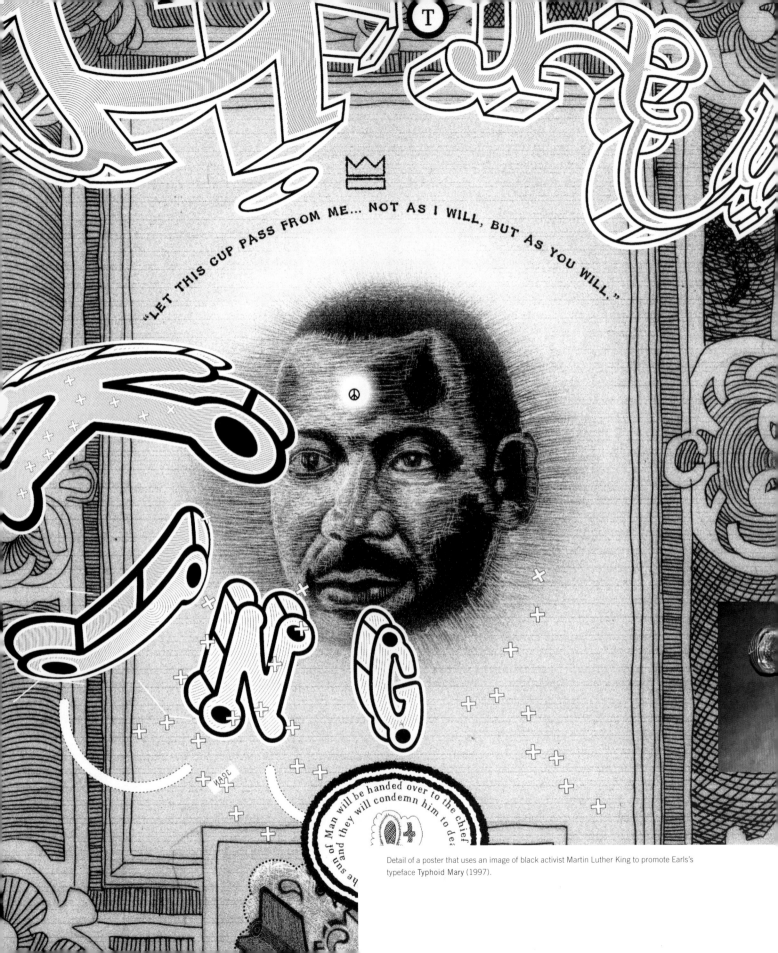

Detail of a poster that uses an image of black activist Martin Luther King to promote Earls's typeface Typhoid Mary (1997).

ELLIOTT PETER EARLS

'It's my belief that new typographic forms come from one of three sources: historical reinterpretation, vernacular appropriation or formal extrapolation. Of these modes, it's when priority is given to formal extrapolation (pure mark-making) that we define type as "experimental". Needless to say, these are not fixed modes they are in flux and overlap. It would be possible, for example, to reinterpret a historical typographic sample in such a way that it would be classified as "experimental". When the purely perceptual or retinal elements do not conform to historically accepted norms, the type is "experimental".'

Technology forms the basis of many of Earls's experiments.

b. 1966
Institution: Cranbrook Academy of Art
Country: United States of America

Cranbrook Academy of Art has an international reputation in design, with some of the most innovative practitioners and educators of their time leading the direction of the institution. Continuing the tradition begun by Katherine McCoy, Laurie Haycock Makela and the late P. Scott Makela, Elliott Peter Earls brings to the post of designer-in-residence and head of two-dimensional design (2001–) a unique approach to graphic design. He takes the traditional notion of the designer and moves it into the realm of the Renaissance man, engaging in forms of expression beyond the printed page. He is at once performance artist, musician, poet, film maker, scriptwriter, typographer and graphic designer. As one critic remarked, 'For Earls, design is a battleground of cultural self-expression'[1].

As new technologies were introduced and as forays into the digital realm gathered momentum, Earls graduated from Rochester Institute of Technology (1988). He went on to receive an MFA from Cranbrook (1993), where he had begun to experiment with non-linear digital video, spoken-word poetry, music composition and design. By the early 1990s, Earls had formed The Apollo

Program, part multimedia studio, part type foundry and promotional office. Clients include Elektra Entertainment, Nonesuch Records, Little Brown & Co., Scribner Publishing Co., Elemond Casabella in Italy, The Cartoon Network in the UK, The Voyager Company and Janus Films.

Earls's first release under The Apollo Program was the pioneering interactive CD-Rom 'Throwing Apples at the Sun' (1995), which was featured in the exhibition 'Digital Zuppe' in Venice (1996). It has won numerous competitions, including I.D.'s 'Annual Design Review' (1996), the American Center for Design's '100 Show' (1996) and the New York Art Directors Club show (1996). Earls later released another CD-Rom, 'Eye Sling Shot Lions', which premiered at the 'New York Video Festival' (1997) and has also been shown at 'Nightwave' in Rimini (1997, Italy), the 'Remaking History' symposium at the American Center for Design (1997) and at Fabrica, an artist research centre, in Treviso (2000, Italy).

'Throwing Apples at the Sun' is a 'kinetic' experience, which 'reveals Earls's unconventional visual sensitivity, and his uncanny ability to remove the viewer from cultural expectations by making the familiar strange'[2]. Earls's work reflects an interest in the Russian formalist concept of ostranenie, or 'making strange', even down to placing the tool bar in the middle of the image field.

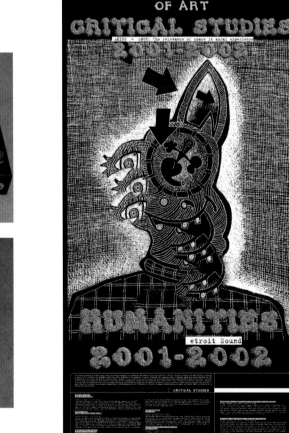

Poster announcing the Critical Studies programme at Cranbrook Academy of Art (2001) and advertising such cultural events as films, music and performances by artist Laurie Anderson. Earls also entertains the reader with such surprises as dropping the first letter of each section, thereby confronting issues of readability.

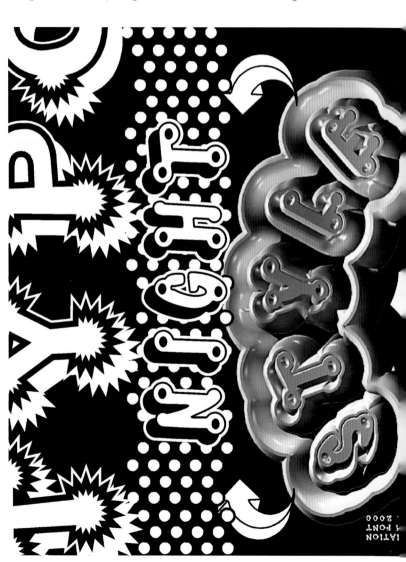

This poster for the 'Typonight' event at the fifth FontShop conference (2000) uses Earls's typefaces Jigsaw Dropshadow (1998) and Typhoid Mary (1997).

Earls challenges the relationship between art and design, between performance and visual language, using a blend of media to create interactive layers of information and audio experiences. Ultimately, this generates an opportunity for intertextuality and, as Earls has remarked, for a 'lexicon of creative process'[3]. For example, Earls has released the typefaces Dyspepsia, Dysplasia and Dyslexia (all 1995), which, as Rick Poynor explains, 'confirmed his gift as a practitioner of outlandishly dysfunctional design'[4]. Other typefaces, such as Typhoid Mary (1997), Venus Dioxide (1997), Jigsaw Dropshadow (1998) and Subluxation Perma (1994), reflect his fascination with that which falls outside the mainstream. His posters are like an issue of the British alternative underground culture magazine Headpress, tackling the dark side of desire, sex, power, mutation and subversive comics. In his exploration of these themes, Earls uses a combination of typefaces, drawings and collages of photographic images to create micro-communities of body parts, mechanical elements and seemingly underworld narratives.

However, it is Earls's performances that have attracted the most attention. In the tradition of experimental performance pioneered by such people as Laurie Anderson, Earls takes 'risks' in his work as well as in his audience. He proves that he is able to move easily across disciplines, from print to performance and from music to film; for example, Catfish, a feature-length digital film (2002) is the artist's monograph in moving pictures. Earls was awarded the 'Emerging Artist' grant by Manhattan's prestigious Wooster Group and was a performer at the group's show 'Performing Garage' (1999). Earls has also performed at the Creteil Theatre Festival in France, the Walker Arts Center in Minneapolis, the Oak Street Theater in Portland and 'Experimenta 99' in Lisbon.

Notes

1 Kenneth FitzGerald. 'The Angel is My Floating Point!' Emigre (no. 39, 1996): 35.
2 Rob Carter. Experimental Typography: Working With Computer Type 4 (Hove, UK: RotoVision, 1997): 114.
3 Elliott Peter Earls. 'WD40.' Emigre (no. 35, 1995).
4 Rick Poynor. 'A Designer and a One-Man Band.' Eye (vol. 12, no. 45, 2002): 38.

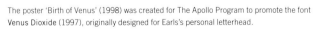

The poster 'Birth of Venus' (1998) was created for The Apollo Program to promote the font Venus Dioxide (1997), originally designed for Earls's personal letterhead.

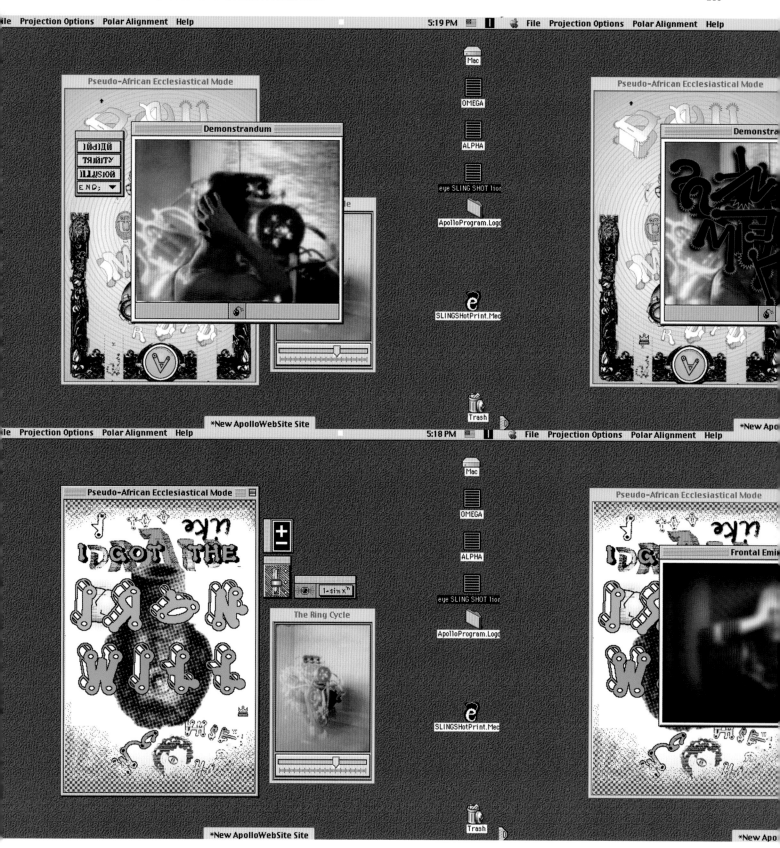

Details from the CD-Rom 'Eye Sling Shot Lions' (1997), which presented work in a multisensory format.

BIBLIOGRAPHY

BOOKS

Aldersey-Williams, Hugh, et.al. Cranbrook Design: The New Discourse (New York: Rizzoli, 1990).

Badaracco, Claire Hoertz. Trading Words: Poetry, Typography and Illustrated Books in the Modern Literary Economy (Baltimore, MD: Johns Hopkins University Press, 1995).

Baines, Phil and Andrew Haslam. Type and Typography (London: Laurence King Publishing, 2002).

Barley, Nick. Lost and Found: Critical Voices in New British Design (London: The British Council/Birkhäuser, 1999).

Barthes, Roland. The Responsibility of Forms: Critical Essays on Music, Art, and Representation (Berkeley, CA: University of California Press, 1985).

Bierut, Michael, William Drenttel, Steven Heller and DK Holland, Looking Closer: Critical Writings on Graphic Design (New York, NY: Allworth Press, 1994).

Bierut, Michael, Jessica Helfand, Steven Heller and Rick Poynor, eds. Looking Closer 3: Classic Writings on Graphic Design (New York, NY: Allworth Press, 1999).

Biesele, Igildo G., ed. Experiment Design (Zurich, Switzerland: ABC Verlag, 1986).

Blackwell, Lewis. 20th Century Type: Remix (London: Laurence King Publishing, 1998).

———. David Carson: 2nd Sight (London: Laurence King Publishing, 1997).

———. The End of Print: The Graphic Design of David Carson (London: Laurence King Publishing, 1995).

———. Twentieth-Century Type (London: Laurence King Publishing, 1992).

Bolter, Jay David. Writing Space: The Computer, Hypertext and the History of Writing (Hillsdale, NJ: Lawrence Erlbaum Associates, 1991).

Bonsiepe, Gui. Interface: An Approach to Design (Maastricht: Jan van Eyck Academie, 1999).

Broos, Kees and Paul Hefting. Dutch Graphic Design: A Century (London: Phaidon Press Ltd., 1993).

Burroughs, William S. The Adding Machine: Selected Essays (New York: Arcade, 1993).

Burroughs, William S. and Brion Gysin. The Third Mind (London: John Calder, 1979).

Carter, Rob. Experimental Typography: Working With Computer Type 4 (Hove, UK: RotoVision, 1997).

Carter, Sebastian. 20th Century Type Designers (London: Trefoil, 1987).

Cohen, Arthur Allen. Herbert Bayer: The Complete Work (Cambridge, MA: The MIT Press, 1984).

Cook, Peter. Experimental Architecture (London: Studio Vista, 1970).

Cotton, Bob and Richard Oliver, Understanding Hypermedia 2.000: Multimedia Origins, Internet Futures (London: Phaidon Press Ltd., 1997, 2nd ed.).

Dair, Carl, Design With Type (Toronto: University of Toronto Press, 1967).

Delany, Paul and George P. Landow , eds. The Hypermedia and Literary Studies (Cambridge, MA: The MIT Press, 1994).

Drucker, Johanna. The Alphabetic Labyrinth: The Letters in History and Imagination (London: Thames & Hudson, 1995).

———. The Century of Artists' Books (New York: Granary Books, 1995).

———. The Visible Word: Experimental Typography and Modern Art, 1909–1923 (Chicago, IL: The University of Chicago Press, 1994).

Dunlap, Carol. The Culture Vulture (Washington D.C.: The Preservation Press, 1994).

Elam, Kimberly. Expressive Typography: The Word as Image (New York, NY: Van Nostrand Reinhold, 1990).

Friedman, Daniel. Radical Modernism (New Haven, CT: Yale University Press, 1994).

Gill, Eric. An Essay on Typography (London: Lund Humphries, 1931).

Glauber, Barbara, ed. Lift and Separate: Graphic Design and the Quote Vernacular Unquote (New York: The Herb Lubalin Study Center of Design and Typography, Cooper Union for the Advancement of Science and Art and Princeton University Press, 1993).

Glusberg, Jorge, ed. Deconstruction: A Student Guide (London: Academy Editions, 1991).

Gombrich, E.H. Meditations on a Hobby Horse and Other Essays on the Theory of Art (London: Phaidon Press Ltd., 1994 reprint).

Gottschall, E.M. Typographic Communications Today (Cambridge, MA: The MIT Press, 1989).

Harvey, David. The Condition of Postmodernity: An Enquiry into the Origins of Cultural Change (Oxford, UK: Blackwell, 1989).

Helfand, Jessica. Six (+2) Essays on Design and New Media (New York, NY: William Drentell, 1997).

Heller, Steven, ed. Design Literacy Continued: Understanding Graphic Design (New York, NY: Allworth Press, 1999).

———. Education of an E-Designer (New York, NY: Allworth Press, 2001).

Heller, Steven and Georgette Ballance, eds. Graphic Design History (New York, NY: Allworth Press, 2001).

Heller, Steven and Marie Finamore. Design Culture: An Anthology of Writing from the AIGA Journal of Graphic Design (New York: Allworth Press, 1997).

Heller, Steven and Philip B. Meggs, eds. Texts on Type: Critical Writings on Typography (New York, NY: Allworth Press, 2001).

Hochuli, Jost and Robin Kinross. Designing Books: Practice and Theory (London: Hyphen Press, 1996).

Hofmann, Armin. Graphic Design Manual: Principles and Practice (New York, NY: Van Nostrand Reinhold, 1965).

Hollis, Richard. Graphic Design: A Concise History (London: Thames & Hudson, 1994).

Holt, Steven Skov, Ellen Lupton and Donald Albrecht. Design Culture Now: National Design Triennial (New York, NY: Princeton Architectural Press, 2000).

Hurlburt, Allen. The Grid (New York, NY: Van Nostrand Reinhold, 1978).

Hyde, Karl and John Warwicker. mmm … Skyscraper I Love You: A Typographic Journal of New York (London: Booth-Clibborn Editions, 1994).

Jury, David. TypoGraphic Writing (London: International Society of Typographic Designers, ISTD, 2001).

Kinross, Robin. Fellow Readers: Notes on Multiplied Language (London: Hyphen Press, 1994).

———. Modern Typography: An Essay in Critical History (London: Hyphen Press, 1992).

Kostelanetz, Richard, ed. Visions of Totality: László Moholy-Nagy, Theo van Doesburg and El Lissitzky (Ann Arbor, MI: UMI Research Press, 1980).

Kress, Gunther and Theo van Leeuwen. Reading Images: The Grammar of Visual Design (London: Routledge, 1996).

Kuijpers, Els, ed. LettError (Maastricht: Jan van Eyck Academie and Charles Nypels Foundation, 2000).

Landow, George P. Hypertext: The Convergence of Contemporary Critical Theory and Technology (Baltimore, MD: Johns Hopkins University Press, 1992).

Lupton, Ellen. Mixing Messages: Contemporary Graphic Design in America (London: Thames & Hudson, 1996).

Lupton, Ellen, ed. Graphic Design and Typography in the Netherlands: A View of Recent Work (New York, NY: Chronicle Books, 1992).

Lupton, Ellen and J. Abbott Miller. Design, Writing, Research: Writing on Graphic Design (New York, NY: Kiosk, 1996).

McLean, Ruari. The Thames & Hudson Manual of Typography (London: Thames & Hudson, 1980).

McLuhan, Marshall. Understanding Media: The Extensions of Man (London: Ark Paperbacks, 1964, reprinted 1987).

———. The Gutenberg Galaxy: The Making of Typographic Man (London: Routledge & Kegan Paul, 1962).

McLuhan, Marshall and Quentin Fiore. The Medium is the Massage (New York, NY: Bantam, 1967).

Massin, Robert. Letter and Image (London: Studio Vista, 1970).

Meggs, Philip B. Fotografiks: David Carson (London: Laurence King Publishing, 1999).

———. A History of Graphic Design (New York, NY: John Wiley & Sons, 1998, 3rd ed.).

Miller, J. Abbott. Dimensional Typography: Case Studies on the Shape of Letters in Virtual Environments (New York, NY: Princeton Architectural Press, 1996).

Moholy-Nagy, Sibyl. Experiment in Totality (Cambridge, MA: The MIT Press, 1969, 2nd ed.).

Moos, Michel, ed. Media Research: Technology, Art, Communication (Amsterdam: Overseas Publishers Association, 1997).

Morison, Stanley. First Principles of Typography (Leiden, the Netherlands: Academic Press, 1928, reprint 1996).

Müller-Brockmann, J. A History of Visual Communication (Teufen, Switzerland: Verlag Arthur Niggli, 1971).

Neuenschwander, Brody. Letterwork: Creative Letterforms in Graphic Design (London: Phaidon Press, 1994, reprint).

Ong, Walter J. Orality and Literacy: The Technologizing of the Word (London: Routledge, 1982).

Poynor, Rick. Design Without Boundaries: Visual Communication in Transition (London: Booth-Clibborn Editions, 1998).

———. Obey the Giant: Life in the Image World (London: Birkhäuser, 2001).

———. Typographica (London: Laurence King Publishing, 2001).

———. The Graphic Edge (London: Booth-Clibborn Editions, 1993).

Poynor, Rick, ed. Typography Now Two: Implosion (London: Booth-Clibborn Editions, 1996)

Poynor, Rick and Edward Booth-Clibborn, eds. Typography Now: The Next Wave (London: Booth-Clibborn Editions, 1991).

Purvis, Alston W. Dutch Graphic Design 1918–1945 (New York: John Wiley & Sons, 1992).

Railing, Patricia. From Science to Systems of Art (Forest Row, UK: Artists Bookworks, 1989).

Rand, Paul. Thoughts on Design (New York, NY: Van Nostrand Reinhold, 1947).

Rasula, Jed and Steve McCaffrey. Imagining Language: An Anthology (Cambridge, MA: The MIT Press, 1998).

Rees, A.L. A History of Experimental Film and Video: From the Canonical Avant-Garde to Contemporary British Practice (London: British Film Institute, 1999).

Ronell, Avital. The Telephone Book: Technology, Schizophrenia, Electric Speech (Lincoln, NE: University of Nebraska Press, 1989).

Ruder, Emil. Typography: A Manual of Design (Teufen, Switzerland: Verlag Arthur Niggli, 1967).

Solt, Mary Ellen, ed. Concrete Poetry: A World View (Bloomington, IN: Indiana University Press, 1968).

Spencer, Herbert. Pioneers of Modern Typography (Cambridge, MA: The MIT Press, 1983, paperback rev. ed.).

Spencer, Herbert, ed. The Liberated Page (London: Trefoil, 1990, paperback).

Stearn, Gerald Emanuel, ed. McLuhan Hot & Cold (London: Penguin Books, 1968).

Strinati, Dominic. An Introduction to Theories of Popular Culture (London: Routledge, 1995).

Svacha, Rostislav, ed. Devetsil: Czech Avant-Garde Art, Architecture and Design of the 1920s and 30s (Oxford, UK: Museum of Modern Art and London: Design Museum, 1990).

Swann, Cal. Language and Typography (London: Lund Humphries, 1991).

Swanson, Gunnar, ed. Graphic Design & Reading: Explorations of an Uneasy Relationship (New York, NY: Allworth Press, 2000).

VanderLans, Rudy and Zuzana Licko. Emigre (The Book): Graphic Design into the Digital Realm (New York, NY: Van Nostrand Reinhold, 1993).

Walker, Sue. Typography and Language in Everyday Life: Prescriptions and Practices (Harlow, UK: Pearson Education Limited, 2001).

Wallis, L. W. Type Design Developments 1970 to 1985 (Arlington, VA: National Composition Association, 1985).

Weingart, Wolfgang. Typography: My Way to Typography (Baden, Switzerland: Lars Müller, 2000, reprint).

Weniger, Del. Cacti of Texas and Neighboring States (Austin: University of Texas Press, 1984).

Why Not Associates. Why Not (London: Booth-Clibborn Editions, 2000, paperback).

Woods, Alan and Ralph Rumney. The Map is Not the Territory (Manchester, UK: Manchester University Press, 2000).

Wozencroft, Jon. The Graphic Language of Neville Brody (London: Thames & Hudson, 1988).

ARTICLES

Babák, Petr. 'Interview. KK Piece of Design.' Deleatur (no. 3, winter, 1998): 12–19.

Barnes, Paul. 'Octavo: 1986–92.' Dot dot dot (2000): 9–15.

Beaulieu, Derek. 'A Word in Another Language I Can Understand: An Interview with Gyöngy Laky.' www.alienated.net/article.php?sid=31

Behrens, Roy R. 'Far From Academic: Richard Eckersley.' Print (LV:VI, 2001): 78–85.

Bell, Jonathan. 'Peter Anderson.' Graphics International (issue 98, September 2002): 14–17.

Bell, Nick and Teal Triggs. 'Wednesday Evenings: Conversations Between Nick Bell and Teal Triggs.' Speak (1996).

Boyd-Maunsell, Jerome. 'Alphabet Soup.' Frieze (issue 72, Jan/Feb 2003): 58–59.

Butler, Frances. 'New Demotic Typography: The Search for New Indices.' Visible Language (29:1): 88–111.

Coupland, Ken. 'West Coast Latitudes.' Eye (no. 31, 1999): 26–37.

Dugdale, Juanita. 'Gyöngy Laky: Matter and Message.' Baseline (no. 32, 2000): 37–44.

Earls, Elliott Peter. 'WD40.' Emigre (no. 35, 1995).

Farrell, Stephen. 'Rousting the Florentine Body.' Electronic Book Review, 1996. www.altx.com/ebr/ads/ebr6/farrell/roustin.htm

FitzGerald, Kenneth. 'The Angel is My Floating Point!' Emigre (no. 39, 1996): 34–44.

Foges, Chris. 'Mind Games.' Blueprint (July, 2001): 28–31.

Gall, John and Steven Bower. 'Massin Ahead of Time.' Print (July/August 1996): 78–84.

Garnier, Pierre. 'Poetry.' Typos 2 (London College of Printing, 1981–82).

Geibel, Victoria. 'R/Greenberg Associates.' Design Quarterly (144, 1989).

Gibson, Nicky. 'A New Medium.' TypoGraphic (no. 56, 2000): 10–13.

Griffin, Deborah. 'Lemon Chiffon Cadillac: An Interview with Sibylle Hagmann and Denise Gonzales Crisp.' Emigre (no. 50, 1999).

Gromala, Diane. 'Virtual Avatars: Subjectivity in Virtual Environments.' Visible Language (31.2, 1997): 214–23.

Hall, Peter. 'Title Waves.' I.D. (vol. 46, no. 2, 1999): 60–64.

Heller, Steven. 'The Cult of the Ugly.' Eye (vol. 3, no. 9, 1993): 52–59.

Hitchcock, Lucinda. 'Word Space/Book Space/Poetic Space: Experiments in Transformation.' Visible Language (34.2, 2000): 162–97.

Homans, Katy. 'BJ, Robert Brownjohn: The Ultimate Conceptualist Reassessed.' Eye (vol. 4, no. 1, 1991): 53–63.

Horsham, Michael. 'Soirée in the Ruins.' Eye (no. 17, 1995): 38–43.

Janáková, Iva. 'The Search for Continuity: Young Czech Designers.' Baseline (issue 25, 1998): 9–16.

———. Foreword to TypoDesignClub Annual 1997, www.typodesignclub.cz/english/tdcjanak.en.htm

———. 'Zdruhé Strany' ('From the Other Side'). Deleatur (issue 2, 1997): 28–29.

Kinross, Robin. 'Type as Critique.' Typography Papers (no. 2, 1997): 77–87.

———. 'The Digital Wave.' Eye (vol. 2, no. 7, 1992): 27–39.

Krejek, Petr. 'Profile: Petr Babák, We'd Better Be Serious About Design!' Deleatur (no. 5, spring 2001): 4–13.

LaPorte, Susan. 'Letterforms & Lexicons.' Emigre (no. 38, 'The Authentic Issue', 1996–97): 36–45.

McCoy, Katherine. 'Experimental Typography.' Unpublished paper, 2001.

———. 'American Graphic Design Expression.' Design Quarterly (148, 1990): 3–22.

Mermoz, Gérard. 'Deconstruction and the Typography of Books.' Baseline (issue 25, 1998): 41–44.

———. 'On Typographic Reference: Part One.' Emigre (no. 36, 1995).

Miller, J. Abbott. 'Word Art.' Eye (vol. 3, no. 11, 1993): 34–43.

Mills, Mike. 'The (Layered) Vision Thing.' Eye (vol. 2, no. 8, 1993): 8–9.

Ormerod, Fiona and Roz Ivanic. 'Materiality in Children's Meaning-making Practices.' Visual Communication (vol. 1, issue 1, 2002): 65–91.

Perry, Mark. Sniffin' Glue (issue 5, November 1976).

Polkinhorn, Harry. 'True Heritage: The Sound Image in Experimental Poetry.' Visible Language (35.1, 2001): 12–19.

Poynor, Rick. 'A Designer and a One-Man Band.' Eye (vol. 12, no. 45, Autumn, 2002): 36–41.

Roberts, Lucienne. 'Read Me! Part 1 and Part 2.' Eye (vol. 10, no. 37, 2000): 76–81.

Rock, Michael. 'Beyond Typography.' Eye (vol. 4, no. 15, 1994): 26–35.

Saiki, Maggie Kinser. 'Ahn Sang-Soo: Going Home.' Graphis (no. 327): 32–49.

Salen, Katie. 'Editor's Note.' ZED.2: Real World Design: The Role of the Experimental (Richmond: Virginia Commonwealth University, 1995): 1–4.

CREDITS

————. 'Speaking in Text: The Resonance of Syntactic Difference in Text Interpretation.' Visible Language (27:3, 1993): 280–301.

Sang-Soo, Ahn and Sharon Poggenpohl. 'Preserving Words: The Korean Tripitaka.' Visible Language (34.1, 2000): 8–13.

Scholz, Christian. 'The Path From the Optophonetic Poem to the Multimedia Text.' Visible Language (35.1, 2001): 92–103.

Small, David, Suguru Ishizaki and Muriel Cooper. 'Typographic Space.' Visible Language Workshop at The Media Laboratory, MIT.

Thrift, Julia. 'Type, Fashion, Fusion.' Eye (vol. 6, no. 22, 1996): 46–53.

————. 'Marks on Paper.' Eye (vol. 4, no. 15, 1994): 54–61.

Triggs, Teal. 'Layers of Language.' Eye (no. 17, summer, 1995): 62–71.

Triggs, Teal and Jonathan Barnbrook. 'Bastard!:The Typo/Language of Jonathan Barnbrook.' (London College of Printing: Design Open Pamphlet Series 1, autumn, 1997).

Vos, Eric. 'New Media Poetry: Theory and Strategies.' Visible Language (30.2, 1996): 214–37.

Warde, Beatrice. 'The Crystal Goblet.' The Monotype Recorder (vol. 44, no. 1, Autumn 1970): 22–23.

Weingart, Wolfgang. 'My Typography: Instruction at the Basel School of Design Switzerland, 1968–1985.' Design Quarterly (130, 1985): 2–20.

Wilkins, Bridget. 'Type and Image.' Octavo (no. 7, 1992).

Wolff, Laetitia. 'Massin in Continuo: A Dictionary.' Design Issues (vol. 18, no. 4, autumn 2002): 31–45.

Worthington, Michael. 'From A to Z.' CalArts, unpublished lecture, 2001.

————. 'Entranced by Motion, Seduced by Stillness.' Eye (no. 33, 1999): 29–39.

Wright, Bruce N. 'The McCoy Generation.' Print (Nov/Dec 1996): 29–43.

All Emigre typefaces courtesy of the designers and Emigre Inc.
All Virus typefaces courtesy of Jonathan Barnbrook and the Virus Foundry.
All Fuse and Fontwork typefaces courtesy of the designers and FSI FontShop International, Berlin.

(Numbers indicate the page number)

Introduction

008 Left Zed. Editor and designer: Katie Salen; Publisher: Virginia Commonwealth University.

008 Right and p. 11, captions 1,3,4 Typographica. Photography: Geremy Butler; Reproduction courtesy of St. Bride Printing Library, London.

009 Dimensional Typography. Reproduction courtesy of J. Abbott Miller and Princeton Architectural Press.

010 Right Emigre. Guest editor: Jeffery Keedy; Designer: Rudy VanderLans; Reproduction courtesy of Emigre.

011 Caption 2 Photograph: Geremy Butler; Reproduction courtesy of St. Bride Printing Library, London and the Stedelijk Museum, Amsterdam. Caption 4 Piet Zwart © DACS 2003.

012 Reproduction courtesy of Laurie Haycock Makela and The MIT Press.

013 Caption 5 Typgrafische Monatsblätter. Photograph: Geremy Butler; Reproduction courtesy of Wolfgang Weingart and St. Bride Printing Library, London. Caption 6 Octavo. Author: Bridget Wilkins; Editor and designer: 8vo (Mark Holt, Hamish Muir, Michael Burke).

014 Cranbrook Design. Reproduction courtesy of Katherine McCoy and Rizzoli.

016 'Output.' Tutors: Joani Spadaro, Teal Triggs, Rupert Bassett.

Chapter 1

020 Typeface courtesy of the designer and Lineto.

022 Dimensional Typography. Rendering: Guy Williams; Reproduction courtesy of J. Abbott Miller and Princeton Architectural Press.

023 Caption 2 Nemesis (arch-deviant mix), 1985.

025 Concept and art direction: Christian Küsters; Design: Paul Beavis.

030 Speak. Publisher and editor: Dan Rolleri; Art director: Martin Venezky for Appetite Engineers. Printed with kind permission of the publisher.

031 Open. Editor: Karen A. Levine; Design: Appetite Engineers.

036 RayGun, October 1993. Publisher and editor: Marvin Scott Jarrett; Art direction and design: David Carson; Photography: Daniel Sturt.

037 Reproduction courtesy of Surfer.

038 Caption 1 Speak. Publisher: Dan Rolleri; Editor: Neil Fineman; Graphic design: David Carson. Printed with kind permission of the publisher. Caption 2 RayGun, September 1993. Publisher and editor: Marvin Scott Jarrett; Art direction and design: David Carson; Photography: Ophelia Chong. Captions 3–4 David Carson's table of contents from The Book of Probes by Marshall

McLuhan to be published by Gingko Press (Corte Madera). Printed with kind permission of the publisher.

040 <u>Wire</u>. Photography: Jacques Cressaty.

041–42 <u>Oll Korrect</u> and <u>Proximity</u>. Photography: Tom Grotta

042 <u>Sound</u>, <u>Of Course</u> and <u>Wake</u>. Photography: M Lee Fatherree.

Chapter 2

056 **Left** Reproduced courtesy of xplicit ffm. **Right** Typeface courtesy of the designer and Lineto.

059 **Caption 6** WD+RU. Project team: Siân Cook, Teal Triggs, Liz McQuiston.

062 **Caption 2** Photography by Hollis Frampton.

064 <u>Lost and Found: Critical Voices in New British Design</u>. Publisher: The British Council/Birkhäuser; Designer: Anne Odling-Smee, Stephen Coates.

082–83 Designer and typographer: Pablo A. Medina; Creative director: Brian Collins; Writer: Charles Hall; Client: Miller Lite.

090 <u>Illustration Now</u>. Reproduction courtesy of Edward Booth-Clibborn.

091 <u>Public Offerings</u>. Reproduction courtesy of The Museum of Contemporary Art in Los Angeles. **Caption 6** Back cover image: <u>Oo Fifi, Five Days in Claude Monet's Garden</u>, courtesy of Diana Thater, 1992; Front cover image: courtesy of the artist Sarah Lucas and Sadie Coles HQ, London. **Caption 8** Courtesy of the artist Mike Kelley.

092 Reproduction courtesy of SBS Television, Australia.

099 Typeface: Sibylle Hagmann; Designer: Denise Gonzales Crisp Client: Art Center College of Design.

102 **Caption 1** Design: Fanette Mellier; Illustrations: Marion Trolley de Pellevaux; Client: Nouvelle Imprimerie du Niger, Niamey.

103 **Captions 3–4** Exhibition design: Pascal Payeur; Scientist: Paul Unschuld; Photography: J.-L. Leibovitch; Client: Grande Halle de la Villette, Paris.

Chapter 3

108 Typeface courtesy of the designer and Lineto.

110 **Caption 1** Director: Todd Mueller and Betsy Blakemore; Designers: Todd Mueller, Eli Gesner and Marco Spier; Animators: Marco Spier, Eben Mears and Todd Mueller; Artist: Company Flow; Client: Rawkus Records, NY.

111 **Captions 4–6** <u>mmm . . . Skyscraper I Love You</u>. Reproduction courtesy of Edward Booth-Clibborn.

112 Reproduction courtesy of the type designers and 2Rebels.

113 **Caption 10** Designer: Martin Woodtli; Photography: Tom Schierlitz.

115 <u>Things That Quicken the Heart</u>. Author: Various; Publisher: Soo Jin Kim; Designer: Michael Worthington.

121 **Caption 1** <u>2000AD</u>. Art: Cliff Robinson and Chris Blythe (May 2001). **Caption 2** <u>2000AD</u>. Art: Mark Harrison (June-July 1999); Design: Steve 'Robo' Cook.

122 Reproduction of typefaces courtesy of Rian Hughes and Device Fonts.

133 **Caption 3** <u>Zivel</u>. Art director: Klára Kvízová with Petr Krejzek, Marek Pistora, Radim Pesko.

138 **Caption 9** Art director: Katsumi Asaba.

Chapter 4

144 **Caption 1** <u>Dinamo-Azari</u>. Reproduction courtesy of the Estorick Collection of Modern Italian Art, London. Fortunato Depero © DACS 2003.

145 **Captions 2–3** <u>Enhance</u>. Publisher: Temporary Release; Text: Deirdre Crowley; Text edits and matrix flow: Ian Sen; Design and spatial enhancements: Peter Maybury.

147 **Caption 5** <u>Patmos</u>. Editor and writer: John Hutchinson; Design and production: Peter Maybury; Publisher: The Douglas Hyde Gallery, Dublin. **Caption 6** Jan van Toorn © DACS 2003.

148 **Caption 9** Reproduced from <u>The Telephone Book: Technology, Schizophrenia, Electric Speech</u>; Author: Avital Ronell; Publisher: the University of Nebraska Press; Designer: Richard Eckersley. **Caption 10** Reproduced from <u>Stupidity</u>; Author: Avital Ronell; Publisher: the University of Illinois Press; Designer: Richard Eckersley.

165 <u>everything Magazine</u>. Editorial: Luci Eyers, Steve Rushton, John Timberlake; Designers: Stuart Bailey, Ruth Blacksell; Front cover: Paul Elliman; Publisher: everything Publications.

166–67 <u>Dot dot dot</u>. Reproduction courtesy of the editors and Broodje & Kaas publishing house.

170–71 Typefaces reproduced courtesy of the type designer and Typotheque.

174 Photography: Kim Hyun-Pil.

175 **Caption 2** Design and photography: Ahn Sang-Soo.

176–78 <u>Space/Sight/Self</u>. Author: Laura Letinsky; Publisher: The Smart Museum of Art and the University of Chicago Press; Art direction: Kathy Fredrickson and Cheryl Towler Weese; Design: Cheryl Towler Weese; Research and production coordination: Matt Simpson.

179 **Top** Client: Chicago Park District; Art direction: Kathy Fredrickson and Cheryl Towler Weese; Design: Cheryl and Dan Towler Weese. **Below** <u>Literary Objects: Flaubert</u>. Editor: Philippe Desan; Publisher: The Smart Museum of Art and the University of Chicago Press; Art direction: Kathy Fredrickson and Cheryl Towler Weese; Design: Cheryl Towler Weese and JoEllen Kames.

Chapter 5

181 **Caption 2** Photography: Rocco Redondo Design; Art direction: Why Not Associates; Client: Smirnoff Agency and Young and Rubicam. **Caption 3** Virgin intro sequence, video (2000). Client: Virgin Special Projects; Design and art direction: Why Not Associates; Client: Virgin Special Projects Design.

182 Reproduction courtesy of David Small, MIT Media Labs.

183 **Caption 6** <u>Typographica</u>. Photograph: Geremy Butler; Reproduction courtesy of St. Bride Printing Library, London.

184 **Caption 7** <u>Trainspotting</u>. Feature-film main titles. Designer: Jason Kedgely; Titles director: Simon Taylon; Director of film: Danny Boyle Studio and Polygram Filmed Entertainment. **Caption 8** <u>Seven</u>. Feature-film main titles. Designer, director and producer: Kyle Cooper; Designers: Kyle Cooper and Jenny Shainin; Executive producer: Peter Frankfurt; Director of film: David Fincher Studio and New Line Cinema.

185 **Caption 9** Reproduction courtesy of BBC Radio Scotland. 'Foggie Bummer' is a promotional trailer for BBC Radio Scotland.

186 <u>Sphere</u>. Length 2:40. Main titles. Design and production: Imaginary Forces (IF); IF creative director: Kyle Cooper; IF directors: Mikon van Gastel and Kurt Mattila; IF designers: Mikon van Gastel and Olivia d'Albis; IF 2-D animators: Ben Lopez and Jennifer Park-Chang; Deep-sea photography: Norbert Wu; Production company and studio: Warner Bros.; Director: Barry Levinson.

189 Centers for IBM E-business Innovation. Environmental site design: Live-Action; Branding: Imaginary Forces; IF creative director: Mikon van Gastel; IF art director: Matt Checkowski; IF animators: Matt Checkowski, Peter Cho and Chun-Chien Lien; IF typeface designer: Jens Gehlhaar; IF editors: Carsten Becker, Jason Kool and Jason Webb; Design office: Principal Architects (George Yu, Jason King); Project designers: Sandra Levesque, Davis Marques, Kai Riedesser; Musikvergnuegen: Creative director, composer and mixer: Walter Werzowa.

191 '745 7th Avenue Signage'. Design and production: Imaginary Forces; IF creative director: Mikon van Gastel; IF art director: Sara Marandi; IF designers and animators: Eddie Opara, Emily Wilson, Matt Checkowski, Fabian Tejada; Principal architect: Kohn Pedersen Fox, Kevin Kennon.